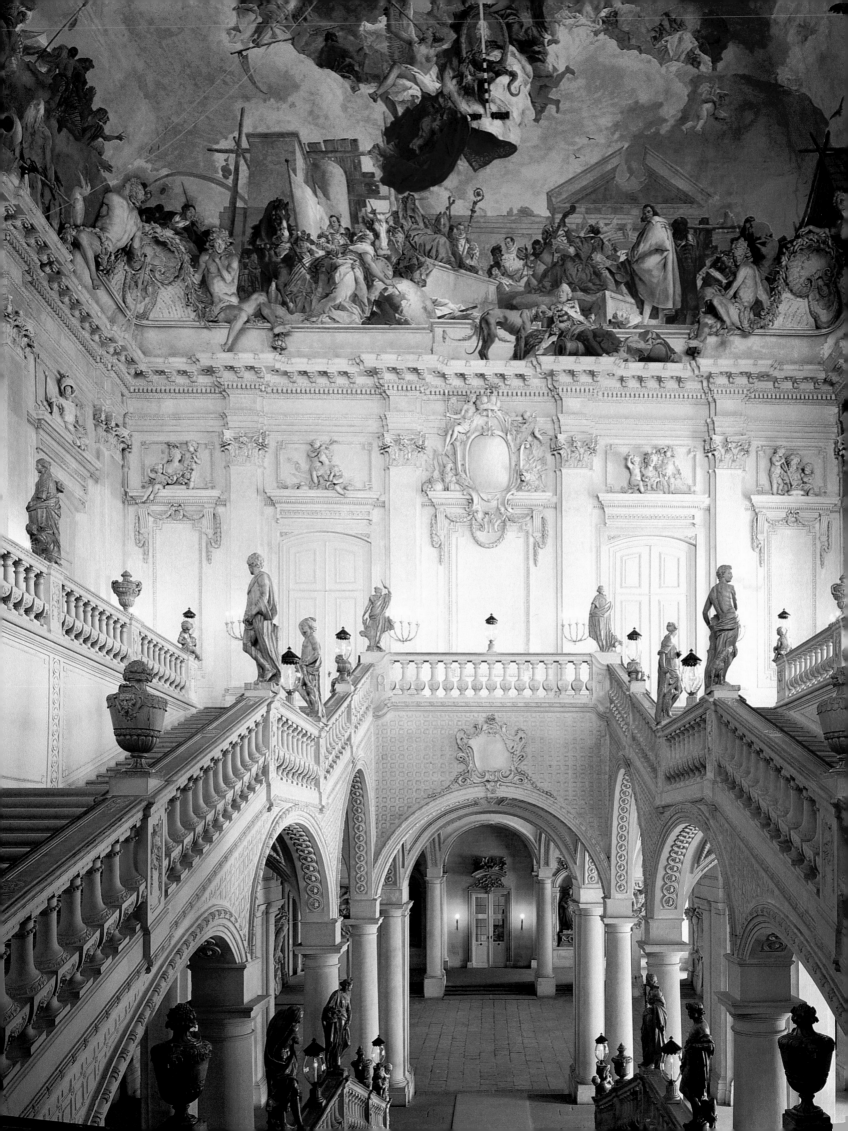

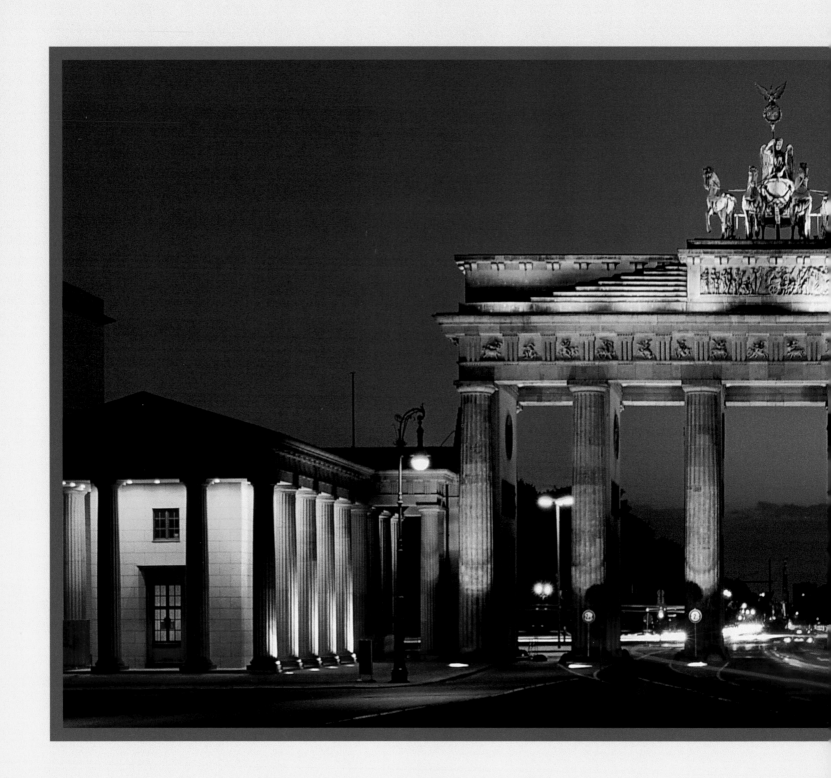

GERMANY

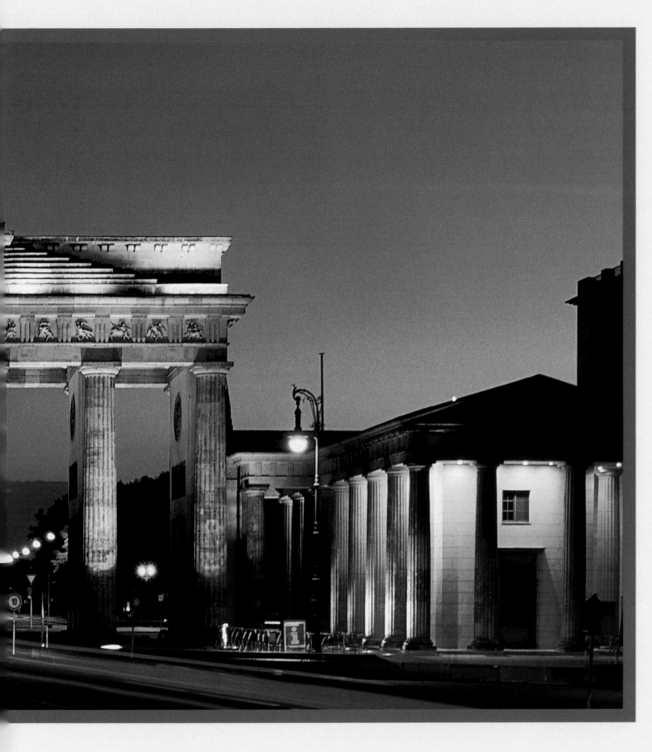

The Brandenburg Gate symbolises both the division and reunification of Germany. Until 1990 it stood on the boundary between the two German states. The end of 1989/beginning of 1990, when the two Germanys celebrated their final coming together here, will remain imprinted on the minds of many forever. The Gate was erected in honour of Karl Wilhelm Ferdinand between 1788 and 1791.

WITH PHOTOS BY JÜRGEN HENKELMANN,
KARL-HEINZ RAACH, MARTIN SIEPMANN,
HORST AND DANIEL ZIELSKE
AND TEXT BY SEBASTIAN WAGNER

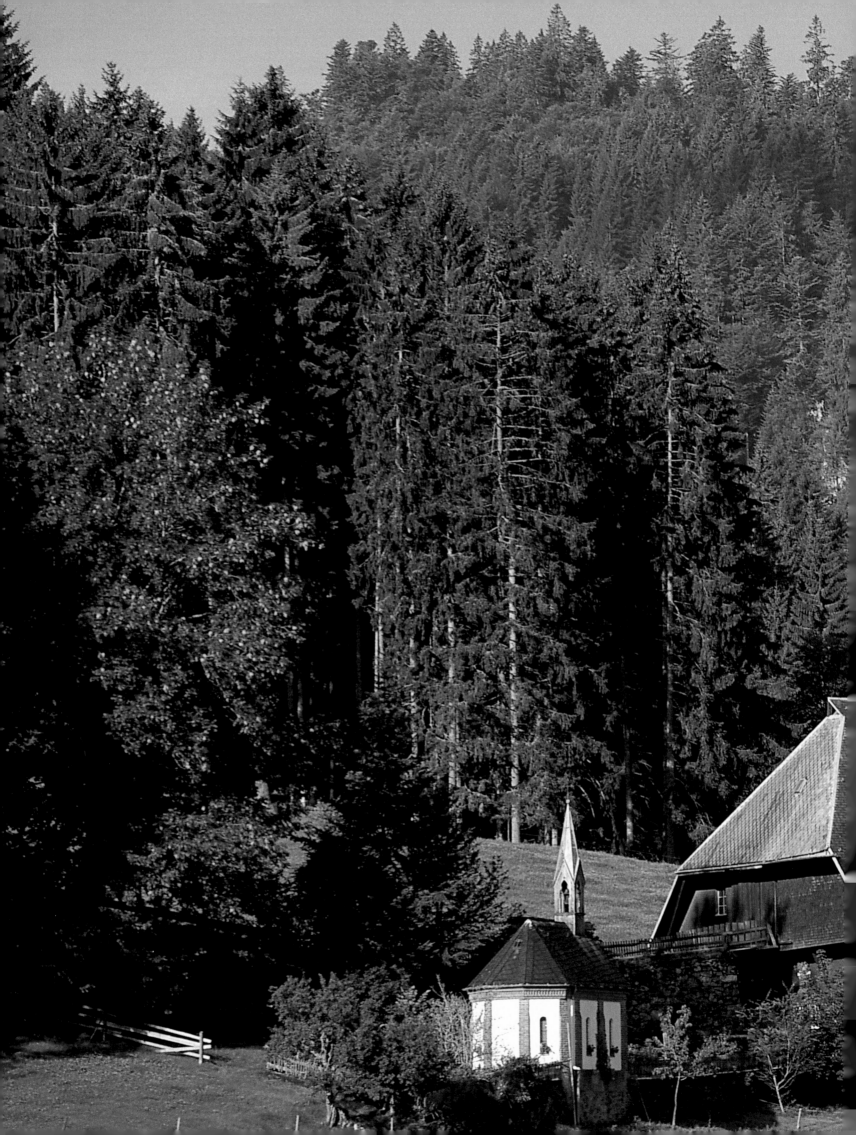

CONTENTS GERMANY

GERMANY –
OVER ONE THOUSAND YEARS
OF HISTORY

Page 16

GERMANY'S NORTH –
FROM THE NORTH SEA TO THE RUHR

Page 30

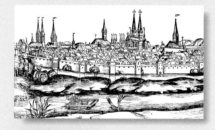

Special
THE HANSEATIC LEAGUE –
MEDIEVAL MERCANTILE POWER

Page 44

Special
CASTLES –
THE MIDDLE AGES COMES TO LIFE

Page 64

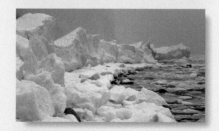

GERMANY'S EAST –
FROM THE BALTIC TO THE ERZGEBIRGE

Page 70

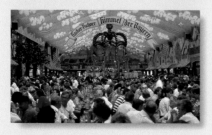

Special
BEER – BREWED ACCORDING
TO THE PURITY LAW OF 1516

Page 92

Page 5:
The roof above the staircase in the residential palace in Würzburg boasts the largest ceiling fresco in the world, the absolute highlight of Giovanni Battista Tiepolo's (1696–1770) creative career. The Residenz, now a UNESCO World Heritage Site, was the seat of Würzburg's prince-bishops. One of the dynasty, Johann Philipp von Schönborn, began implementing Balthasar Neumann's designs in 1719.

Page 8/9:
The idyllic Kesslerhof in the mountains of the Black Forest is surrounded by tall pine trees. The product of several centuries of building and extension, pounded by wind and weather, the complex is both home and working farm.

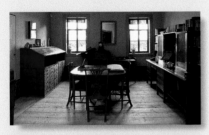

Special **Page 106**

GOETHE & SCHILLER –
THE GREATS OF CLASSICAL WEIMAR

GERMANY'S SOUTH – **Page 110**
FROM THE RHINE TO THE ZUGSPITZE

Special **Page 126**

WINE –
THE GIFT OF THE ROMANS

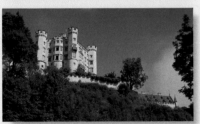

Special **Page 144**

LUDWIG II –
A GERMAN FAIRYTALE KING

Index **Page 154**
Map **Page 155**
Credits **Page 156**

Page 12/13:
The Benedictine monastery of Andechs in Upper Bavaria atop a 760 m (2,493 ft) hill is a place of pilgrimage for worshippers of God and the monks' brew alike. Pilgrims have been coming here since the 12th century; the famous beer was first served in 1455.

Page 14/15:
Potsdamer Platz in Berlin has been reborn; once the busiest square in Europe, today it resembles an open-air museum of contemporary architecture. One of the prime exhibits is the Sony Center, covered by an enormous glass tent roof designed by Helmut Jahn.

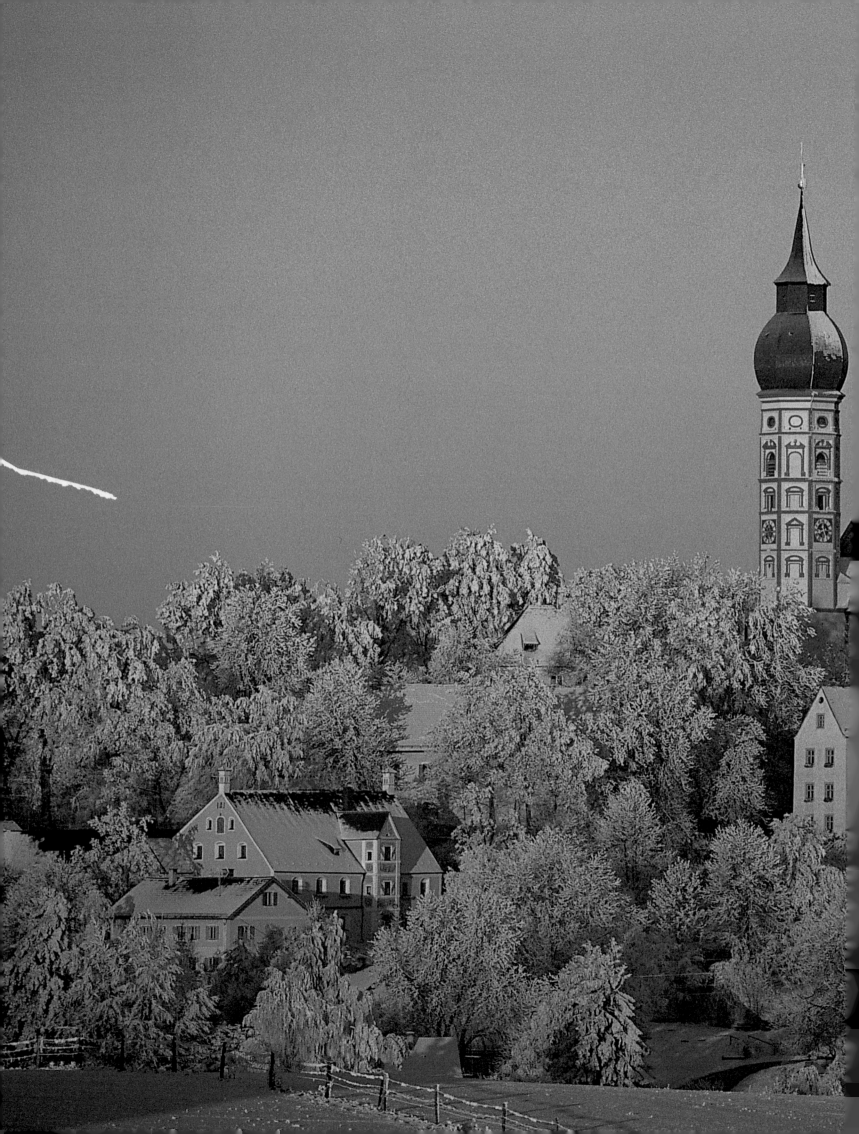

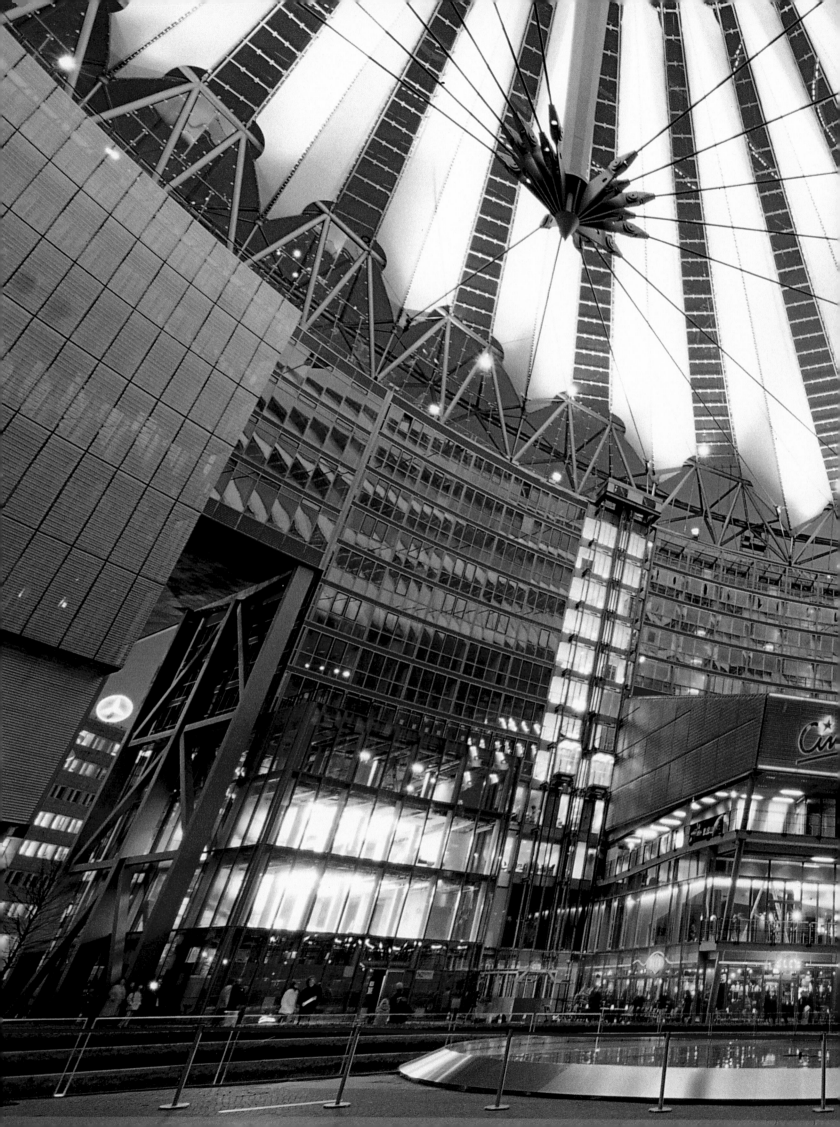

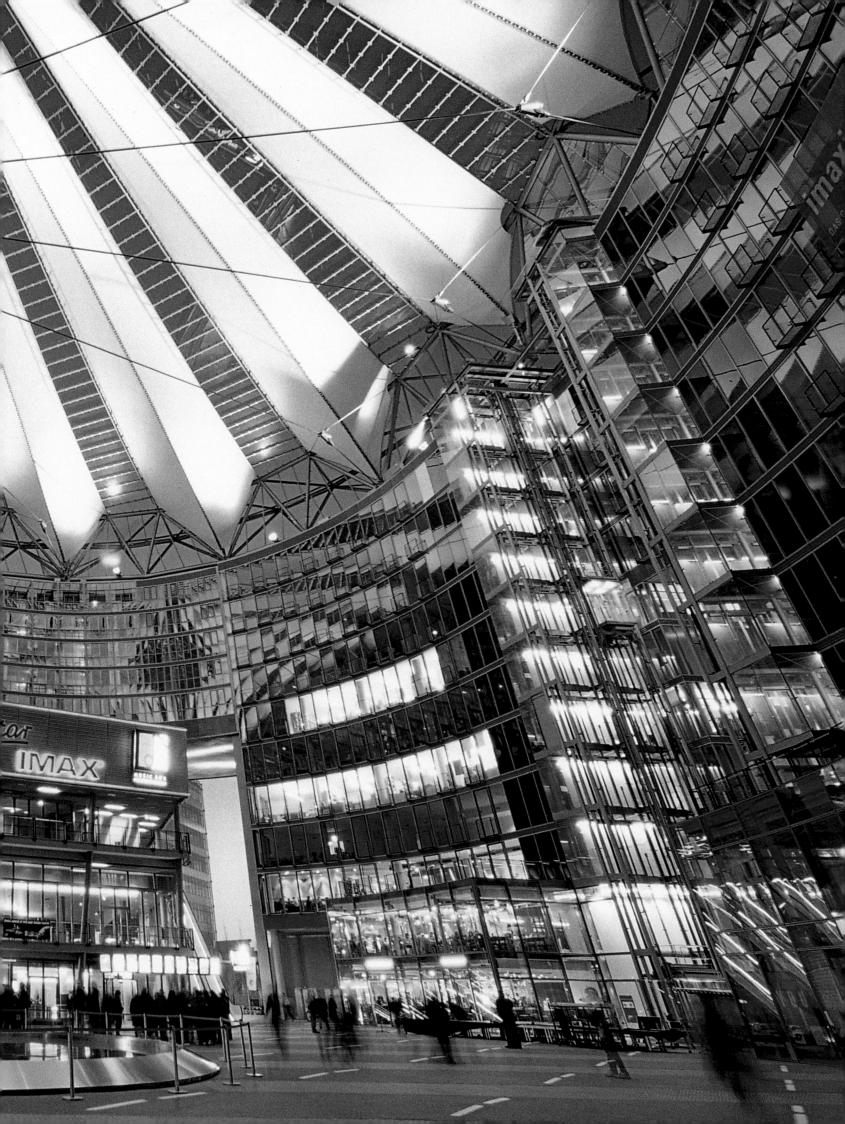

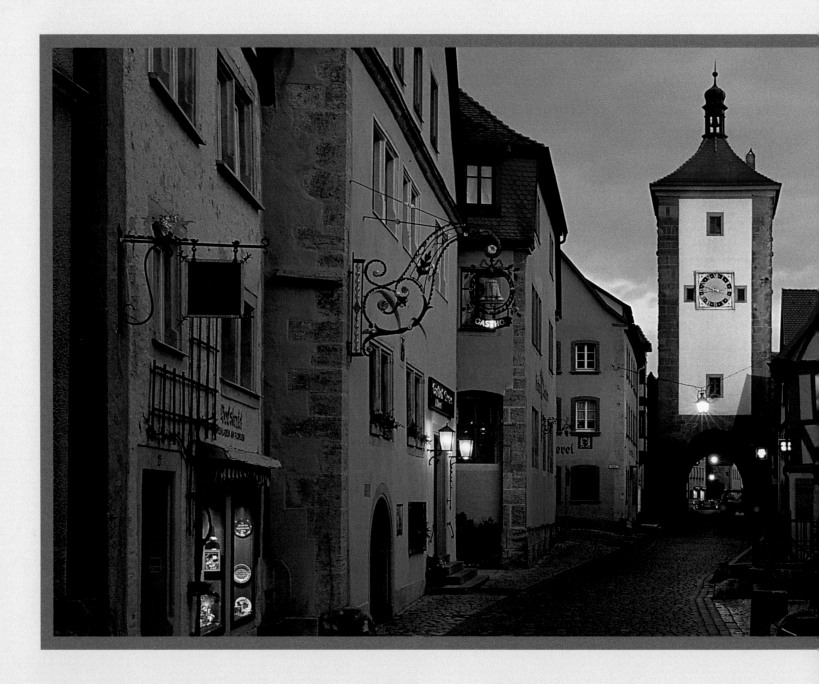

GERMANY – OVER ONE THOUSAND YEARS OF HISTORY

If you look up "Germany" in the encyclopaedia, the first thing you'll come across are numbers; area: 357,021 square kilometres (137,846 square miles), number of inhabitants: 82.06 million, number of federal states: 16, official language: German – with the stress on "official". For German has many different permutations. A fisherman from the island of Wangerooge in the North Sea, for example, will have serious difficulties trying to communicate with an Alpine farmer in Upper Bavaria. His North German dialect has very little in common with its southern counterparts, not to mention the many other modes of speech which characterise the regions of Germany.

Almost by chance Rothenburg ob der Tauber has managed to retain its medieval character of half-timbered buildings, thick walls and foreboding towers which once guarded all entrances to the town. While the city boomed during the 14th century, the years that followed were less prosperous, leaving the city financially incapable of implementing any plans for modernisation it might have been harbouring.

Germany is a land of variety and not just in the linguistic sense. The topographical kaleidoscope ranges from the flat coastline of the North and Baltic seas to the elevations of the Alps, along a north-south axis over 876 kilometres (544 miles) long and 640 kilometres (398 miles) wide from east to west. From top to bottom there is an entire geographical catalogue of landscapes, each with its own particular charm. The North Sea coast with its mudflats and tidal waters, ravaged by wild storms and floods almost every year, peters out into the lowlands of northern Germany which run into the plateaux of the east. Going south you hit the gentle undulations of the midland hills from the Eifel to the Elbsand-steingebirge. In the south the Danube carves its way through increasingly spectacular scenery, culminating in the foothills of the Alps and the Zugspitze, at 2,962 metres (9,718 feet) above sea level the highest point in Germany.

THE GERMANIC TRIBES – ALEMANNI, FRANKS AND SAXONS

As far as Germany's history is concerned, we have to go back quite a long way to ascertain from which point on there was something we can refer to as Germany. At the transition from BC to AD there were no determinable national

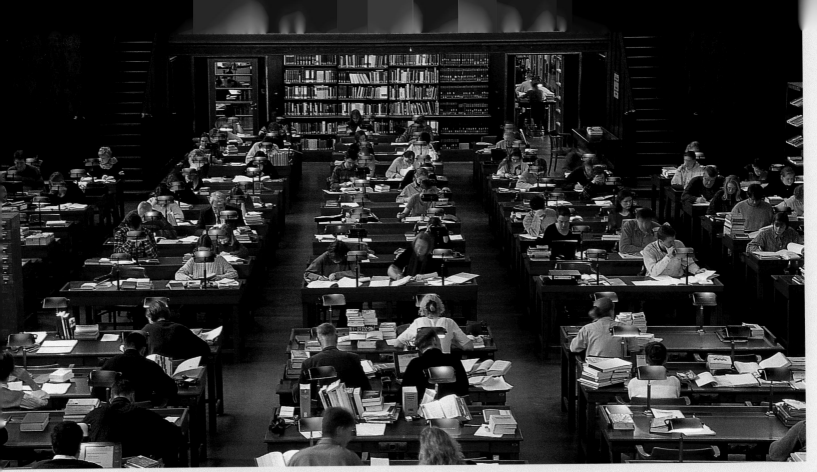

structures, with 'Germany' merely a region populated by numerous independent Germanic clans. These gradually banded together to form the larger tribes of the Alemanni, Franks and Saxons. From the 3rd to the 6th centuries AD the first political entities were formed. It wasn't until the 8th century and Emperor Charlemagne that a common entity emerged with the founding of the Frankish Empire. This wasn't to last; in 843 at the Treaty of Verdun Charlemagne's grandsons split the empire into two administrative units, with the area east of the Rhine and Aare rivers falling to Ludwig the German. After much confusion, the crowning of Conrad I as king of the East Franks in 911 and the ensuing Declaration of Indivisibility, in 920 the first mention is made of a Regnum Teutonicum or German Empire. Only in the Middle High German period (1050–1350) did the expression "das deutsche Land" (the country of Germany) begin to find any currency, eventually merging into "Deutschland" in the 16th century.

THE AGE OF KNIGHTS, CASTLES AND MINNESINGERS

With the question of name out of the way, let's turn to other events in Germany's past – and particularly to those of its Middle Ages which were of great significance. The Middle High German period is the first phase in the history of the German language to have produced unique literary sources still available to us today. One of the great minnesingers of the age was Walther von der Vogelweide (c. 1170–1230). His origins are lost in the mists of time; it's thought that he was born in South Tyrol and probably lies buried in the idyllic cloister gardens at Würzburg Cathedral. His songs of courtly love are of the highest poetic calibre and his political texts show him to have been a skilled propagandist. He and his 'colleagues' Hartmann von Aue and Gottfried von Straßburg bear witness to an age of grand artistic and cultural achievement.

Back to politics. From 962 onwards the Kingdom of Germany in the Holy Roman Empire continued to expand its territories which by the 13th century reached far down into Italy and across into eastern Europe. With the fall of the Hohenstaufen dynasty and the end of central administration under the king in 1254 the empire soon came to resemble a political patchwork, however. The eternal wrangling of small states, of minor and practically insignificant electors, princes and counts for supremacy characterised

the late Middle Ages. The concept of a unified German nation was still very much a thing of the future.

MONK MARTIN LUTHER UPSETS THE WORLD ORDER

The Middle Ages drew to a close in c. 1517, making way for what historians have categorised as the modern era, the age of great discovery, humanism and the Renaissance. Europe experienced the redefining of mankind and the world he inhabited. The initiator of this new epoch was the monk Martin Luther who in 1517 published his "95 Theses" on the selling of indulgences; whether he actually nailed them to the door of the church in Wittenberg or not, his revolutionary ideas set the wheels of the Reformation in motion, causing the foundations of the medieval world order to slowly crumble.

In the wake of hefty fighting between the confessional warring factions, the Protestant Union and the Catholic League, Europe was dragged into the Thirty Years' War which totally depopulated entire regions of Germany. Following the famous „defenestration" episode in Prague in 1618 the massacre began. After four long years of negotiation the conflict was ended in 1648 at the Congress of Westphalia which reaffirmed the religious state of play of 1624 and officially recognised the Protestant confession. Extensive territorial settlements were also made, in which Alsace fell to the Habsburgs, Pomerania and Wismar were given to the Swedes and the Upper Palatinate was granted to Bavaria. A further outcome of the

Peace of Westphalia was the legalisation of the 300 German states under autonomous rule. By the mid 17th century, the unification of Germany seemed to be a completely lost cause.

An age of absolutism followed where local potentates put themselves beyond the law, resulting in all kinds of government imaginable across the chaotic map of what can only loosely be termed Germany. Here, too, it can be observed that extremes gave rise to contradiction. From the middle of the 18th century on a form of classic literature emerged which blossomed towards the end of the century in the works of Goethe, Schiller and others. The Romantic period dawned and with it the era of German idealist philosophy.

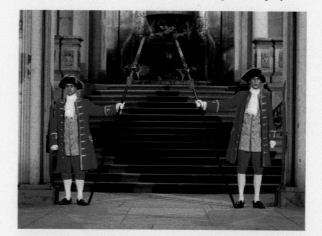

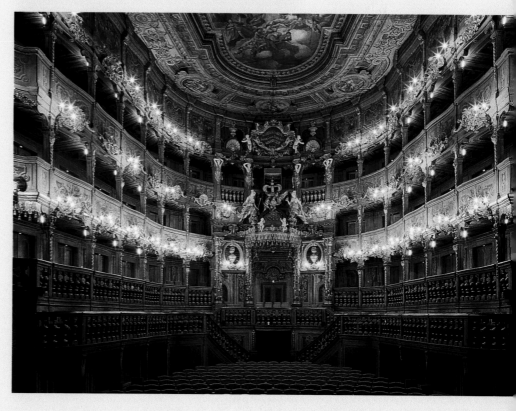

Left:
Wieskirche pilgrimage church near Steingaden is an architectural masterpiece of the baroque by Dominikus Zimmermann (1685–1766). The oval edifice with its stucco and frescos effuses a perfect elegance and airiness of design.

Left:
The royal splendour of Augustus the Strong has been reinstated; guards in historic costume watch over the entrance to the Zwinger in Dresden, one of the great buildings of the baroque.

Bottom:
The margravial opera house in Bayreuth is also a product of the baroque period, erected as a place where the royal court could present itself in public. The modest exterior hides a decorative wealth of colourful splendour inside.

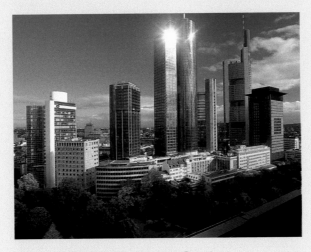

Right:
With its skyscraper banks and high-rise houses of finance, Frankfurt is Germany's major exhibition venue. Its role as a centre of trade goes back to the early fairs of the 13th century which placed the city at the hub of economic activity in Central Europe.

THE REDISTRIBUTION OF EUROPE

The wars of liberation put an end to the havoc of the French Revolution and the rule of Napoleon, the most famous battle being fought at Leipzig in 1813. After Napoleon had finally been defeated the Congress of Vienna was called into being, chaired by the prince of Metternich, at which the political map of Central Europe was redrawn. The Holy Roman Empire was disbanded in favour of a German Confederation, a loose alliance of states whose majority decisions were to be reached by 37 sovereign princes and four free cities. This confederation, however, came nowhere near to satisfying the national movement towards unity.

Below:
Freudenberg is an old mining town near Siegen. The ensemble of half-timbered buildings in the Alter Flecken quarter is absolutely unique.

Liberalism was the new order of the day, championed by broad sections of the bourgeoisie calling for political freedom and the abolition of aristocratic privileges. The movement's best-known and most publicity-geared event was the festival of 1832 at Hambach Castle, a mass rally in which over 30,000 took part and numerous speeches advocating a free and unified Germany were made. German parliament retaliated with total censorship of the press and suppression of the freedom of assembly. This was the era of poet Heinrich Heine, whose most famous works include the "Book of Songs" cycle (1827) with his "Harz Journey" and "Germany, a Winter's Tale" (1844). In keeping with the spirit of the age Heine's writings were banned following the publication of his biting satire of conditions in Germany. Heine moved to Paris in 1831 where he died at 58.

The March Revolution of 1848, instigated by the bourgeois middle classes, brought about the collapse of Metternich's system of feudalism and led to the founding of a German National Assembly which met at the Church of St Paul's in Frankfurt. German unity now seemed to be within reach; a "bill on the fundamental rights of the German people" had even been agreed upon. Yet it was not to be; the designated emperor, the

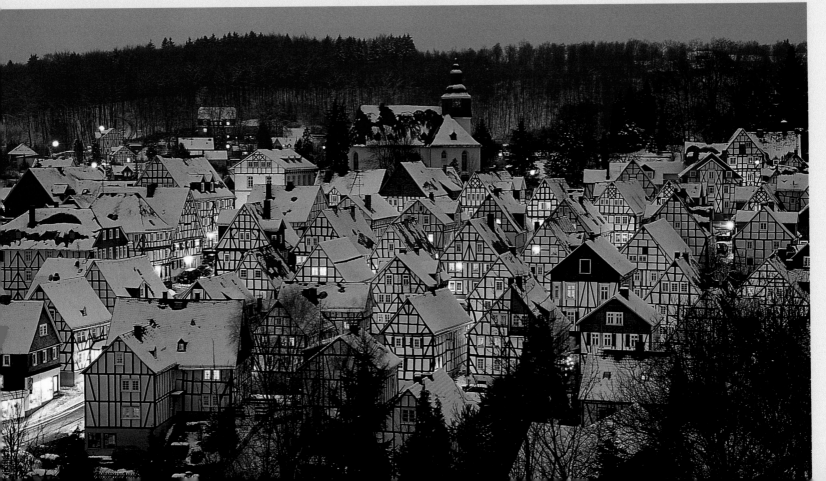

then king of Prussia Frederick William IV, refused the crown. The dream of a united nation was once again crushed – forever, it appeared, after troops from Württemberg stormed the parliament building in 1849. The status quo of the German Confederation was reinstated.

All seemed to be lost, yet hope was in sight in a very different guise. By the mid-19th century Europe was in the throes of a new, industrial revolution and by 1860 much of the country was linked by 6,000 kilometres (3,728 miles) of railway track. Through unification by 'public' transport Germany was gradually brought together to form a common market in the most modern sense of the word. The Franco-Prussian War of 1871 terminated in the establishing of a German Empire and, with Bismarck pulling the strings, of economic union of the many German states. There was now one Germany, one German nation which was able to exert international claims to power, to build up a network of colonies abroad and a naval fleet at home and – under the wilful leadership of Emperor William II – to slide headlong into the First World War.

The public enthusiasm with greeted the Great War of 1914–1918 far exceeded that shown for almost any previous event in Germany's history. Eager to fight for the fatherland, men joined up in their thousands – and in their thousands they perished.

GERMANY GOES DEMOCRATIC

The catastrophe of the First World War ended in the November Revolution of 1918, triggered by naval mutinies in Wilhelmshaven and Kiel. Emperor William II was forced to abdicate and went into exile in the Netherlands where he spent the rest of his days in seclusion as a country gent. With the monarchy out of the way the German Republic could now be proclaimed; much to the annoyance of provisional head of state Friedrich Ebert, Philipp Scheidemann 'accidentally' did so, with socialist Karl Liebknecht quick to second the motion. Germany found

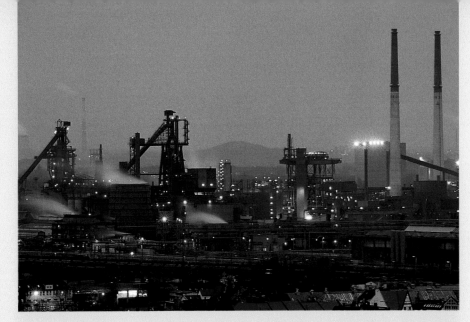

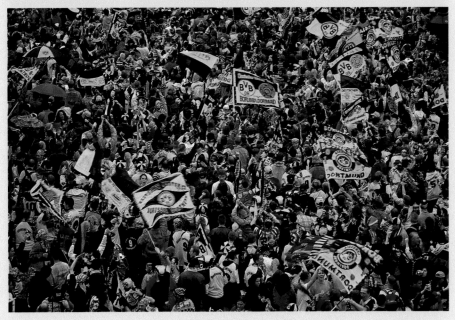

itself in a period of turbulent transition coloured by anarchism in all forms, from fundamental democracy to despotism. These 'soviet republics', administrative councils of soldiers and workers, were soon usurped by the fated Weimar Republic overseen by Ebert, the new president the people themselves had elected.

Germany was now a democratic republic. History could have taken a turn for the better had it not been for the excessive weakness of the leading political parties and hefty attacks on the government – akin to civil war – from both left and right. This was compounded by economic difficulties, these in turn heightened by the reparations demanded by the Treaty of Versailles. With each year that passed the delicate flower of democracy slowly withered until in 1933 it was finally trampled into the ground by Nazi jackboots.

Top:
This skyline of winding towers, blast furnaces and industrial chimneys was once a symbol of prosperity and progress – and also one of grime, smog and stench. The Ruhr has since been "cleaned up", the Westfalenhütte steelworks in Dortmund one of the more recent closures in March 2001.

Above:
The Ruhr is also home to football, with trips to the game a popular local pastime. Here Borussia Dortmund fans celebrate another victory over their opponents.

21

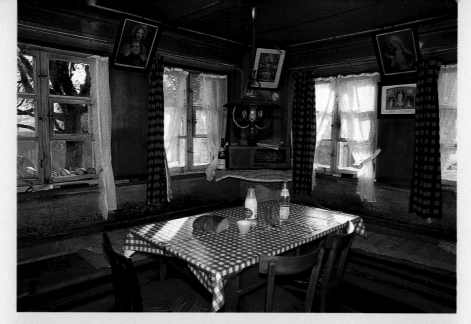

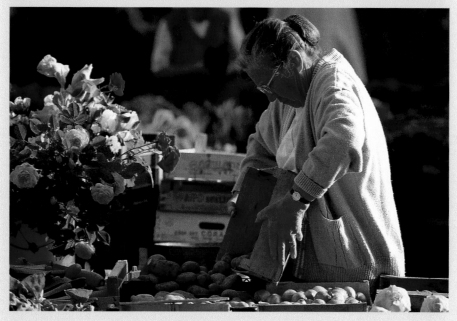

Top:
The farms in the south of the Black Forest have often seen centuries of habitation, with this cosy farmhouse kitchen still the focal point of day-to-day life. The prime building material of these ancient homesteads is wood, a commodity which is in plentiful supply in the surrounding forest.

Above:
The farmers' market outside Freiburg Minster sells local produce grown on the fertile farmland of the city's environs, the raw ingredients being used in the preparation of Baden's many delicious culinary specialities.

Despite the potentially explosive situation in Germany the 1920s heralded the dawning of a new age. Berlin blossomed into a cultural metropolis on a par with Paris. Potsdamer Platz was the busiest square in Europe; the favourite hangout of the continent's stars and artistes was either Berlin or Paris. Yet the buzz of creative activity could not mask the fact that Germany was in financial dire straits and that much of the population didn't know where their next meal was coming from. The Berlin of the 1920s – and indeed the entire country – was in trouble, as Alfred Döblin excellently portrays in his novel "Berlin Alexanderplatz".

THE SKIES DARKEN OVER GERMANY

In 1933 the darkest chapter in Germany's history began. In the January 30 elections the National

Socialists seized the parliamentary majority and Adolf Hitler was made chancellor. His first deed in office was to pass a series of emergency decrees and the infamous Enabling Act with which he could eradicate his opponents. Following Hindenburg's death in 1934 he proclaimed himself Führer and chancellor of the Reich, setting up a brutal, inhumane system of rule and abolishing many basic civil and human rights. Jews and political adversaries were ruthlessly persecuted and deported to concentration camps. Hitler's foreign policies were no less aggressive. In a number of expansionist moves 1938 saw the "Anschluss" or annexation of Austria and the Sudetenland, of Bohemia and Moravia. In the face of impending terror much of Germany's intellectual elite had either fled the country, were forbidden to work or languished in prison. Those who had escaped abroad were often destitute; only those who had been successful at home were assured a comfortable life in exile.

On September 1 1939 Hitler began his blitz on Poland, signalling the beginning of the disastrous Second World War. This was followed by attacks on France, the Soviet Union, Belgium, Holland, Great Britain and others. Only after Hitler's suicide on April 30 1945 and the capitulation of the Germans on May 7/8 of the same year did the war in Europe grind to a bloody close. The fighting and the Nazi reign of terror had claimed over 42 million lives. A further casualty was Bismarck's German nation state of 1871, now doomed to change forever.

In the aftermath of war Germany, like much of Europe, was totally devastated; millions of people had been displaced and the Allies – the USA, Great Britain, France and the Soviet Union – had split the country up into four zones of occupation governed by the Allied Control Council. The Treaty of Potsdam of August 2 1945 again redefined Germany's borders, confiscating most of its eastern territories. One new boundary was still to come, however. Amidst growing conflict between East and West during the Cold War two socio-economic systems gradually emerged, cemented in 1949 with the establishing of the

Federal Republic of Germany (FRG) and the German Democratic Republic (GDR). For the first time in history there were two German nations, with a frontier running slap bang through the middle of Berlin. At first people were able to cross the great divide with relative freedom of movement; the erection of Berlin's „antifascist wall of protection" on August 13 1961, however, hermetically sealed West Berlin off from the rest of the East overnight. Passage between the two fronts was now only possible via one of the seven zealously guarded border crossings, Checkpoint Charlie being the most well-known.

After the horrors of war West Germany rose like a phoenix from the ashes and boomed from the mid-1950s onwards, the entire country basking in the prosperity of the "Wirtschaftswunder". German industry thrived, people bought consumer goods "en masse" and slowly rebuilt their lives. Despite several hiccups, such as the financial crisis of the 1960s, the West steadily grew, both economically and culturally, with writers such as Heinrich Böll and Günter Grass poignantly tackling the country's recent past and reaping the highest honour possible, the Nobel Prize for Literature, in reward.

TWO GERMANYS

The capitalist FRG and the socialist GDR grew in completely different directions, making a peaceful coexistence practically impossible. The more positive economic development of the FRG prompted an increasing number of East Germans to emigrate to the West; the GDR retaliated by installing barbed wire blockades and soldiers armed with machine guns to stem the flow of escapees. The resulting, frighteningly permanent structure of the Berlin Wall remained an inviolable obstacle until 1989. Looking back, the GDR had a much tougher start than its Western counterpart. The occupying forces in the East had gradually ruined the economy, making any form of financial recovery extremely difficult. The steady exodus of skilled workers weakened any attempts to boost post-war economy and private economic initiatives were a social taboo. Totally reliant on the intervention of the state the GDR limped pitifully behind its Western neighbours, a sorry plight which did not escape the attention of the general public.

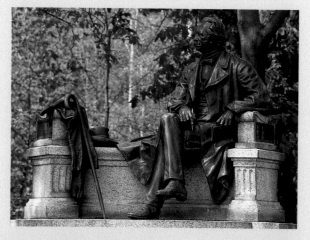

This monument in Neuruppin pays homage to the city's famous writer, Theodor Fontane, who honoured his native town in his memoirs entitled "Travels through the March of Brandenburg". His other major contributions to German literary history include the novels "Effi Briest" and "Der Stechlin".

The Spree Forest southeast of Berlin is crisscrossed by a network of waterways the locals still regularly traverse by boat.

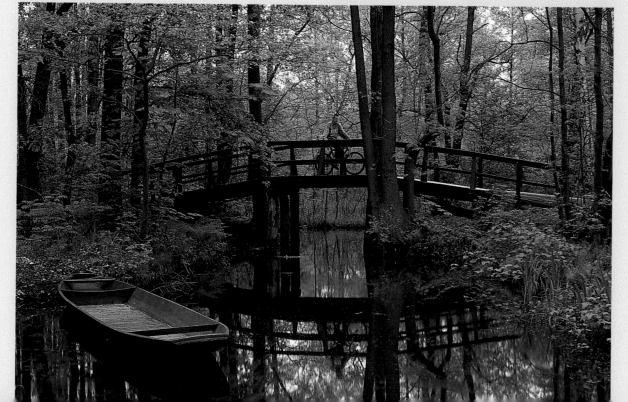

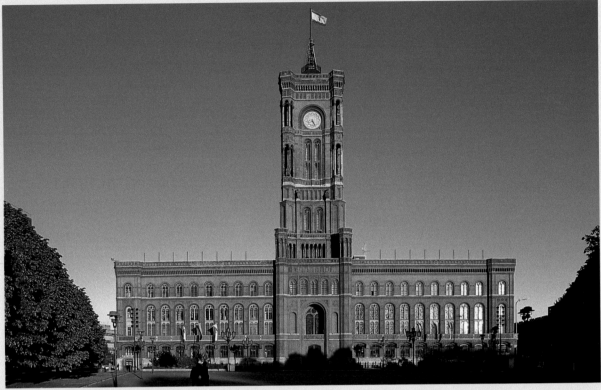

Right:
The Red Town Hall in Berlin is so called not because of its socialist past but because of the red brick of its facade. Erected between 1861 and 1869 it is now the headquarters of the city mayor and senate.

Below:
The Göltzschtalbrücke at Mylau in Saxony's Vogtland is the biggest brick bridge in the world. From 1846 to 1851 26 million bricks were used in the massive structure, 78 m (256 ft) in height.

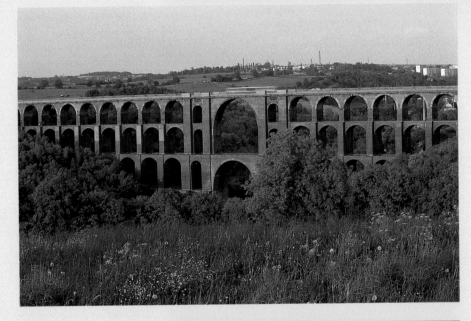

Right:
The most famous bridge in Dresden is the Blauer Wunder or "blue wonder", thus called after the original green paint turned blue. On completion in 1893 the mighty iron construction, 226 m (741 ft) long, was unparalleled throughout Europe.

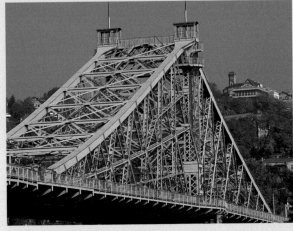

With the manipulated local elections of May 7 1989 the political climate within the GDR rapidly worsened. By the summer angry citizens had occupied West German embassies in Prague, Budapest and Warsaw, with a wave of refugees flooding across the open borders of the Eastern Block. After much intensive diplomatic bartering West Germany's foreign minister Dietrich Genscher managed to gain permission for the asylum seekers to emigrate to the West. The groundbreaking news was departed to jubilant crowds in a famous speech Genscher delivered from the balcony of the Prague embassy. And within the GDR itself resistance was building up. What became known as the Monday demonstrations took place in several cities across the country, particularly in Leipzig, where on October 9 over 70,000 thronged the streets. Under the increasing pressure of both the public and the "Politbüro", GDR head of state Erich Honecker stepped down and handed over to Egon Krenz.

REVOLUTION AND DEMOLITION GANGS

Late in the evening of November 9 1989 the Berlin Wall unexpectedly opened, rapidly followed by the GDR's many other borders; the popula-

tion of the East promptly surged, dazed, into the West. From this day forward there was no stopping the reunification of Germany; all danger of the army taking pot shots at demonstrators and potential defectors had finally passed. In retrospect it seems strange that the GDR regime should have been deposed in such an unpretentious manner. The government had been caught unawares; its lame inaction prevented the worst. Within a very short space of time the entire country had been turned upside down, its repressive machinery and state order completely paralysed down to the last infringement on the private individual. What had seemed impossible just a few weeks or even days before was now reality. Thousands scrambled onto the Berlin Wall and began to chisel away at the concrete, demolishing the hated edifice before the very eyes of the GDR's incredulous border guards. The most impenetrable frontier in Europe, perhaps even in the world, was now the scene of merry destruction.

It wasn't long before the desire was expressed for Germany to once again become a unit, although the further existence of East Germany was also the subject of much heated discussion. The two German states met the Allies of the Second World War in Moscow to negotiate a possible solution. A unification treaty was signed on August 30 1990; with the five East German "Länder" now part of the FRG, the historic era of the GDR had come to an end. On October 3 1990, now a national public holiday, Germany was officially reunited. A wave of euphoria and an almost unprecedented sense of new departure washed over Germany. There was work to be done, however; the social, historic and economic repercussions of 40 years of division had to be overcome. Creating equal opportunities for all regions of the new Germany was an important goal and one which has not yet been fully accomplished, with industry in the former GDR well below modern standards and an infrastructure in desperate need of drastic reform. Germany is, however, now a single entity and the scars of its forced separation are slowly fading.

Since the first mention of the word "German" in 920 and the liberal movement of the early 19th century which called for a united Germany, the nation which long wasn't has lived through turbulent times. Despite epoch-making events like the reunification, the most recent chapter in the history of Germany – from the birth of the Federal Republic on – has seen it at its most stable and peaceful.

Page 26/27:
Rügen in the Baltic Sea is the largest island in Germany and a popular destination in Mecklenburg-West Pomerania, particularly treasured for its many quiet, idyllic spots. Time seems to have stood still here at Klein Zicker in the southeast of the island.

Wörlitz Park outside Dessau was laid out between 1765 and 1810 and became one of the first landscaped gardens in mainland Europe. The Gotisches Haus, built – as the name suggests – in neo-Gothic, was finished in 1813 and today exhibits paintings by Lucas Cranach the Elder, among others.

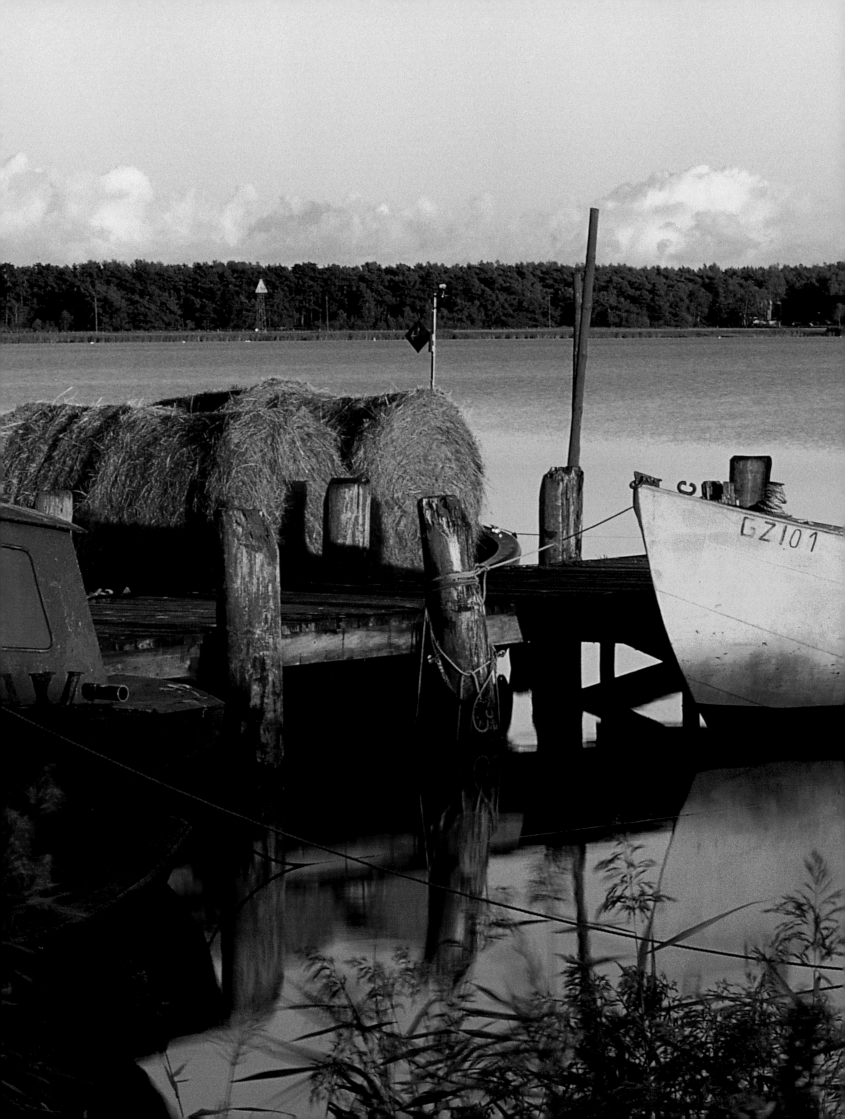

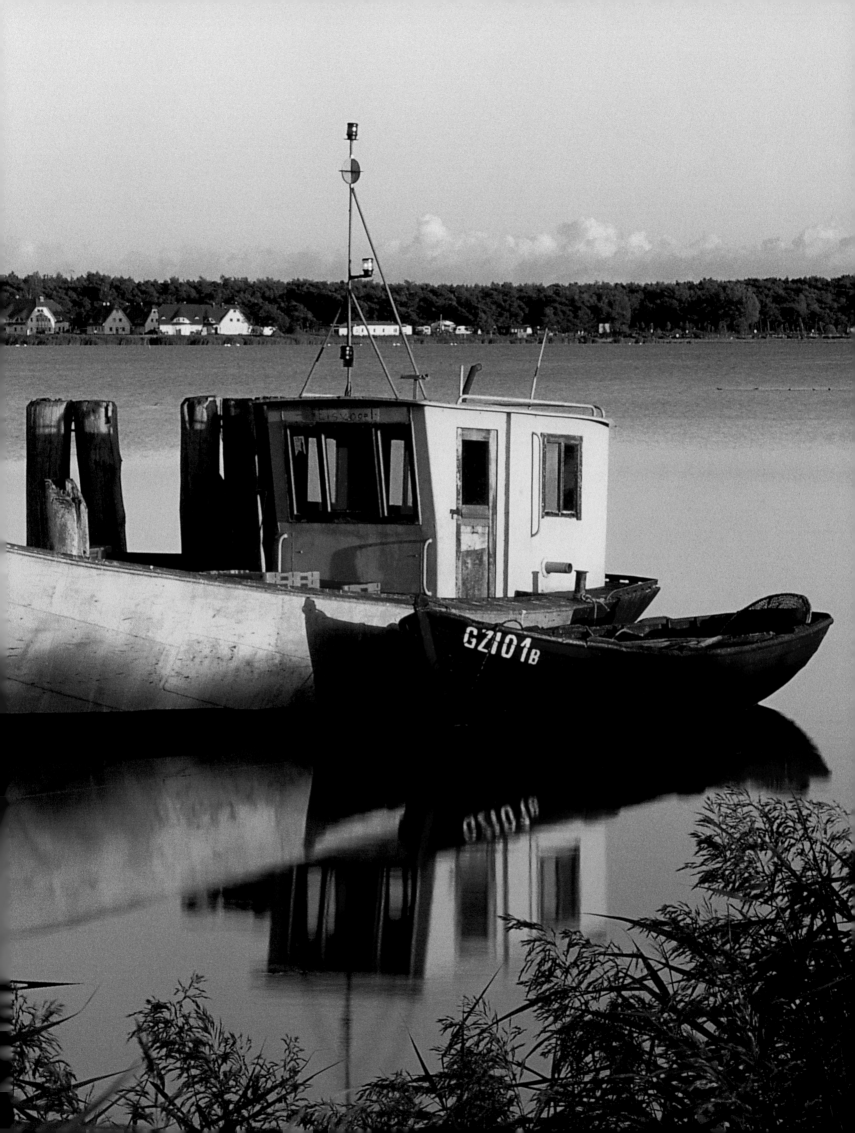

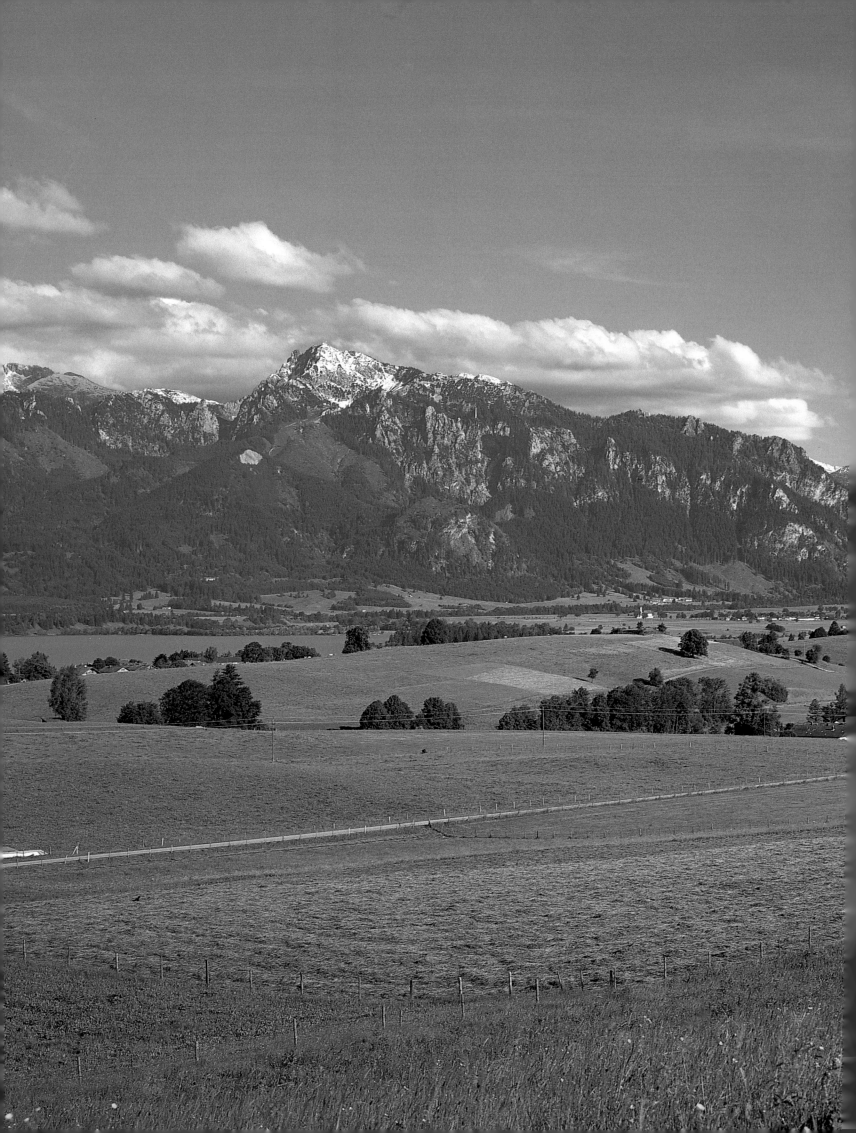

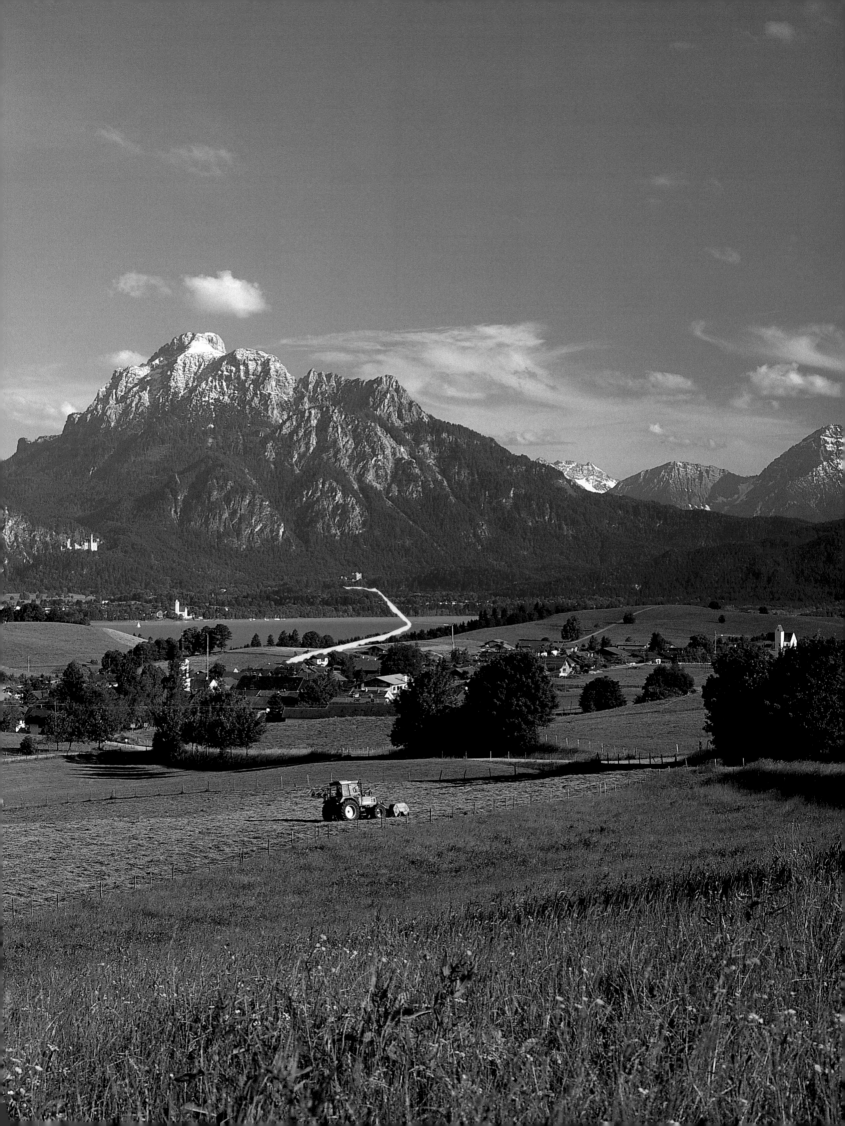

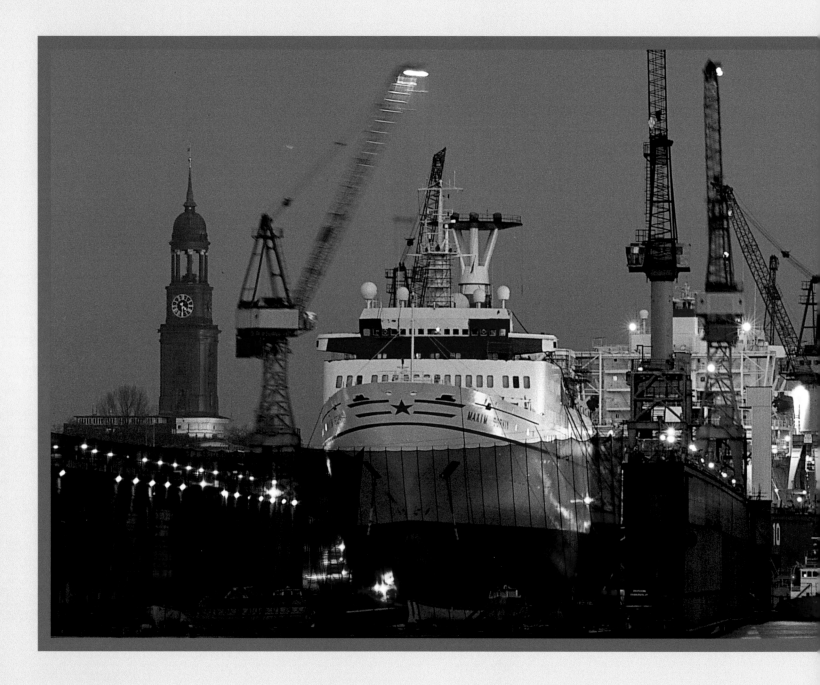

GERMANY'S NORTH – FROM THE NORTH SEA TO THE RUHR

Germany starts in Hamburg – at least it does if you approach by sea. The harbour is the largest in Germany and the city itself the nocturnal and cultural metropolis of the north. Hamburg's legendary reputation goes back to the days of the Hanseatic League. The economic power generated by harbour and docklands still brings prosperity to the entire Hamburg region. Tourist pleasure boats now chug between the freighters and liners, past the dry docks, the container depot and the many landing stages, past ship's crews hurrying to enjoy the few hours' shore leave granted them. The pace of life has quickened, the romantic wanderings of the seaman's heart restricted to a whistle-stop tour of the world's major ports.

Page 28/29:
Lush green meadows are the trademark of the Alpine foothills in the eastern All-gäu. Schloss Neuschwanstein is majestically juxtaposed against the backdrop of Tegelberg and Säuling mountains in the distance, with the village of Rieden and the Forggensee at its feet.

Life in Hamburg has been dominated by its harbour since the 12th century. Ships bound for the North Sea from Hamburg have to cover a long 104 kilometres (65 miles) along the River Elbe before hitting the ocean waves. Craft travelling inland from all over the world often end up at the Blohm and Voss wharf near the landing stages, where they are over-hauled in the dry docks.

From the Jungfernstieg, the catwalk of northern Germany, to the red light district and pubs of St Pauli, Hamburg embraces roving mariners and foreign visitors with its unique cosmopolitan flair, from the historic allure of the ancient docks right down to ladies of the night promising erotic adventure.

The city and suburbs of Hamburg spill out into the rural areas of Schleswig-Holstein. The out-posts of Germany's northernmost federal state are the storm-lashed North Frisian Islands, from Amrum to Sylt. Life here has become easier yet is still very much marked by the eternal battle with the North Sea which regularly claims its dues.

With each flood the sea swallows up another piece of land, the locals engaged in a permanent tussle with the waves to save what they have managed to reclaim. Along the east coast of Schleswig-Holstein the Baltic is positively tame in comparison. Gently it laps the shores of Kiel, the historically inferior neighbour to Lübeck, which with its idiosyncratic Gothic brick archi-tecture was the head of the Hanseatic League for almost half a millennium. Where fishing only just kept the towns and villages on the North Sea from starvation, foreign trade brought wealth and riches to those on the Baltic. The name Lü-beck also travelled the world through literature. Thomas Mann's novel "Buddenbrooks" was set

Fehmarn is the third-largest island in Germany and something of a stepping stone to Scandinavia. Ferries regularly set out to sea for the Danish island of Lolland from Puttgarden on the north coast. The lighthouse southwest of Fehmarn helps guide marine traffic safely on its way.

in his native Lübeck, where he was born and bred, winning him the Nobel Prize for Literature in 1929.

THE BREMEN TOWN BAND

Bremen is another north German city to feature in the world of literature. One of the famous fairytales by the Brothers Grimm tells of the Bremen Town Band, a group of animals-cum-musicians who rose to fame through their cunning and intelligence. The city's ancient Schnoor quarter once inhabited by craftsmen and fishermen takes you back in time, with other areas of town mirroring the glory and riches of the omnipresent, all-important Hanseatic League. Made a bishopric in 782 by Emperor Charlemagne, Bremen was once the heart of missionary activity for the whole of northern Europe. Over a thousand years later in 1827, Germany's smallest federal state embarked on a career as a major sea port. By founding the harbour at Bremerhaven, the

state managed to halve the distance of 120 kilometres (75 miles) from inland Bremen to the North Sea along the River Weser.

Wilhelmshaven, in East Frisia in the north of Lower Saxony, is the major oil port and the only deep-sea harbour on the German coast. The region is also battered by the storms and climes of the North Sea which tear at its dykes and sea defences. The East Frisian Islands in particular, from Borkum to Wangerooge, are sorely tested in the wild winter months. Where the north suffers from its proximity to the ocean, further south in Lower Saxony's regional capital of Hanover the coastal elements are barely noticeable. The land begins to take on a new guise, the Harz Mountains rising up from the plateaux of northern Germany to greet the middle hills.

The entire region is characterised by the architectural Weser Renaissance, particularly well preserved in the cities of Lemgo, Hamelin and Minden, and by books and scholars.

The library at Wolfenbüttel, where Gottfried Wilhelm Leibniz and Gotthold Ephraim Lessing studied, is famous the world over, as is the University of Göttingen, home to one-time professors Jacob and Wilhelm Grimm and mathematician Carl Friedrich Gauß.

INUSTRIAL HEARTLAND – THE RUHR

North Rhine-Westphalia is just as diverse, although many immediately associate it with the history of the Ruhr, Germany's largest and most important industrial heartland. In fact almost half of the state is farmed; the Münsterland, Lower Rhine, Eifel and Sauerland are practically devoid of heavy industry. Alongside Düsseldorf media metropolis Cologne is a humming national centre of economy and the arts.

The financial powers that be never rest – except during Carnival, when Rhineland "joie de vivre bubbles" to the fore and the rules and regulations governing public life are thrown to the wind. Nobody works; everyone's out on the streets partying. Whether from the big cities or out in the country, the people of North Rhine-Westphalia work hard and play hard.

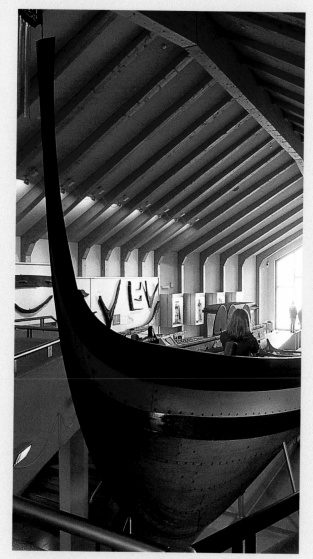

Left:
Haithabu near Schleswig was the first large settlement on the Baltic Coast and a major Viking trading centre. The local museum documents the history of the town and has a Viking longboat on show, dredged up from the old harbour at Haithabu in pieces and painstakingly restored.

Bottom left:
Hamburg's floating pontoon or Landungsbrücken, opened in 1909, is 685 m (2,247 ft) long, with an impressive entrance hall measuring 200 m (656 ft). The landing stage was once the place where grand cruise liners docked; today, it leads a more mundane existence as the central station for harbour traffic, local ferries and pleasure boats offering trips round the docks.

Bottom right:
The container depot in Hamburg is far removed from romantic life at sea; freighters docking here are loaded and unloaded with sombre speed and efficiency.

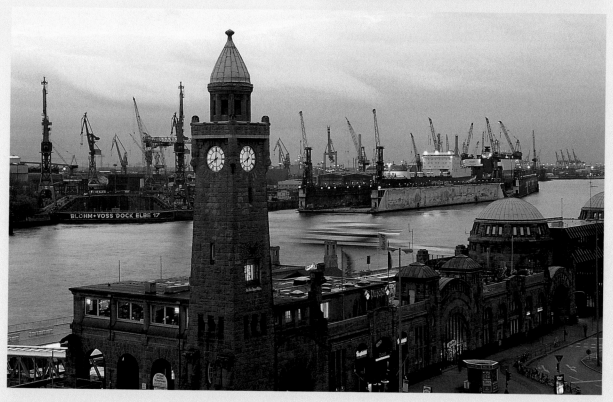

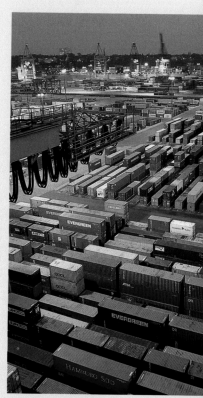

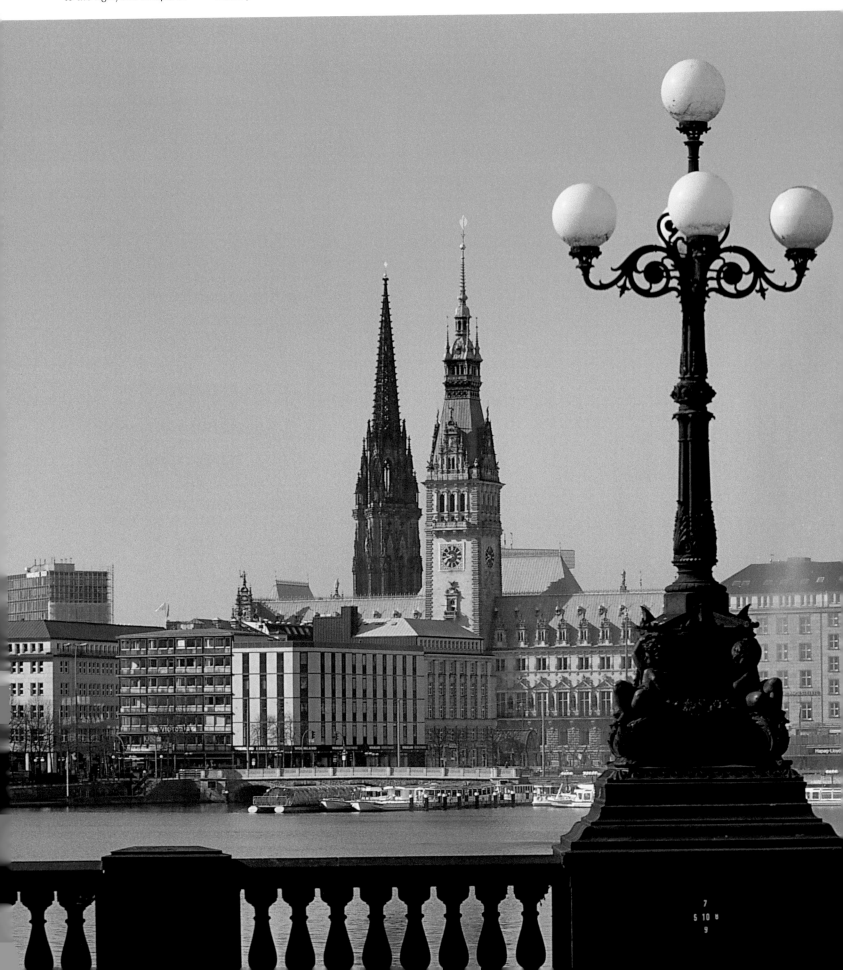

Below:
Hamburg's more picturesque attributes include the Lombardsbrücke and Jungfernstieg with the Binnenalster lake sandwiched in between them, the town hall (tower to the right) and steeple of St Nikolai (left). The city is encircled by water; whereas the Elbe is the scene of busy harbour activity, the Binnenalster, Hamburg's chic boulevard, bears elegant witness to the city's glorious Hanseatic past.

Top right:
Hotel Atlantic on the Außenalster is a Hamburg institution. The hotel effuses a certain "fin de siècle charm", built in 1909 to accommodate passengers disembarking from famous luxury liners docked at the then newly opened Landungsbrücken.

Centre right:
Hamburg's Speicherstadt was set up at the end of the 19th century as a free port. Brick warehouses which once stored coffee, tobacco, spices, carpets and all kinds of other goods shipped to Hamburg from countries far afield still line the narrow canals.

Bottom right:
From the arcades along the shores of the Alster, past the fleet of riverboats, you look across to Hamburg's town hall from 1897. The elaborate neo-Renaissance edifice mirrors the pride and confidence of the indigenous population, epitomised in the magnificent Great Hall.

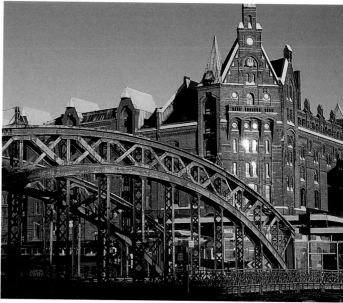

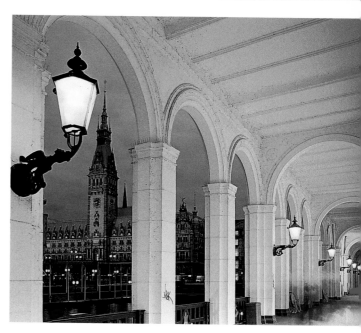

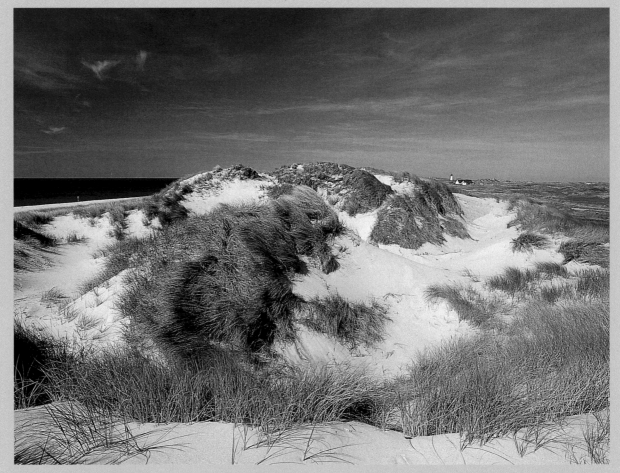

Sylt is the most northerly island in Germany, with the Ellenbogen nature reserve perched at its northernmost tip. The elongated peninsula with its precipitous drifting sand dunes which can reach heights of up to 35 m (115 ft) has been under private ownership for 250 years.

Fun on the beach in Duhnen near Cuxhaven on the North Sea, with bathing huts as far as the eye can see. The wicker alcoves offer welcome protection from the stiff sea breeze and allow holidaymakers to soak up the sun in relative privacy.

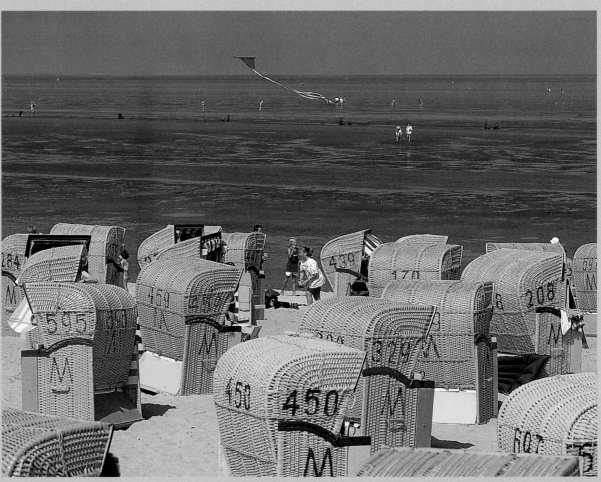

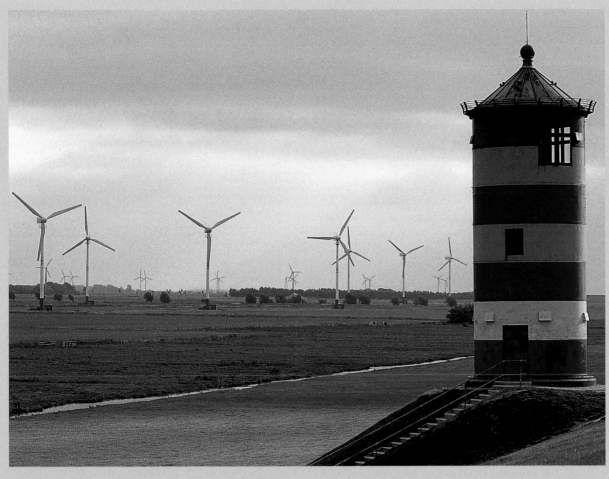

The colour of the lighthouse near Pilsum in East Frisia indicates that it has served its purpose; those still in service are painted red and white. The stout tower has, however, found a new role in life – as a film set for a number of German movies and a popular TV detective series.

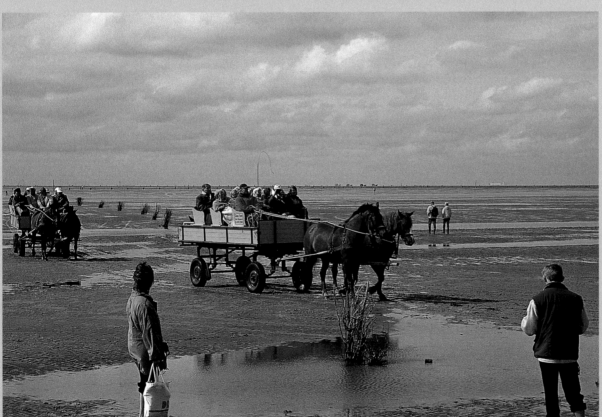

One great attraction of the North Sea Coast is wandering through the mudflats at low tide. Whether on foot or chauffeured by horse-and-cart, experienced guides help visitors explore the wonderful fauna and flora of the coast. The mudflats in Lower Saxony (here at Sahlenburg) were made a national park in 1986 and cover 236,330 hectares (583,971 acres) of land.

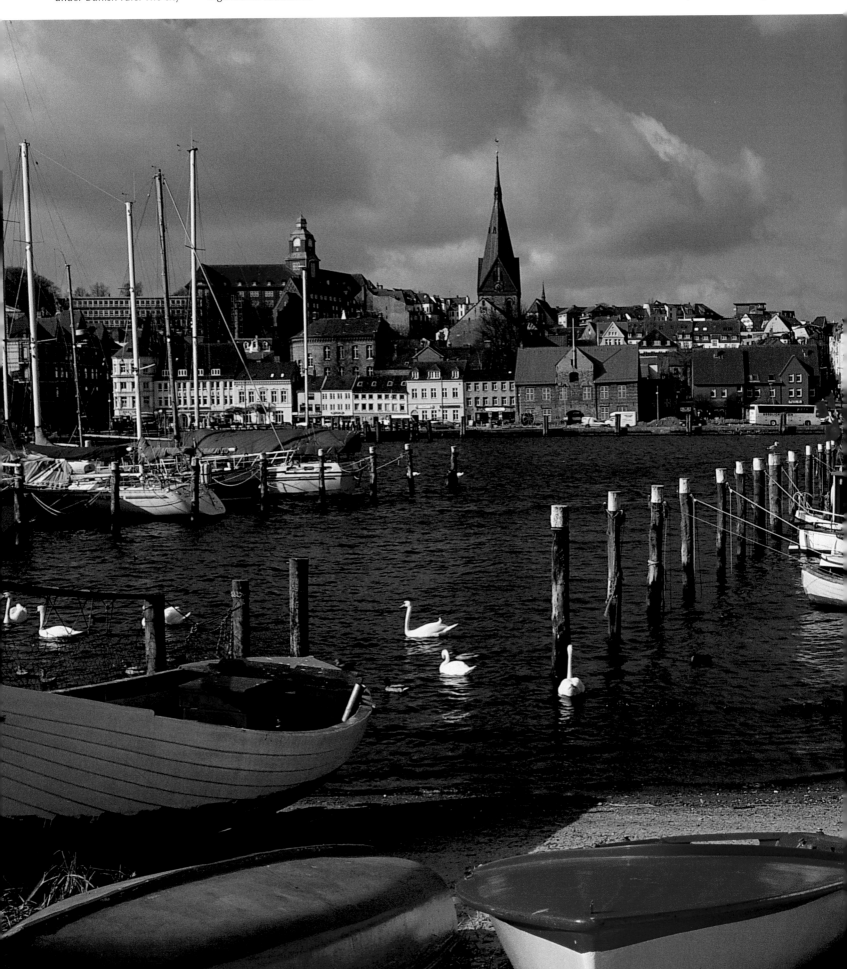

Below:
Flensburg is the northern-most city in Germany, its harbour and trade flourishing under Danish rule. The city lies sheltered in a Baltic fjord and is famous throughout Germany as the place where traffic offenders are catalogued and cautioned.

Top and bottom right:
The island of Neuwerk in the mudflats of the Elbe Estuary is part of Hamburg. The tower (above) dates back to 1310 and doubled as a landmark for seafarers and a fortification for the local populace. The island's no cars policy guarantees that any holiday here is sure to be quiet and relaxing.

Kiel is a German mecca for the international sailing community. The Kieler Woche regatta, now the largest maritime sporting event in the world, has been held in the Kieler Förde since 1882. Numerous cultural activities complement the many marine competitions.

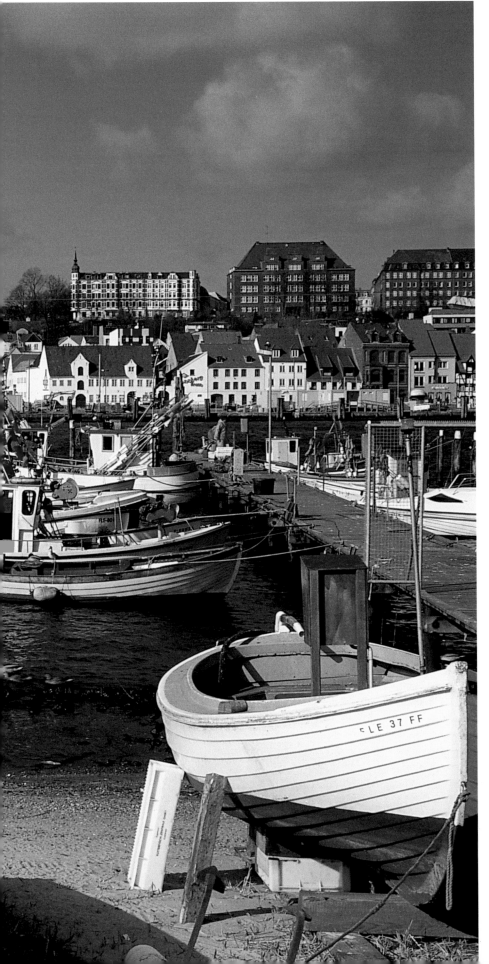

39

Right:
South of Kiel in Molfsee is the Schleswig-Holstein open-air museum which has farm buildings from all over the country on display, from the great barn to the humble cottage. Ancient crafts such as wickerwork and weaving are demonstrated at the various workshops.

Below:
At the end of the 19th century a tiny settlement on Teufels-moor north of Bremen blossomed into the flourishing artists' colony of Worpswede. Famous painters such as Paula Modersohn-Becker lived and worked here. Barkenhoff, depicted here, was home to Heinrich Vogeler.

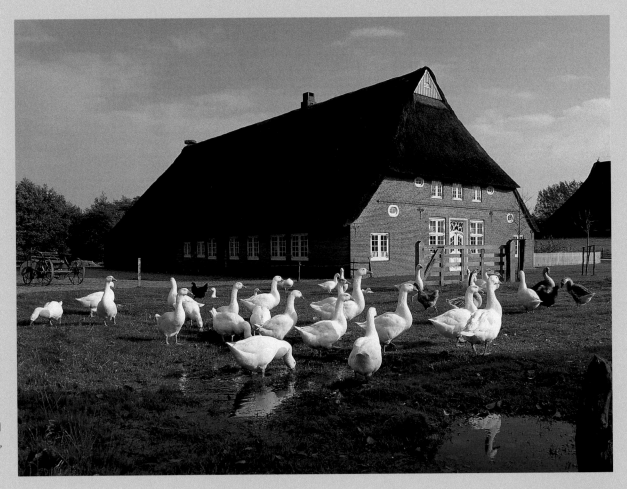

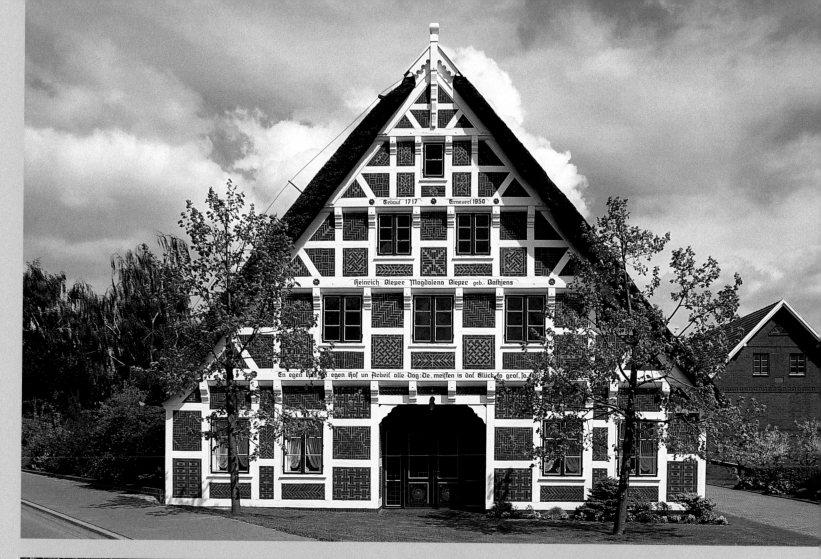

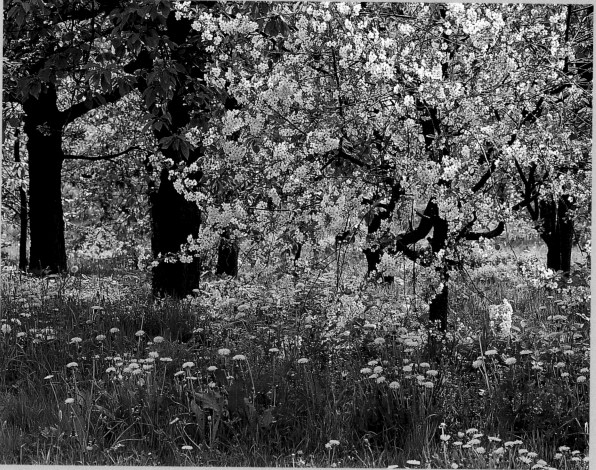

Above:
The Altes Land, an area of fertile marshland, stretches along the left bank of the Lower Elbe between Hamburg-Harburg and Stade. Despite its proximity to the city, the land here is still farmed as it always has been, with stately farmhouses dotted about the countryside.

Left:
The Altes Land looks its best when the fruit trees are in bloom. Fruit, particularly cherries and apples, has been grown here for six centuries.

Below:
Some of the more famous
personalities of Bremen are
the Bremen Town Band
who in a display of wit and
courage managed to trick
their way out of trouble.
The bronze statue of the
musical quartet by Gerhard
Marcks has a place of honour
to the northwest of the old
town hall.

Below right:
The huge figure of Roland
from 1404 at the centre of
Bremen's market square
stands for civil liberty and
self-government under the
emperor, for autonomy
from the rule of the local
archbishop.

Right:
Bremen's Marktplatz is also
a symbol of local pride and
municipal independence.
The town hall (right), a Gothic
brick building from 1410, was
given its splendid Renaissance

facade at the beginning of
the 17th century. In its great
hall, reckoned to be one of
the most sumptuous in Ger-
many, a traditional banquet
for shipowners and fishermen
is held once a year.

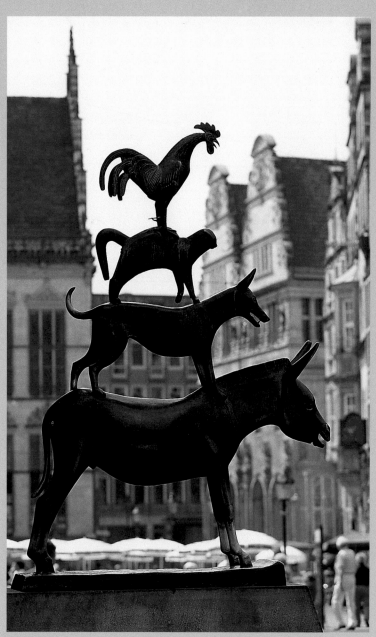

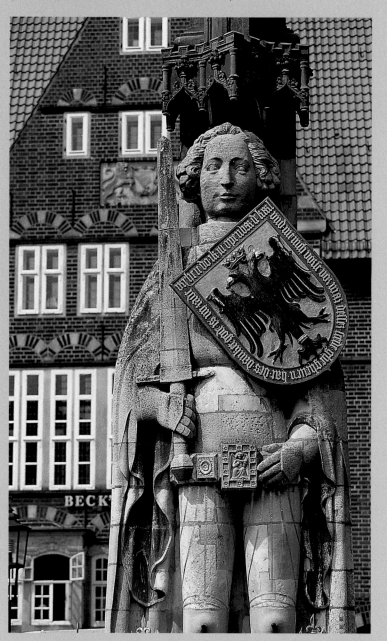

Right:
The Schnoor quarter is where
Bremen's fishermen and
craftsmen once lived. The
pretty, low houses with their
tiny courtyards make up the

only area of town which has
remained completely intact.
It has been fully restored
and is now populated by
art galleries, pubs and chic
boutiques.

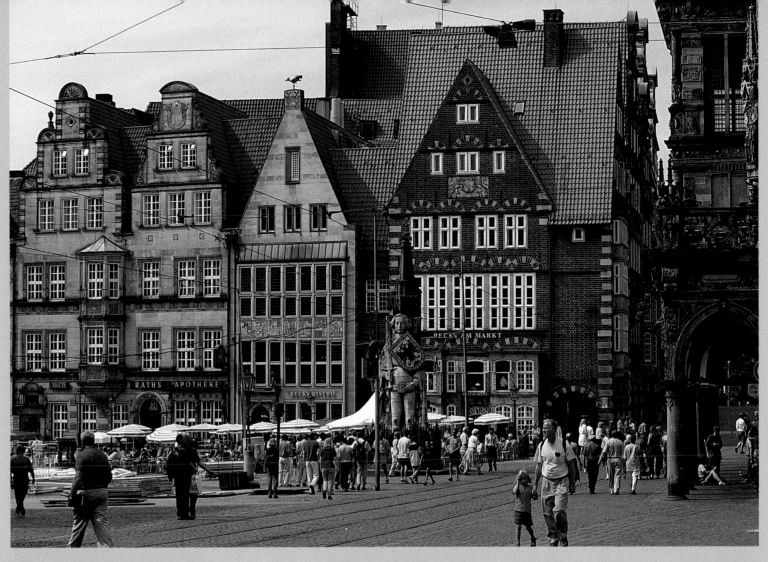

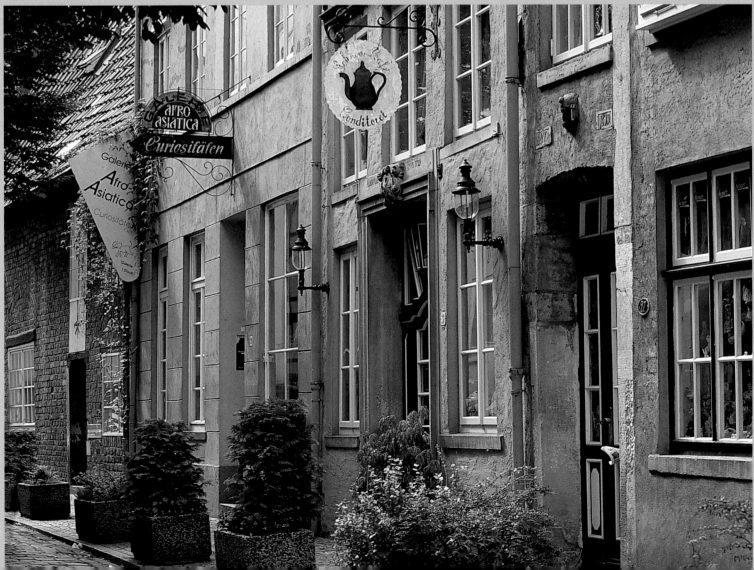

MEDIEVAL MERCANTILE POWER –
THE HANSEATIC LEAGUE

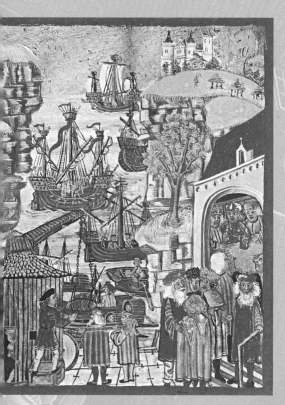

At its height in the 15th century the Hanseatic League had over 160 members, from the Zuijdersee in The Netherlands to the Baltic, from Visby, the capital of the Swedish island of Gotland, to the southern Cologne-Cracow axis. The League was the most powerful trade organisation of the Middle Ages, an association of merchants keen to exploit their business interests and mutually guard their privileges and rights. The League began in the 12th century and dominated trade in northern Europe for a period of around five hundred years; it nurtured relations as far as Novgorod, built up numerous towns and cities along the Baltic Coast and brought wealth and prosperity to its member tradesmen. Its most significant strongholds and leaders in foreign trade were the seafaring ports.

Above:
The "shipping law" miniature from Hamburg's town charter of 1497 depicts the customs post in the harbour. At the bottom and to the right of the picture the merchants sport fur hats and handsome, bright clothes edged with ermine, obvious symbols of great wealth.

Centre:
Lübeck was the undisputed head of the Hanseatic League. Founded in 1143, the town was made a free city in 1226 and a few years later began trading with Novgorod in Russia.

At the heart of the League were the cities of the Wends. Lübeck was the most important, closely followed by Wismar, Rostock and Hamburg and, of lesser significance, Stralsund, Lüneburg and Kiel. Smaller towns in the region were financially dependent on their richer neighbours. Power lay in the hands of the merchants of Lübeck. After being made a free city of the Holy Roman Empire in 1226 and entering into a series of alliances with the princes, coastal towns and trading centres of northern Germany, the Hanseatic League was founded with Lübeck at

its head. It was here that the League's assemblies or diets were held from 1358 onwards. Just how important Lübeck was is still evident today, its Gothic brick buildings preserved for prosperity as a UNESCO World Heritage Site.

A NEW KIND OF SHIP

One clear advantage when trading overseas was the possession of a suitable fleet of ships, the development of the League being inextricably linked to its marine potential. For two centuries

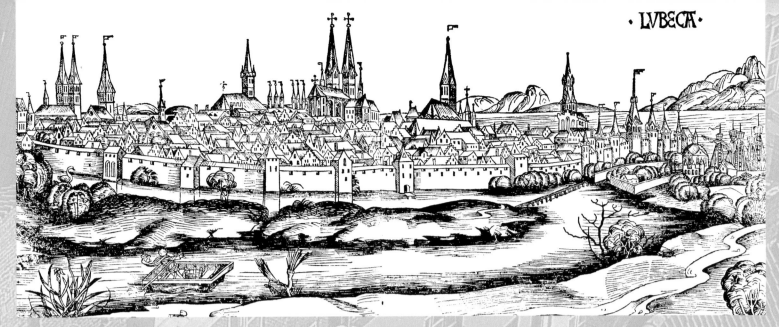

Lübeck, Hamburg and Bruges. The majority of goods imported from the east were furs and wax; those exported included cloth and salt. Other merchandise was soon added to shipments going east, particularly wine, metal goods, beer and grain.

THE DECLINE OF THE LEAGUE

The League's monopoly was only threatened after hefty mercantile intervention from the Dutch and the establishing of an inland trade route running from Wroclaw to Leipzig to Frankfurt. Trade on the Baltic was gradually dominated by other, much larger enterprises. The Fuggers of Augsburg, for example, began trading worldwide with the support of local rulers. The event which finally triggered the slow demise of the League was the closing of the trading settlement or „Kontor" in Novgorod. Ivan III terminated the privileges granted to German merchants in 1494. This first blow to the League's trading activities on the Baltic led to a steady loss of grip on the market. Following the closure of the London „Kontor" in 1598 and the Thirty Years' War of 1618–1648 Lübeck, Hamburg and Bremen endeavoured to continue the Hanseatic tradition but finally capitulated in 1669, when the last diet was held.

German ships proved far superior to their foreign counterparts. The League's prime asset was the cog, a wide-bellied sailing ship which began trawling the Baltic at the end of the 12th century. This type of craft could hold eight to ten times more freight than its predecessors.

The Hanseatic League was initiated by German merchants wanting to trade with eastern Europe and transport goods from east to west and vice versa. The trade route ran from Novgorod in Russia to London via Reval (now Tallinn),

Above:
This illustration of Lübeck from 1493 shows the city at the pinnacle of power. Enclosed by mighty town walls numerous church towers puncture the horizon. The steeples were both a religious and a status symbol publicising the city's prosperity.

Below:
Hanseatic cogs were far superior to any other marine craft of the age, with regard to both technology and capacity. This depiction is taken from a travel journal from 1486.

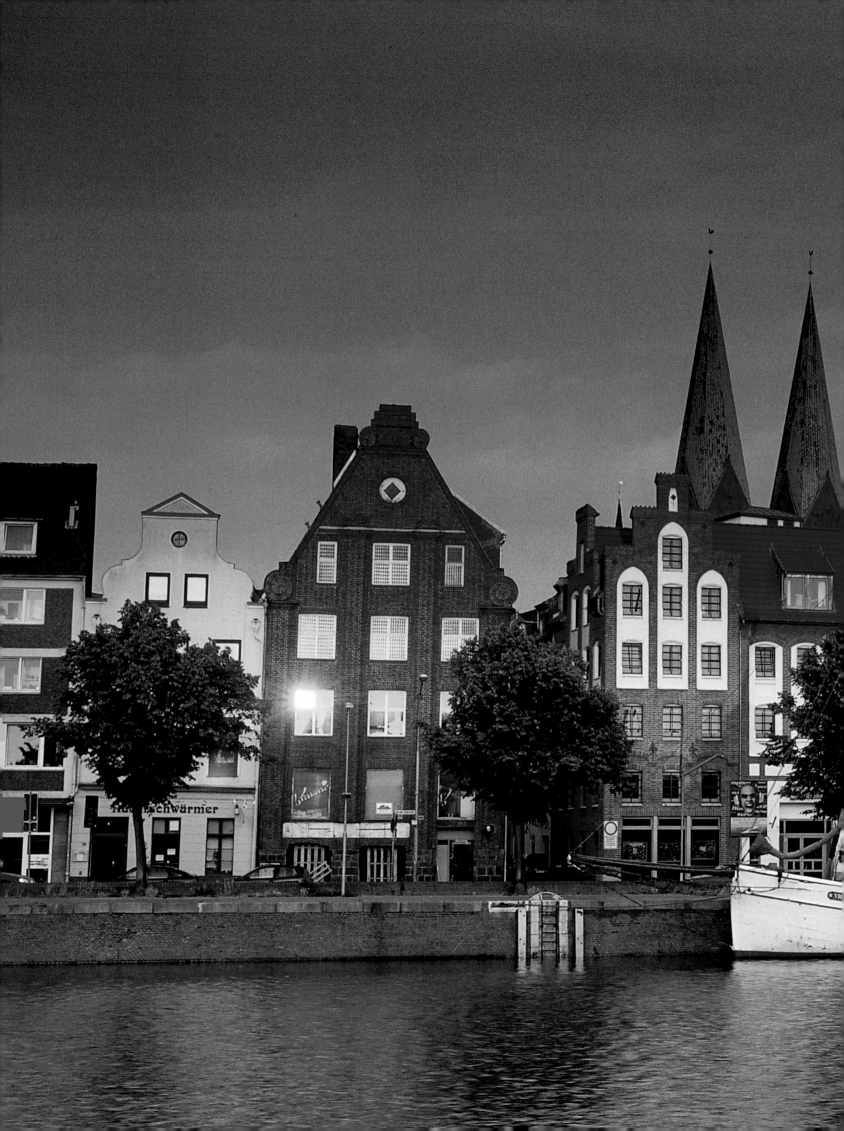

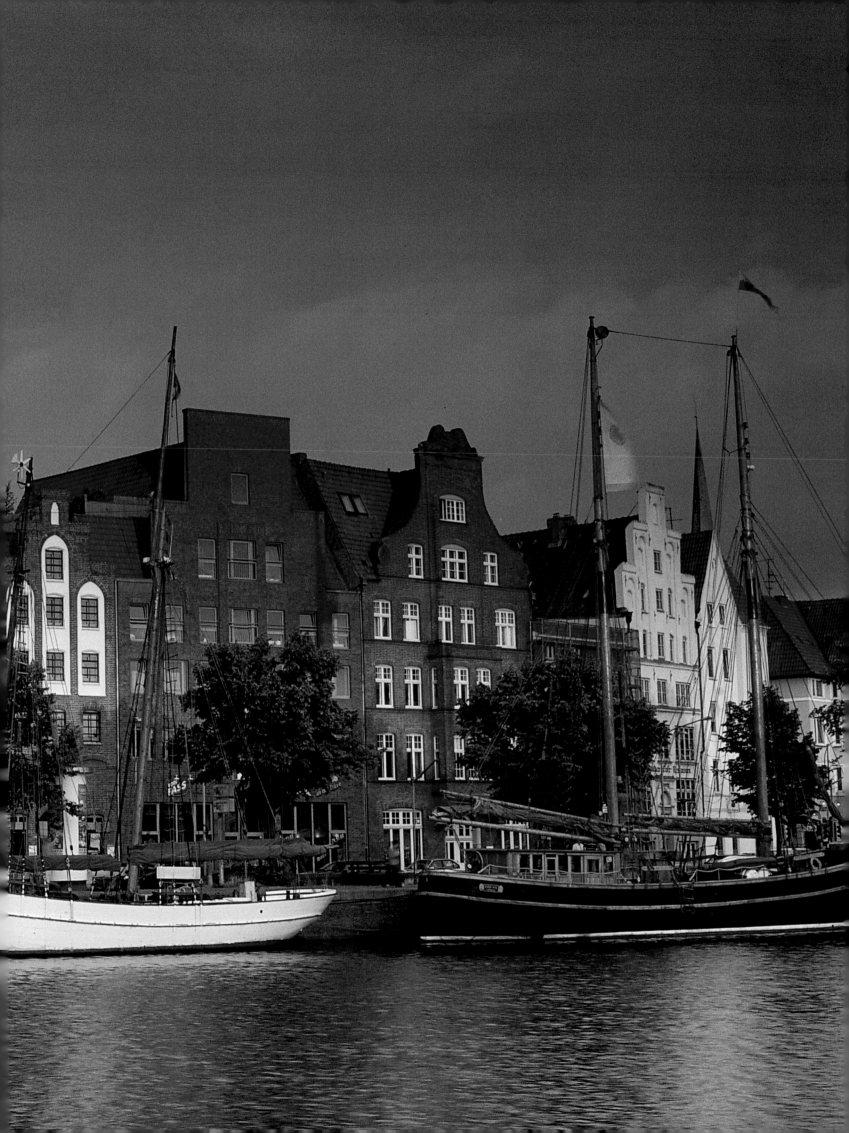

Page 46/47:
If you ignore the boat in the photo, this picture of Holsten harbour on the Lower Trave River in Lübeck could be ages old. Small wonder that UNESCO has made it a World Heritage Site.

Right:
The Holstentor is Lübeck's city landmark. Modelled on the fortified bridges of Flanders, the twin-towered city gate was built between 1466 and 1478. The walls are so thick and heavy that the edifice is slowly sinking into the ground; the lower arrow loops are already below street level.

Right page and right:
Thomas Mann is Lübeck's most famous VIP. He paid homage to his native city in his novel "Buddenbrooks" which earned him the Nobel Prize for Literature. Thomas Mann and his equally well-known brother Heinrich grew up in what has become known as the Buddenbrookhaus on Mengstraße. Both the facade (right page) and the interior (right – view from the Landscape Room to the Dining Room) give us an impression of the high status the Mann family enjoyed.

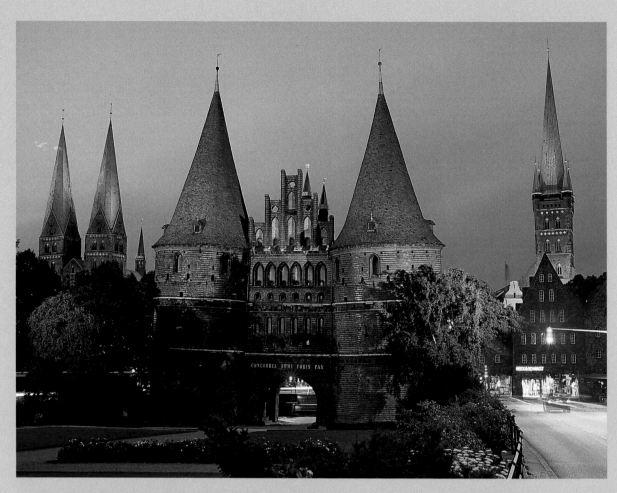

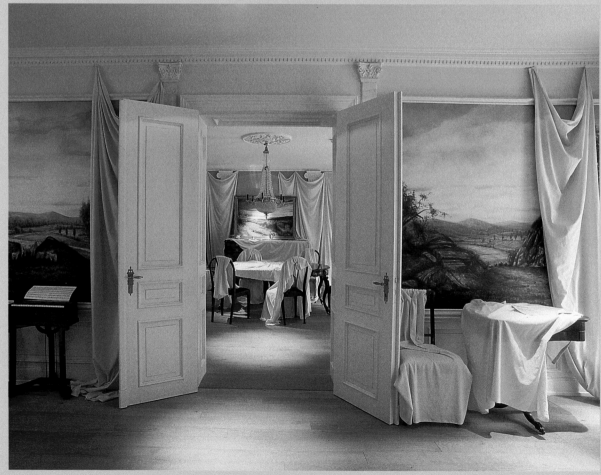

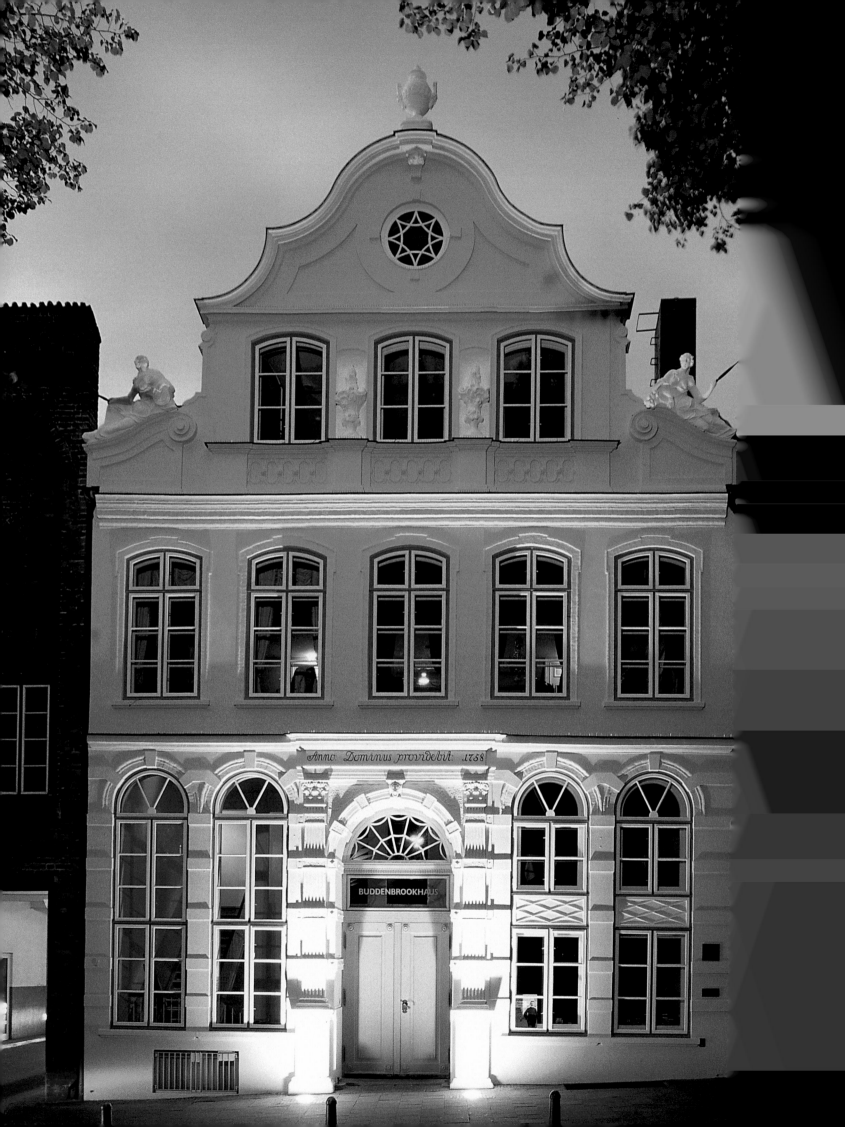

Above and right:
Lüneburg Heath is one of the most popular destinations in northern Germany. The 20,000 hectares (ca. 50,000 acres) of the nature reserve can be explored in a pony and trap or by bike, here at Wilsede (above), to the bleating of the reserve's many German moorland sheep (right). The park wasn't always heathland; until the Middle Ages this was an area of oak and beech forest. The wood was rigorously cleared to make room for pastureland and also to gain fuel to heat the saltpans. The relatively unfertile soil was soon covered with heather which to this very day is one of the botanical trademarks of the region.

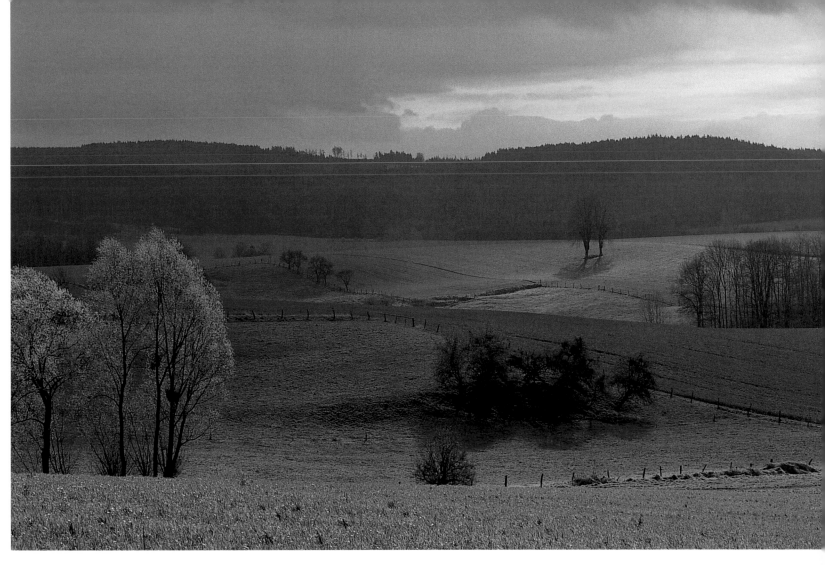

51

Hanover is the state capital of Lower Saxony, its Neues Rathaus a local landmark. It was built between 1901 and 1913 in the Wilhelmine style on foundations consisting of over 6,000 trunks of oak. Outside the town hall the Maschteich and Maschsee artificial lake are popular with Hanoverians seeking respite from the hustle and bustle of the city.

Left:

Herrenhausen Gardens to the west of Hanover were once part of the summer residence of the House of Hanover. The palace, erected in 1665, was completely destroyed in the Second World War, yet the gardens have remained intact. The Großer Garten was created between 1666 and 1714 in the geometric style and is considered one of the best of the early baroque period. In summer the elegant surroundings provide the backdrop for Herrenhausen's festival of music and theatre (bottom left).

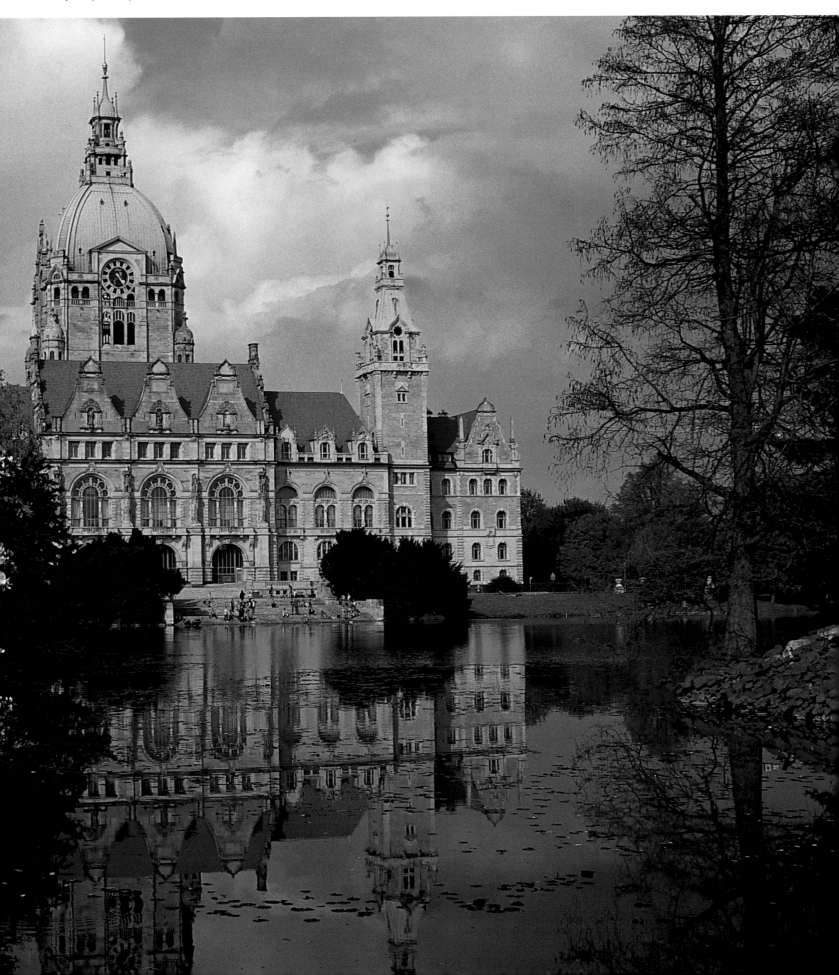

Below:
Göttingen is one of Germany's traditional university towns and the place where over 40 Nobel Prize winners have either studied or taught. Johannisstraße with the church of the same name is one of the most scenic spots in the old part of the city.

Right:
The cathedral in Hildesheim was built in the 11th century; one of Germany's major architectural monuments, it was made a UNESCO World Heritage Site in 1985. The legendary "1,000-year-old rose" scrambles up the east choir.

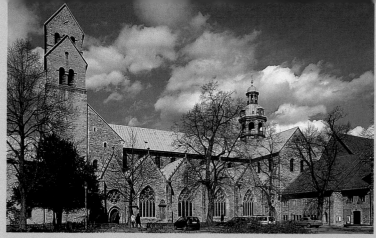

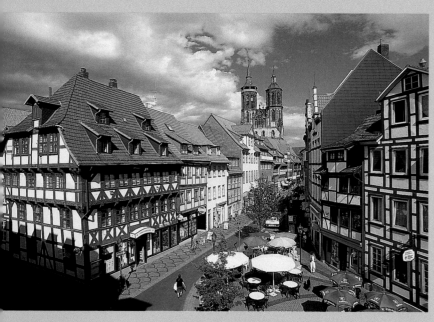

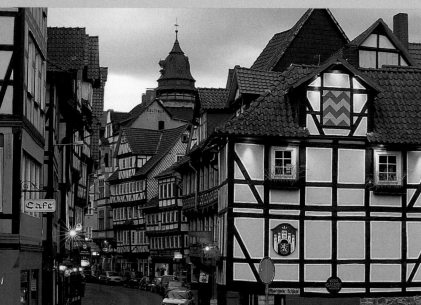

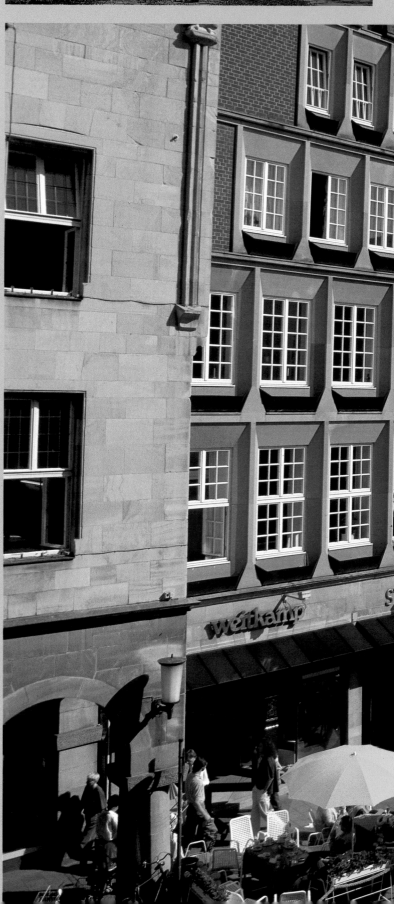

Above:
Hannoversch Münden is famous for its half-timbered houses, several hundred of which span a period of six centuries.

Right:
Münster's Prinzipalmarkt is surrounded by arcaded and gabled buildings dating back to the Renaissance. The Peace of Westphalia signalling the end of the Thirty Years' War was signed in its town hall.

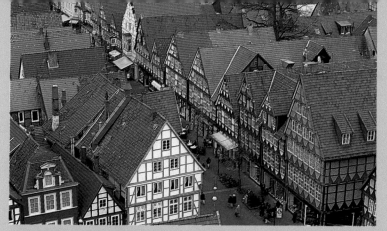

Left:
Celle's charming half-
timbered dwellings seen
from above, the oldest
of which are from the
16th century.

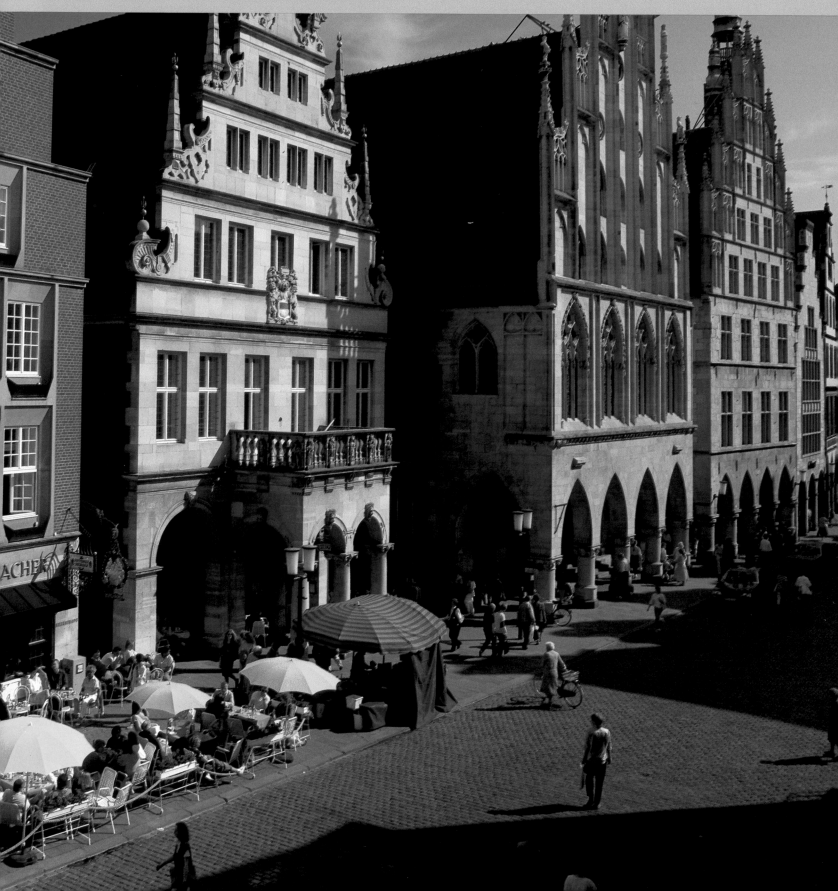

Above and right:
Olenhausen farm (above) lies hidden in the woods in the south of Lower Saxony; with the harvest in, things settle down for the winter. In summer life is much more industrious, with corn to thresh and straw to be baled, such as here near Elliehausen (right).

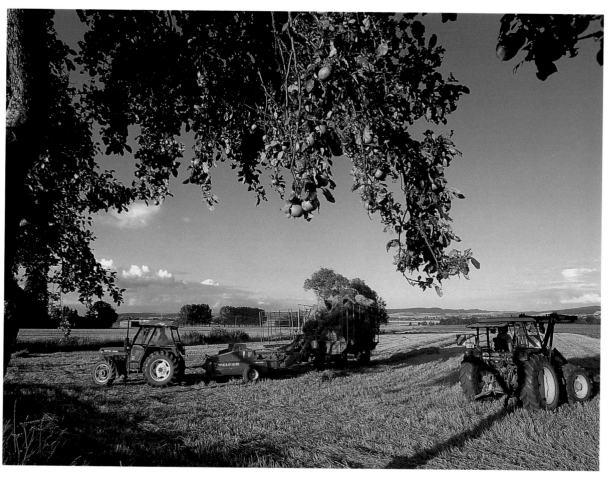

Huge areas of fields in Lower
Saxony require the services
of modern machinery if the
land is to be farmed econom-
ically. In the past there
was often much money to
be earned in agriculture,
as this palatial farmhouse
magnificently demonstrates.

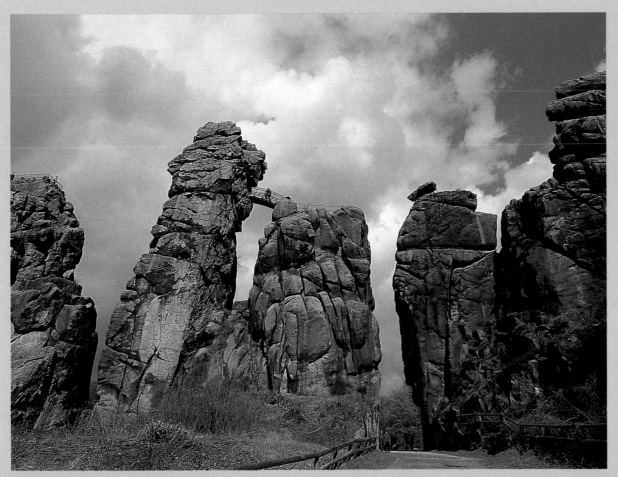

Left page:
An entire region is named after the River Ruhr, long synonymous with heavy industry. Today the waterway is very much changed; at Blankenberg the Ruhr is positively idyllic.

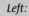

Left:
The environs of Detmold harbour one of the more magical places in Germany; the Externsteine were both heathen relic and place of Christian pilgrimage. In c. 1120 a gigantic relief of Christ's Descent from the Cross was chiselled into the sandstone.

Left:
Time has stood still here on the flat plains of the Lower Rhine near Xanten. Frequent flooding has created expanses of lush pastureland peacefully grazed by sheep and cattle.

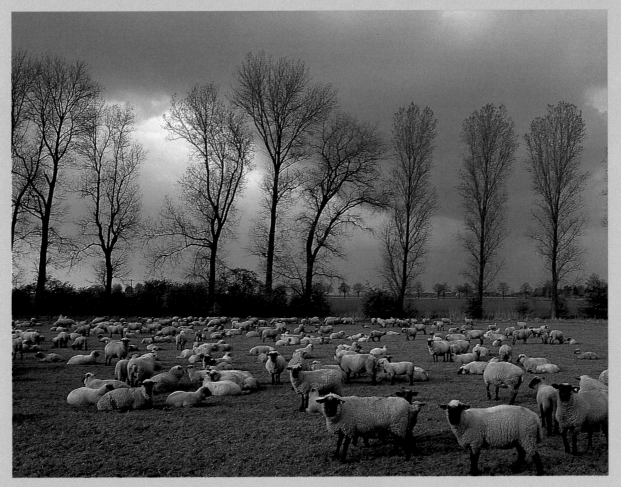

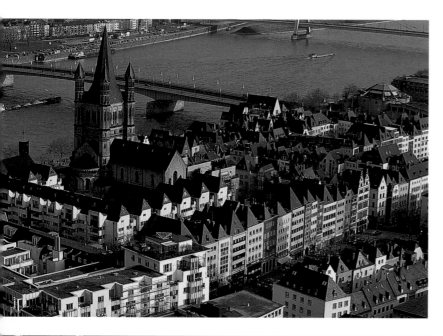

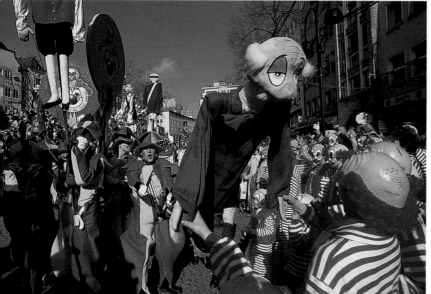

View from Cologne Cathedral
of the River Rhine, the Alter
Markt and the church of
Groß St Martin, consecrated
in 1172. This is one of the
prettier quarters of Cologne,
with the old fish market
along the banks of the river
well worth exploring.

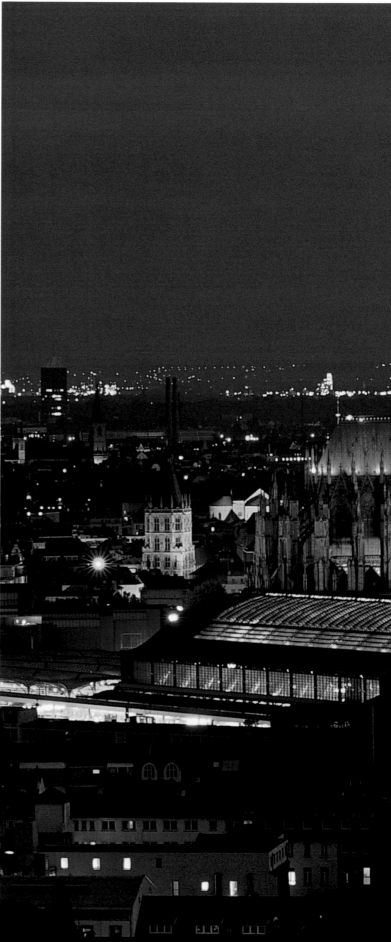

Centre left:
Carnival in the Rhineland
makes any semblance of nor-
mality practically impossible
when from Weiberfastnacht
on Thursday to Shrove Tues-
day party-goers take to the
streets.

Bottom left:
Looking down from Cologne
Cathedral onto the rooftops
of the Museum Ludwig,
famous for its fascinating
architecture and firstclass
collection of 20th-century art.

Below:
Cologne Cathedral is the
monumental landmark of
the city on the Rhine. Begun
in 1248 as one of the most
adventurous building projects
of the Middle Ages, it was
only completed centuries
later in 1880.

Page 62/63:
Until 1531 Emperor Charle-
magne's palace chapel in
Aachen Cathedral was where
Germany's kings were crowned,
a tradition which lasted
600 years. Charlemagne's
throne, depicted here,
is made of slabs of marble.

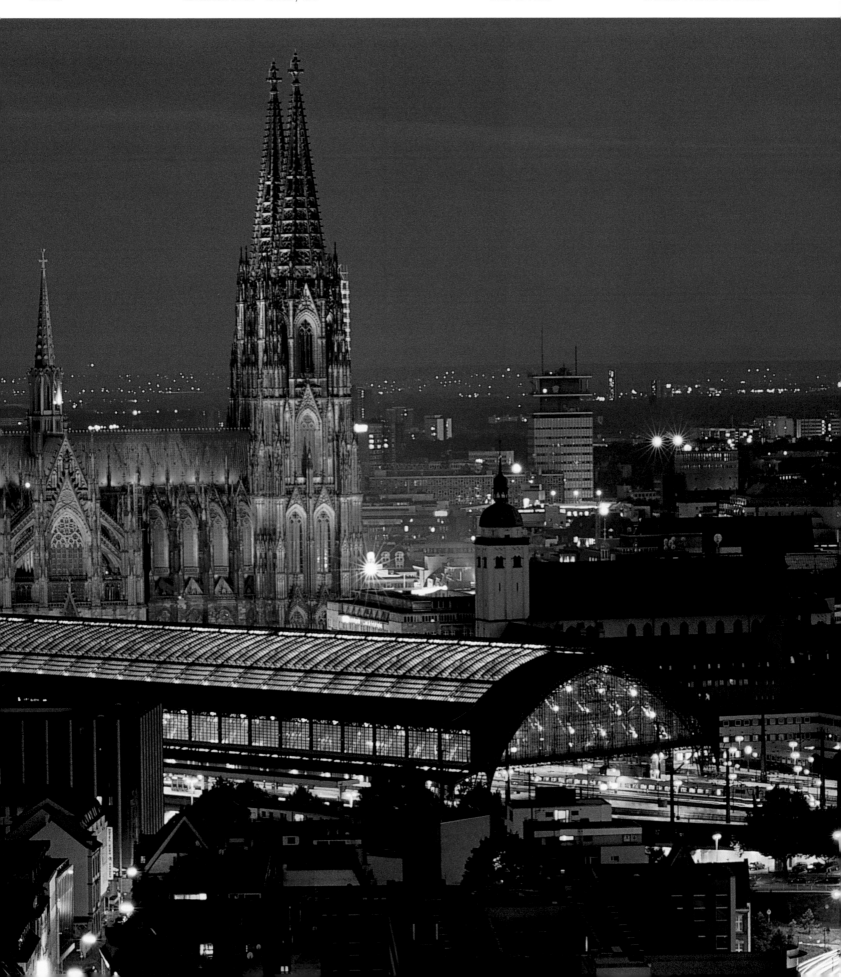

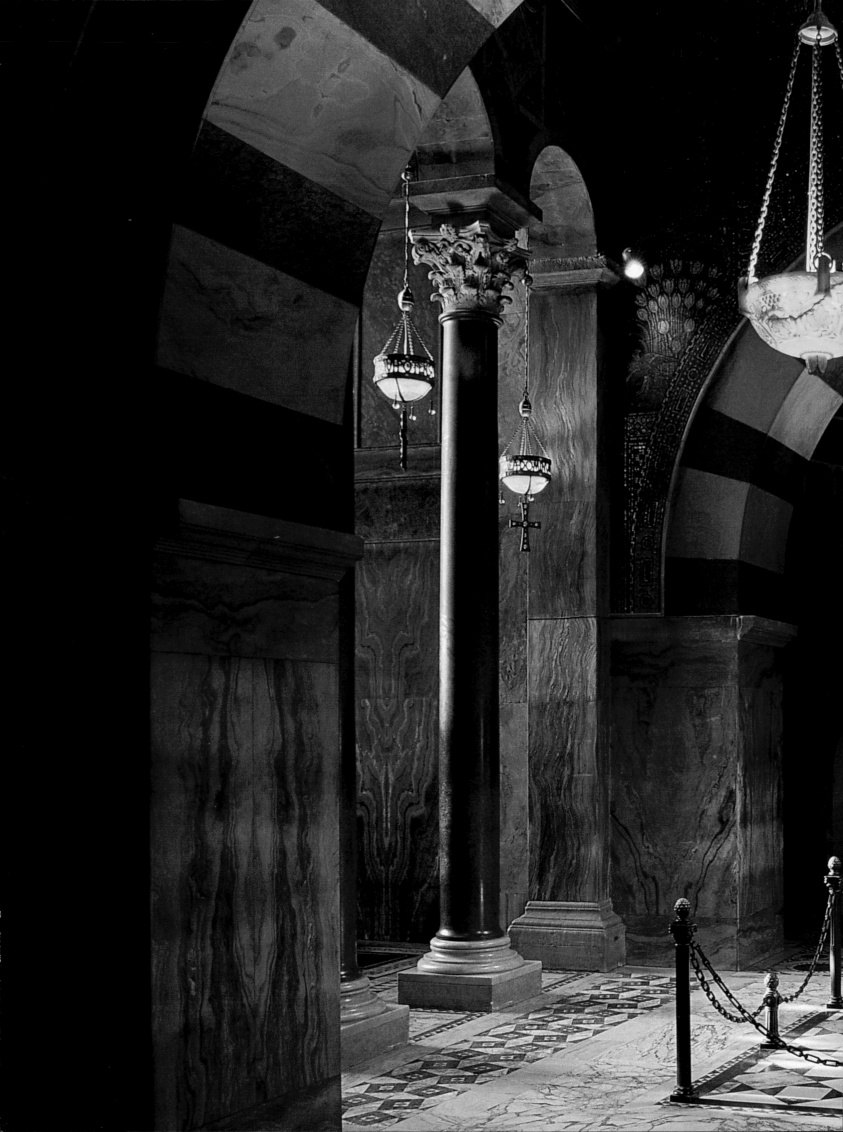

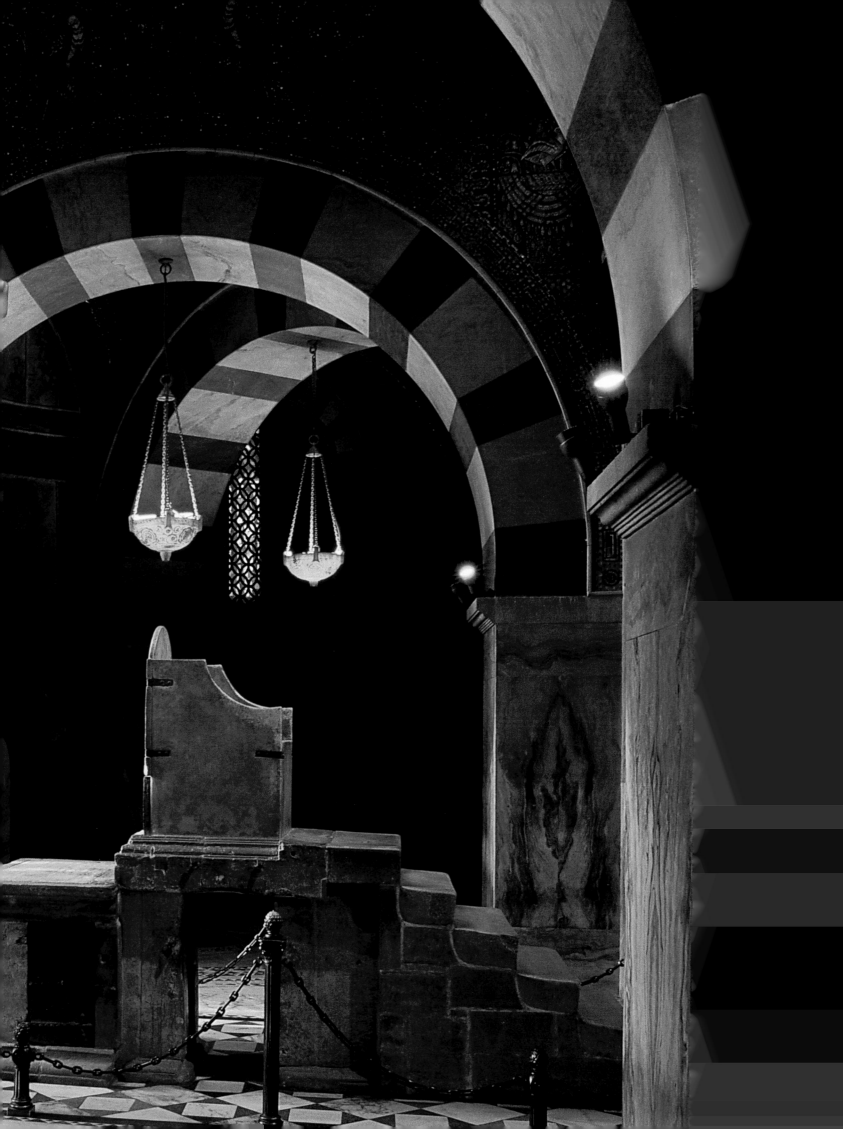

THE MIDDLE AGES COMES TO LIFE –
CASTLES

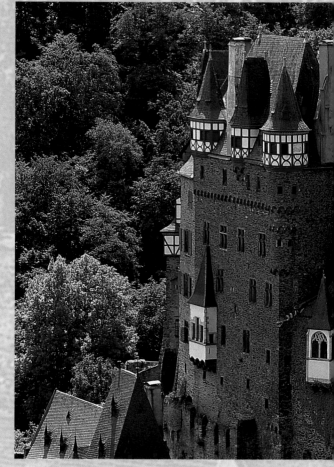

Centre:
Burg Eltz is one of the most spectacular and best preserved castles in the country. The complex, which was continually extended and modernised down the centuries, dates back to the 13th century. Today it is under private ownership.

Brave knights on white chargers and damsels in distress, lords and ladies living a life of luxury in indomitable fortresses high up above the River Rhine; the Middle Ages seen through coloured spectacles were an invention of the 19th century. In the Romantic period a wave of castle euphoria washed over Germany. Ruins were excavated and reconstructed; ancient strongholds were once again restored to their former glory. One such edifice which didn't need to be rebuilt was Burg Eltz which had miraculously survived the ravages of time more or less intact. It was constructed in the first half of the 12th century by the lords of Eltz in the Eifel on the road leading from the Moselle to Maifeld. In c.1268 the family split and over the years the various branches erected their own living quarters, sharing the communal well and inner courtyard. The result was the archetypal fairytale castle, a kind of medieval apartment block with stringent rules and regulations governing the lives of those within.

Below:
The Meersburg on Lake Constance is the oldest inhabited stronghold which is still in private hands. Its squat central tower is its most dominant architectural feature.

Germany has several areas simply riddled with castles, among them the River Saale, Franconian Switzerland or the Fränkische Schweiz and the famous valley of the Middle Rhine from Mainz to Koblenz. Stronghold upon stronghold perches atop the steep slopes on both sides of the river. Proud names – Rheinstein, Ehrenfels, Marksburg and Lahneck – testify to an illustrious past. The most striking of the Rhine's fortresses perhaps is Pfalzgrafenstein at Kaub. Heavily fortified, this ancient toll booth squats immovably in the middle of the river. The taxes collected from the many tradesmen navigating the rapids of the Rhine helped line the pockets of local lords.

The celebrated Wartburg in Thuringia was not only home to Martin Luther from 1521 to 1522 and the place where he worked on his translation of the Bible but was also the venue of the legendary "Sängerkrieg". In this epic poem from

the Middle Ages, which narrates the events of a singing competition in verse, the godliness of Wolfram von Eschenbach conquers over the malicious devilry of the evil sorcerer Klingsor. Richard Wagner's opera "Tannhäuser" takes up the story in true 19th-century fashion.

FROM PLACE OF REFUGE TO PLACE OF RESIDENCE

The origins of the castle are less heroic and far more practical than the likes of Wagner would

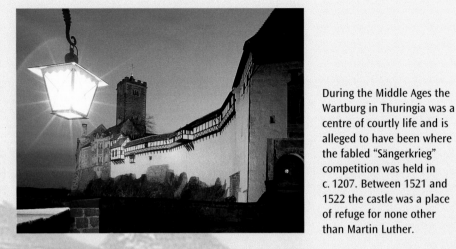

During the Middle Ages the Wartburg in Thuringia was a centre of courtly life and is alleged to have been where the fabled "Sängerkrieg" competition was held in c. 1207. Between 1521 and 1522 the castle was a place of refuge for none other than Martin Luther.

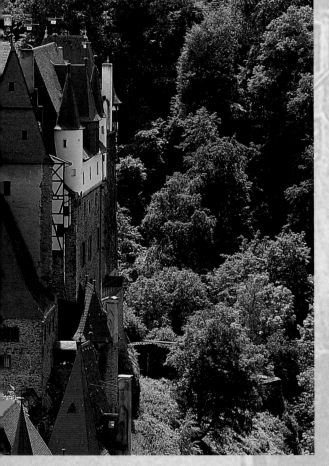

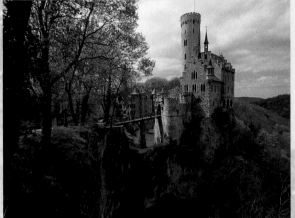

Schloss Lichtenstein was constructed in 1842 on a steep rocky outcrop above the valley of the Echaz near Reutlingen. The neo-Gothic edifice was erected on the foundations of an older fortification.

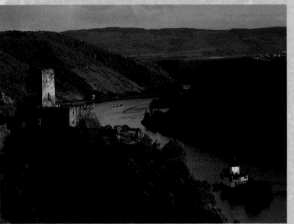

Below Burg Gutenfels at Kaub 13th-century Pfalz-grafenstein Castle clings to an island in the middle of the Rhine, long a toll and customs post for passing ships.

have us believe. Incursions by the Normans and the Hungarian Wars of the 9th and 10th centuries prompted nervous monarchs to fortify their estates, with the first "policy on castles" introduced under Heinrich I. Along the borders of the empire towers, ramparts and drawbridges were erected as both a form of defence and seats of regional administration. What were originally places of refuge gradually became places of residence, although the comforts of courtly life as we visualise it today were long in coming; most were extremely spartan. Over 19,000 historic castle sites have been catalogued in Germany, many of them made only of wood which over the centuries have disappeared without trace.

It wasn't until the 12th century and the rise of the Staufer dynasty that castle building entered its heyday. This was the age of the courtly romance and minnesingers recounting tales of mighty royal residences decked out with lavish furnishings, the floors decked in green marble, the ceilings in cedar and the walls hung with magnificent tapestries.

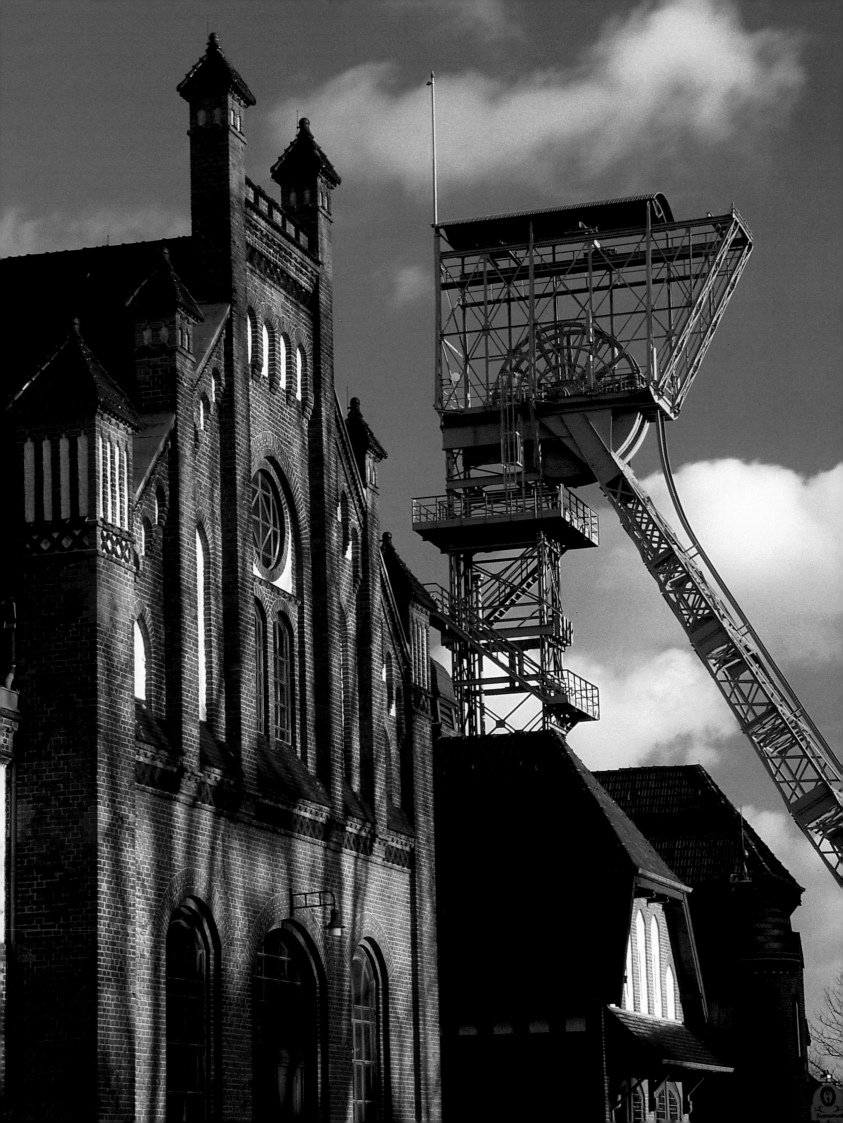

Below:

The boiler house of the old colliery in Essen now houses a museum of design. The building, erected in c. 1930 in the Bauhaus style, has been refurbished by British architect Sir Norman Foster. The permanent exhibits feature choice examples of contemporary design.

Below:

The Hanseatic coking plant is a relic of the industrial age. The coke manufactured here was used to heat and smelt pig iron.

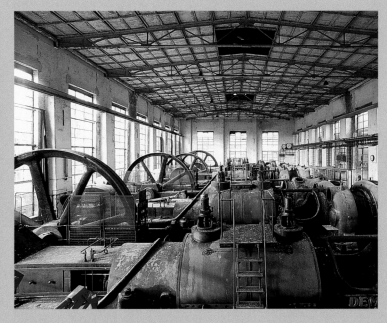

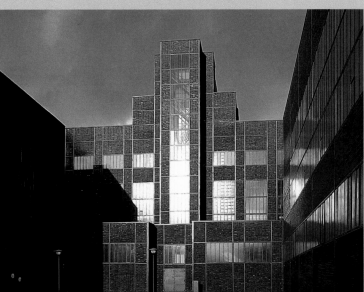

Left and above:

The Dortmund suburb of Bövinghausen is home to Westphalia's industrial - museum. The prime attractions are the now defunct collieries with the machine room housing the equipment once needed to run the pit. Next to it is one of the winding towers which were once so characteristic of the Ruhr area.

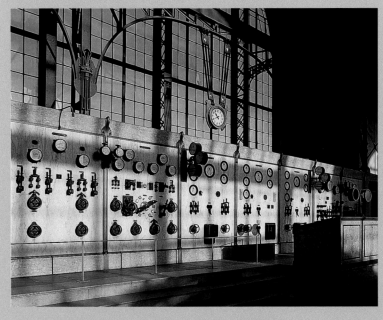

Above:

The colliery, completed in 1904, boasts a surprising number of elements from the Art Nouveau period. After its closure in 1966 a citizen's action group fought long and hard to preserve this incredible example of industrial architecture, their successful endeavours eventually resulting in the founding of an industrial museum.

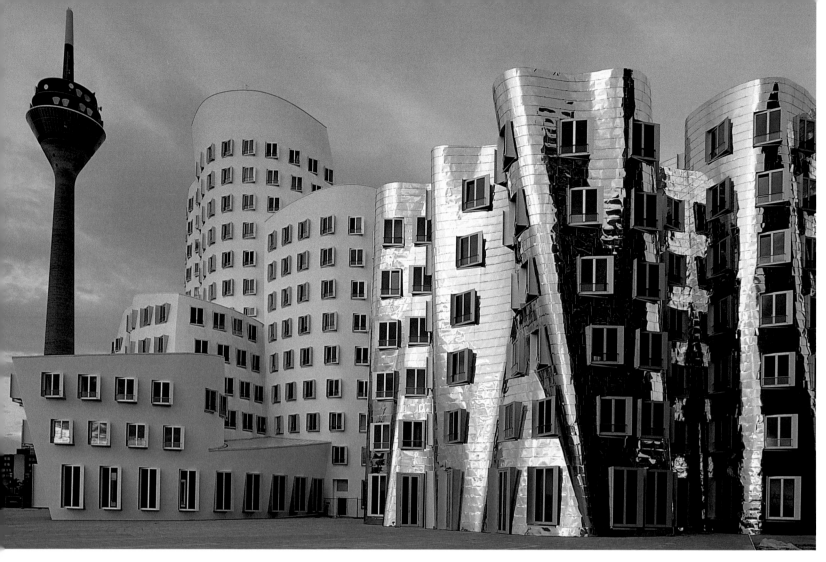

Above:
The futuristic array of the new customs post on Düsseldorf harbour, the work of American Frank O Gehry, evolved between 1997 and 1999. Since their completion the offices have become something of a place of pilgrimage for fans of contemporary architecture.

Right:
A further architectural highlight in Düsseldorf is the theatre. Completed in 1969, the building with its curved facade was designed by Bernhard Pfau.

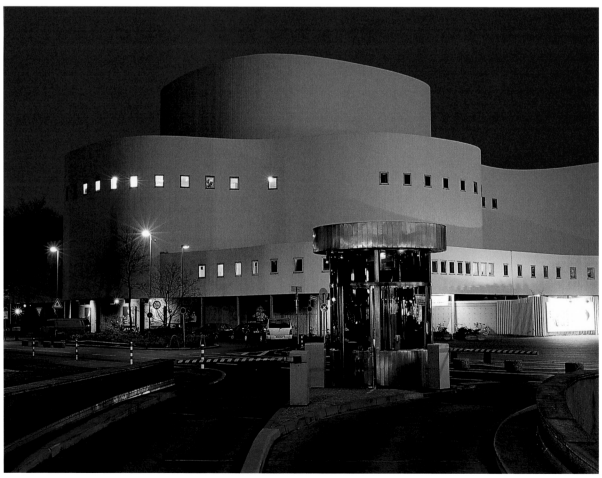

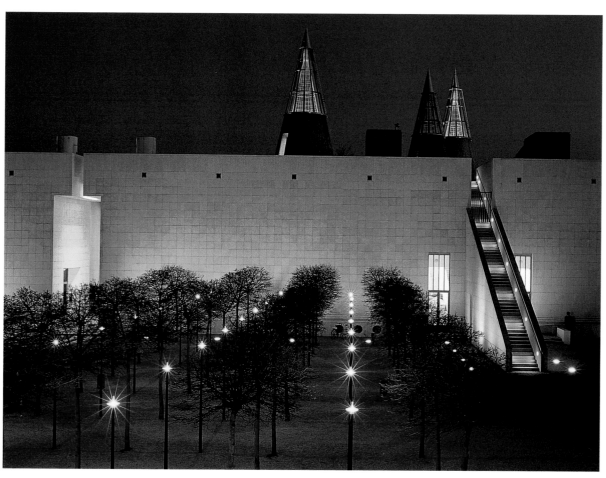

Left:
Germany's federal art and exhibition centre in Bonn, designed by Viennese architect Gustav Peichl, was opened in 1992. It stages up to five different international exhibitions a year which centre on art, architecture, cultural history and technology.

Below:
The museum in Wolfsburg, also home to the VW car factory, is chiefly devoted to contemporary art, with works by artists ranging from Andy Warhol to Anselm Kiefer on display. The museum, finished in 1994, has earned itself an acclaim which far transcends its national boundaries.

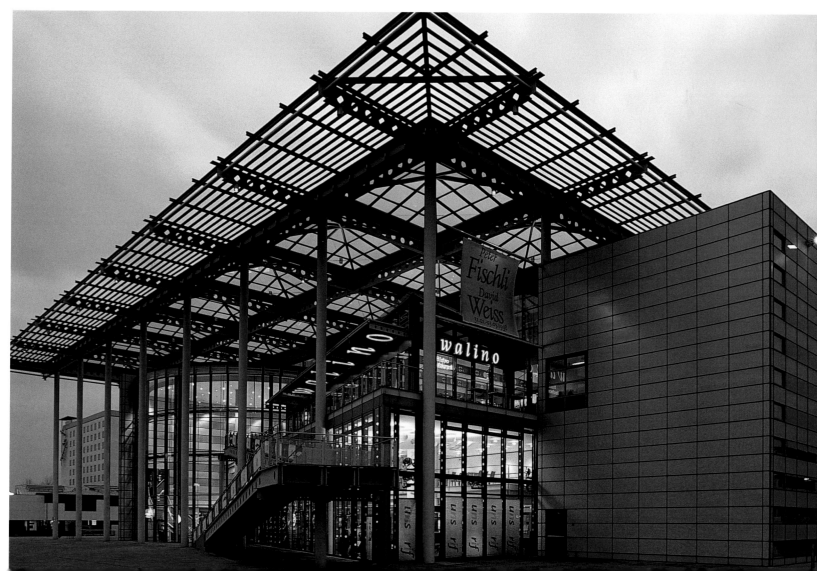

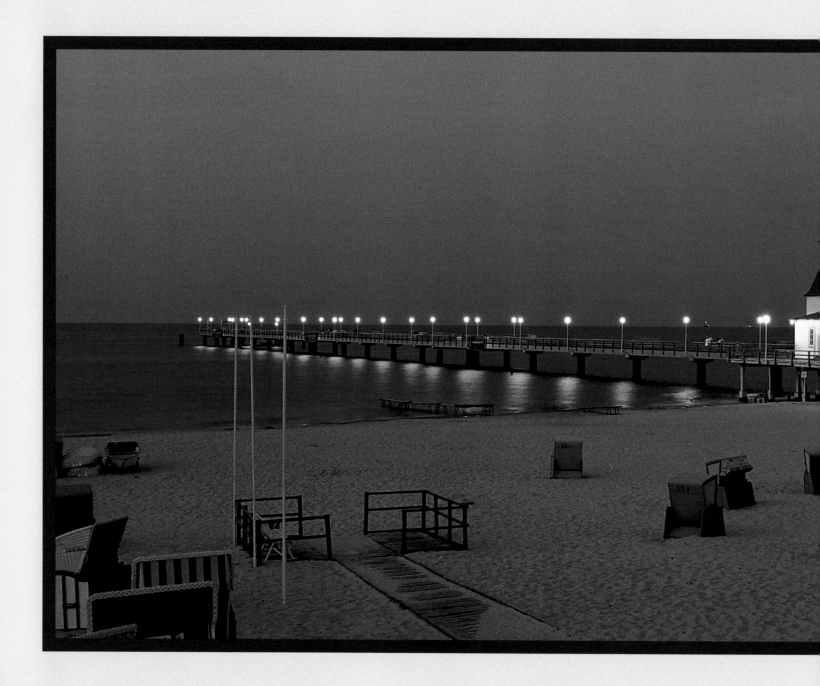

GERMANY'S EAST – FROM THE BALTIC TO THE ERZGEBIRGE

The coast of Mecklenburg-West Pomerania is 1,470 kilometres (913 miles) long and has no less than 794 offshore islands, Rügen being the best known. In 1818 artist Caspar David Friedrich, born in Greifswald in 1774, captured its gleaming chalk white cliffs in a painting which was to become famous all over the world. The quiet spots where the Romantics once sat and reflected on their surroundings and their emotions can still be found. The coastal resorts on the island of Usedom are more turbulent. The Seebrücke pier at Ahlbeck is the epitome of early 20th-century seaside architecture and still popular with all those who choose to spend their holidays on the Baltic. Water also predominates

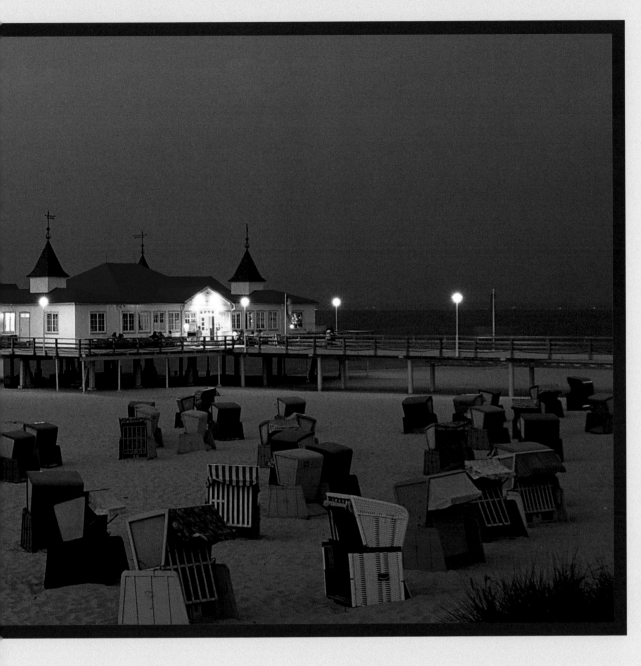

The wooden pier at Ahlbeck on the island of Usedom was completed in 1898, gaining its current guise in 1930. Ahlbeck was one of the "three imperial" seaside resorts of the Wilhelmine period, Heringsdorf and Bansin holding equal significance for royal bathers.

inland; the Mecklenburger Seenplatte, a unique natural paradise and lake district, covers over 150 kilometres (90 miles) from the provincial capital of Schwerin to the Uckermark in Brandenburg.

Brandenburg also has a fantastic watery landscape and urban paradise in the Spree Forest. Riddled with rivers and marshy canals, this area of Lower Lusatia has retained many of its Sorb traditions. Besides operating various boat trips for visitors the main source of income is farming, pickled gherkins from the Spree being famous throughout Germany. Much of the rest of Brandenburg is dry sand and expansive forest,

perhaps most eloquently described by Theodor Fontane (1819–1898). In his journal "Travels through the March of Brandenburg", which begins at Lake Ruppin where Fontane originated from, the author paints a sensitive and realistic picture of his native homeland.

BERLIN – THE REUNITED CAPITAL

The German capital of Berlin lies at the heart of Brandenburg and since the fall of the Wall has done much to overcome its divided past. The building activity of the last decade has given rise to some truly spectacular architecture, the focal

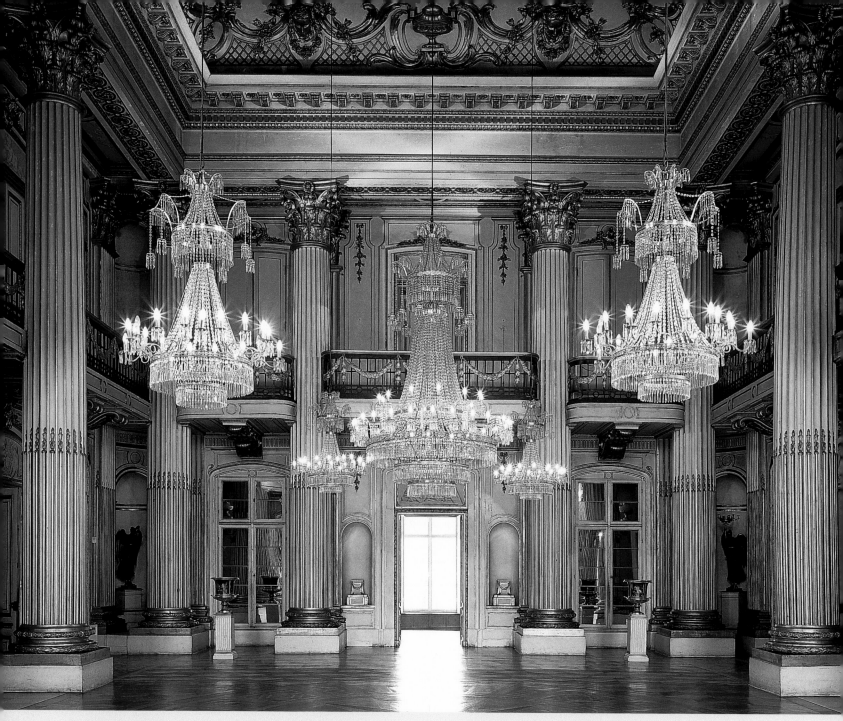

The late baroque palace of Ludwigslust in the town of the same name south of Schwerin was constructed between 1772 and 1776. Some of the lavish decoration in the Golden Salon in the main wing of the palace is made of painted and gilded papier-mâché.

point being the monumental Potsdamer Platz. The busiest crossroads in Europe in the 1920s and a barren no-man's-land in the wake of the Second World War, new impetus has been pumped into the epicentre of Berlin with a vengeance. For several years the move of the federal government from Bonn to Berlin was hotly disputed; today, hardly anyone can imagine the country being ruled from the depth of the provinces. The new government quarter with its domed Reichstag and diplomatic strongholds representing all corners of the globe have made Berlin the buzzing capital it once was. Yet Berlin is not all national politics and mainstream culture; the city also boasts a thriving subculture which peaks each year in the technicolour Love Parade.

THE BIRTHPLACE OF THE REFORMATION

Such megaevents are not typical of Saxony-Anhalt, Brandenburg's neighbour, which instead concentrates on the more peaceful disciplines of art and art history. The twelve world-famous statues of the founders from the workshop of the Master of Naumburg in the west choir of Naumburg Cathedral are among the most significant sculptures of the Middle Ages. The palace chapel in Wittenberg is another well-known place of worship; it is to these doors that Martin Luther (1483–1546) allegedly nailed his "95 Theses" protesting the abusive selling of indulgences on October 31 1517, setting the wheels of the

Reformation in motion throughout the whole of Europe. Dessau is another locality to have merited international attention; it was to here that the Bauhaus school of design was moved in 1925, with Walter Gropius, Mies van der Rohe and Paul Klee – among others – on the illustrious teaching staff. The lasting influence the Bauhaus had on architecture and design is still evident all over the world. In 1996 the complex was made a UNSECO World Heritage Site.

DREAMS COME TRUE

Most of the edifices in Saxony and Dresden date back to the reign of Augustus the Strong whose enthusiasm for art and architecture helped earn Dresden the epithet of "the Florence on the Elbe". Master builder Matthäus Daniel Pöppelmann made his ruler's dreams come true; his legacy includes the Dresden Zwinger, Schloss Pillnitz, the refurbishing of Schloss Moritzburg and an astounding contribution to the rise of the baroque in Saxony. Where Dresden is the city of art, Leipzig is the centre of trade. The town is characterised by its many ancient exhibition buildings and merchandising houses with numerous passageways and arcades which have been expertly restored. The Mädlerpassage is one of the most celebrated thanks to the historic restaurant Auerbachs Keller which features in a scene from Goethe's "Faust". Where this is fiction, Johann Sebastian Bach's time in Leipzig is fact; the great master was director of church music at St Thomas's for many years.

What Bach was to music in Leipzig, Johann Wolfgang von Goethe was to literature in Weimar in Thuringia. At the end of the 18th and beginning of the 19th centuries the little town on the River Ilm was the intellectual centre of Germany under the auspices of Duchess Anna Amalia and Duke Charles Augustus. The town had many famous visitors, among them Friedrich von Schiller, Christoph Martin Wieland and Johann Gottfried Herder, all of whom went down in literary history as the major players of Classical Weimar.

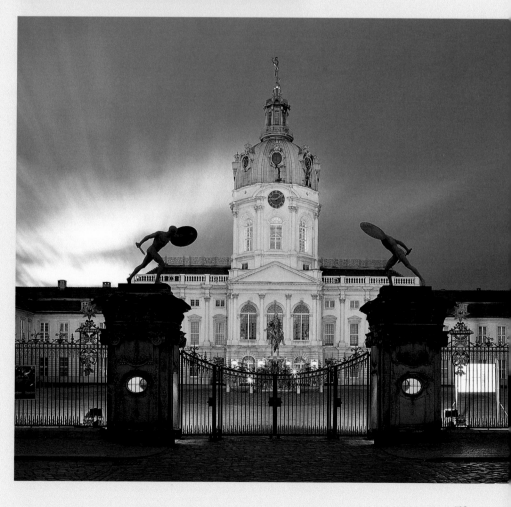

Left:
The state porcelain manufacturer's in Meißen owes its existence to alchemist Johann Friedrich Böttger and his invention of hard porcelain in 1708/09. The factory, founded in 1710, is now run by the Free State of Saxony. Factory products are still laboriously painted by hand.

Centre:
This violinmaker's workshop is in Markneukirchen in the Vogtland in Saxony, also known as the "music quarter". The town and its surrounding villages are home to more makers of musical instruments than any other region in Germany.

Below:
Schloss Charlottenburg was created in several phases between 1695 and 1746 and is a prime example of the architectural fervour of the kings of Prussia.

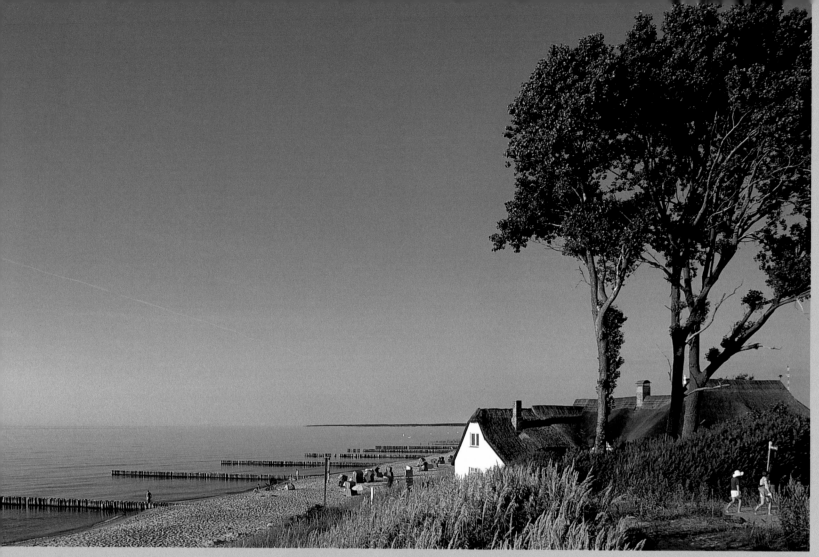

Above:
Ahrenshoop on the Baltic is famous for its colony of artists which established itself in c. 1880. The town itself was founded in c. 1760 and still has many of the old thatched cottages typical of northern Germany.

Right:
Almost completely enclosed by the Baltic peninsula of Fischland and Darß, the Saaler Bodden is a natural paradise. A "Bodden" is a shallow, irregularly shaped bay with a narrow channel leading out to sea, best explored aboard one of the local "Zeesenboote" built specially for fishing in this area.

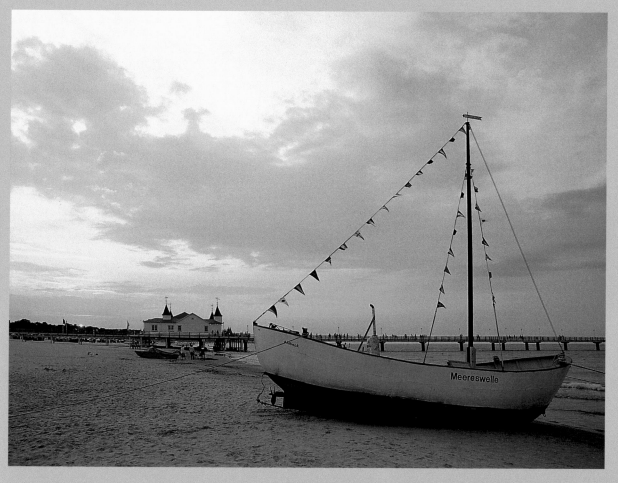

Left:
By evening the beach at Ahlbeck on Usedom has emptied; people taking a late stroll are only likely to come across one of the trawlers returning home after a day's fishing.

Below:
Kap Arkona, the north-easternmost point of the island of Rügen, has not one but two lighthouses. The taller of the pair, built in 1902, still guides shipping safely on its way. The lower tower, constructed by Karl Friedrich Schinkel in 1827, has a museum on the history of lighthouses and marvellous views from its rooftop.

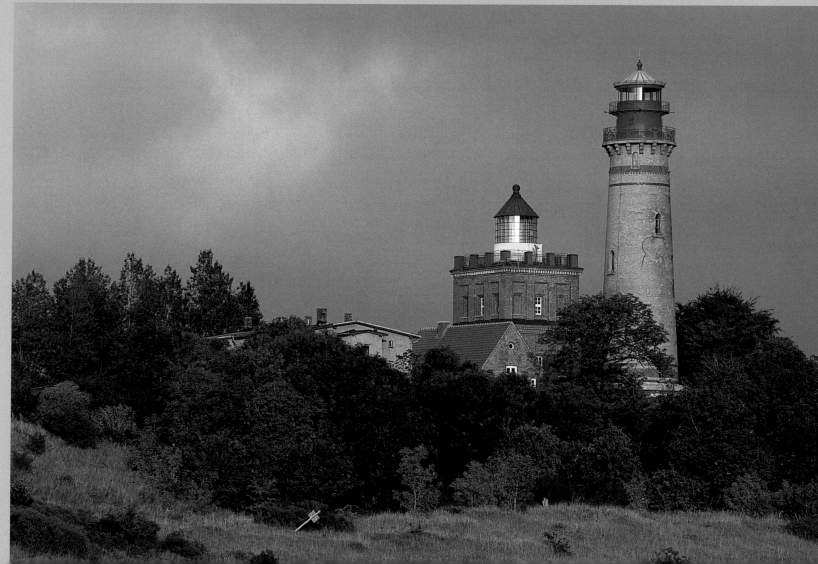

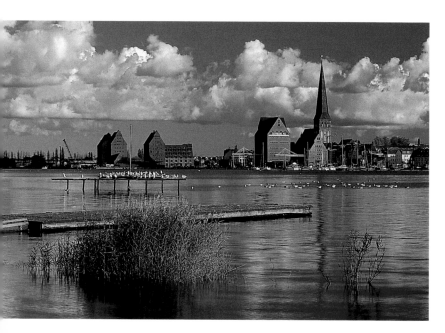

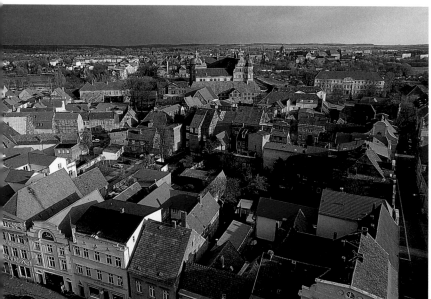

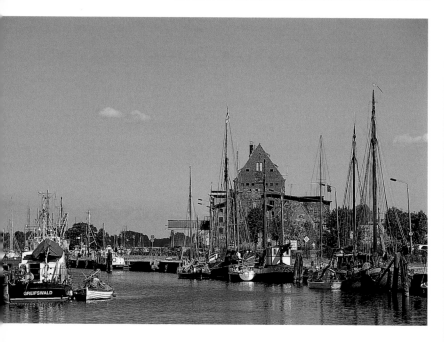

For centuries life in Rostock on the lower reaches of the River Warnow was dominated by marine trade and the harbour, both of which still play a major role here today.

Centre left:
The town of Güstrow ca. 40 kilometres (25 miles) from Rostock boomed in the 14th century thanks to a thriving cloth industry and wool trade. The palace at the top of the picture is one of the most important Renaissance buildings in northern Germany.

Bottom left:
The history of Greifswald
was largely determined by its
membership of the Hanseatic
League and also by its univer-
sity, founded in 1456 and
thus the second oldest in
northern Germany.

Below:
Looking out from atop the
Marienkirche in Stralsund
you can make out the Niko-
laikirche on the horizon.
The medieval town centre
with its many buildings in
northern German brick
Gothic has remained intact,
an eloquent witness to the
town's glorious past.

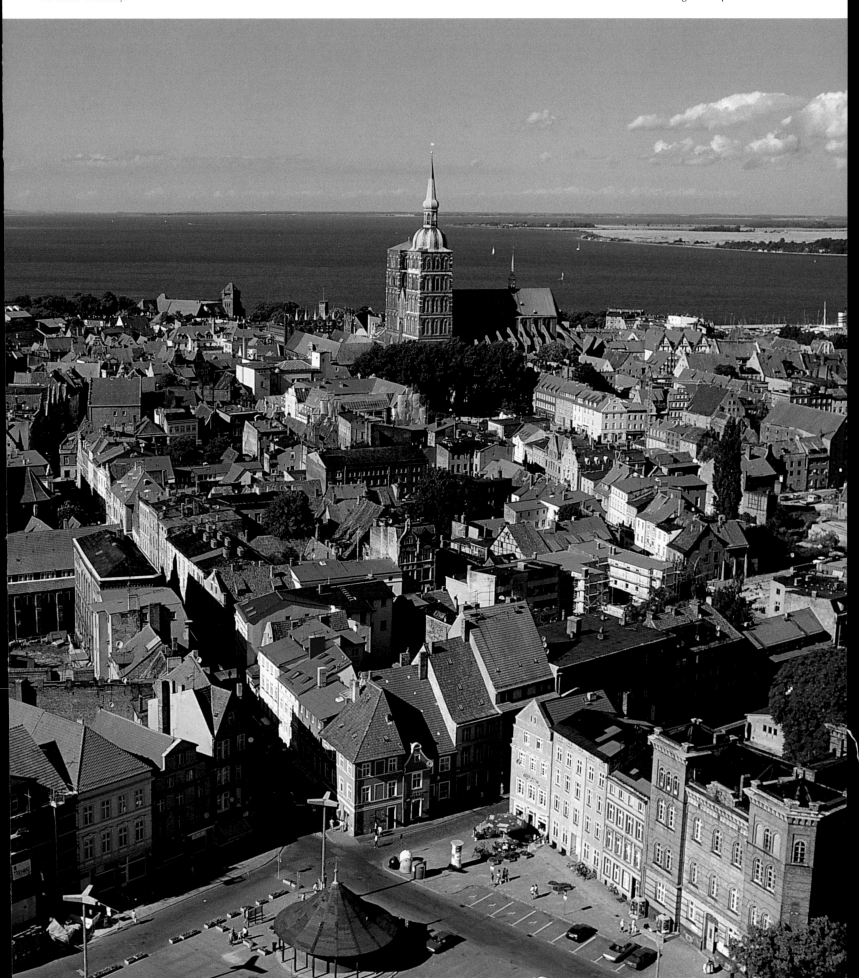

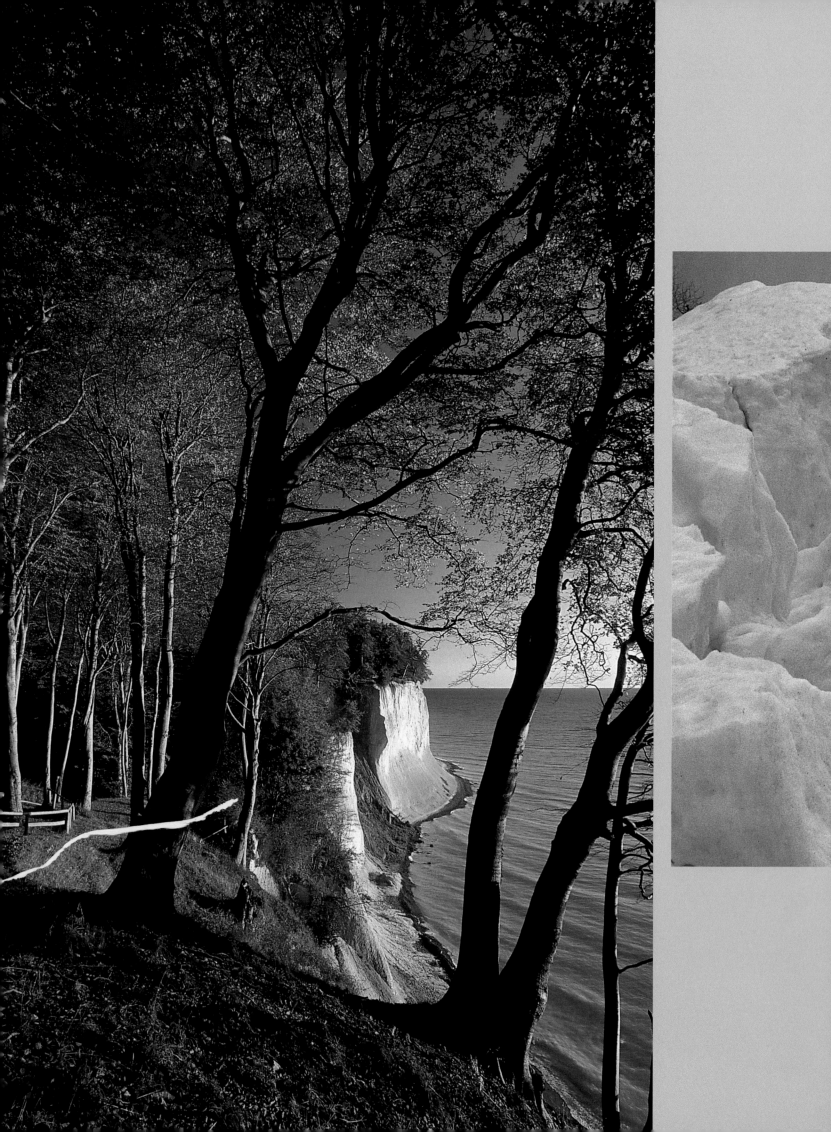

Left:
The chalk cliffs of Rügen, here the Stubbenkammer, are the island's local trademark, publicised around the world in Caspar David Friedrich's famous painting of the same.

This natural monument on the east coast of the Jasmund peninsula is made up of thick layers of chalk which reach giddy heights of up to 161 m (528 ft) at Piekberg.

Below:
In particularly cold winters the chalk cliffs of Rügen are spectacularly coated in thick sheets of ice, reminiscent of a Romantic painting by Caspar David Friedrich.

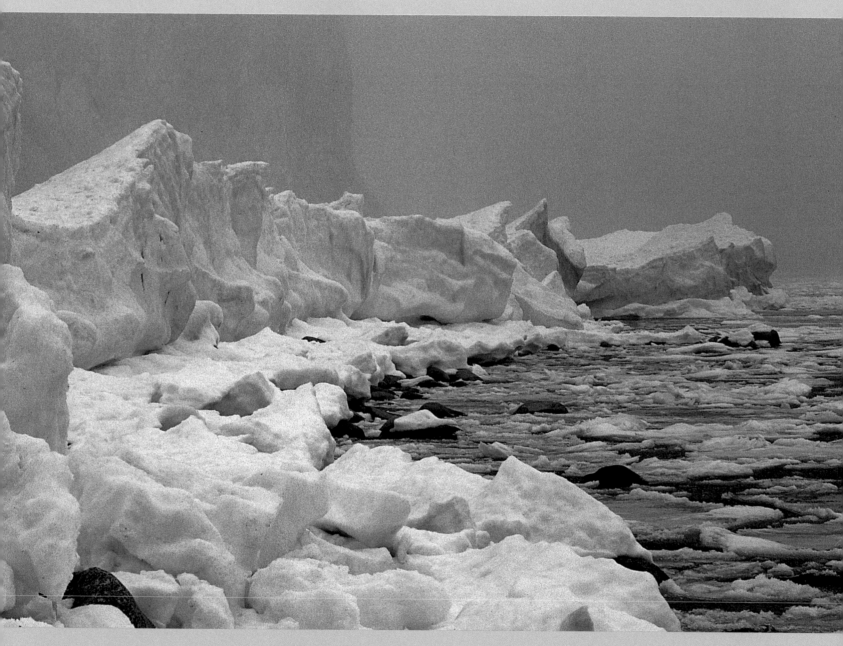

Left:
In the far south of Mecklen-
burg is the idyllic Stechlinsee,
one of the waterways of the
Mecklenburgische Seenplatte,
the area's beautiful lake
district.

Below:
With its turrets, oriels, gables
and island location Schloss
Schwerin is like something
out of a fairytale. The palace
took on its present, mock-

French appearance in the
mid-19th century. Following
extensive restoration the
magnificent interior is now
open to the public.

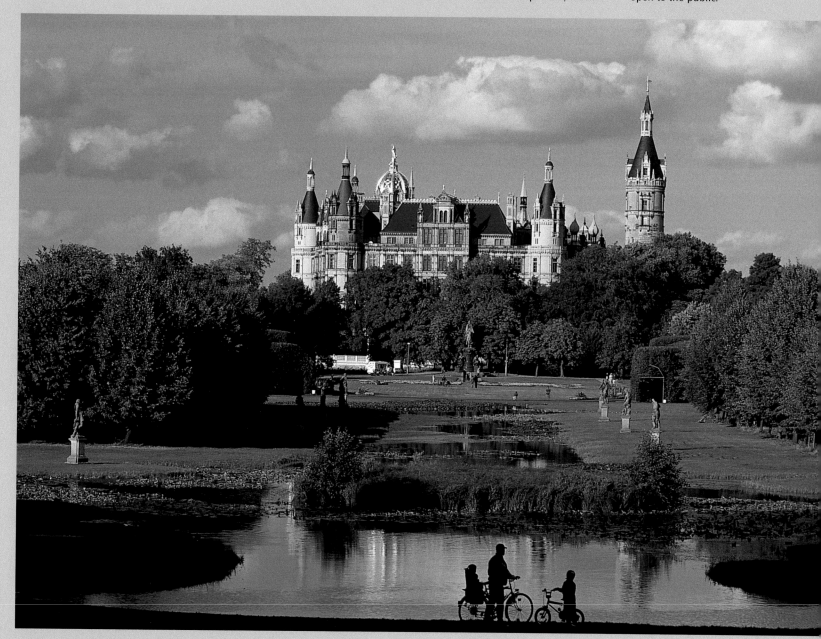

Left:
This avenue of trees on
Rügen is one of many which
have thankfully not fallen
prey to bulldozers and chain-
saws wanting to widen the
island's roads.

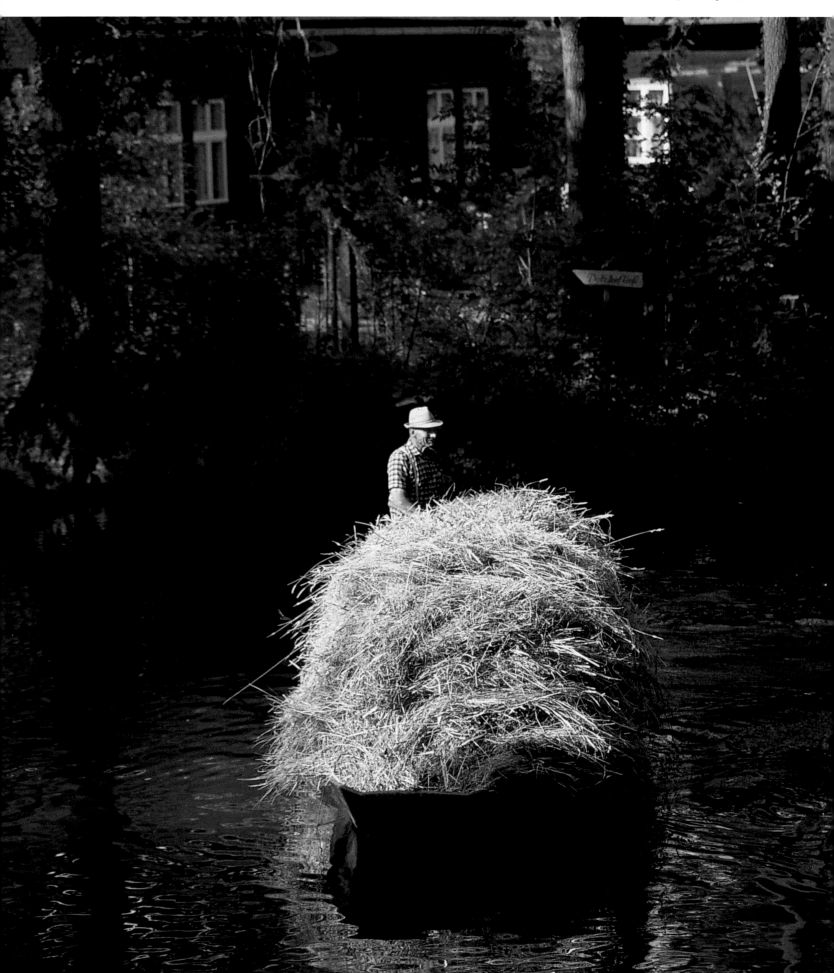

Below:
The Spree Forest, an area of marshland riddled with streams, rivers and canals, is one of the most charming stretches of country in Germany. The main form of transport here is still the boat, with even the hay transferred from field to barn by river.

Top right:
The Spree Forest has always been home to Slavic Sorbs who still uphold their ancient customs and traditions here, including their own language and national dress.

Centre right:
The Spree Forest punt, still manufactured according to old traditions, is an essential mode of transport – even if you're just popping over to your neighbour's.

Bottom right:
Count Hermann von Pückler-Muskau (1785–1871) was one of Germany's most famous landscape gardeners.

Between 1846 and 1871 he created an English park in the grounds of Schloss Branitz which can be viewed along the many axes of the gardens.

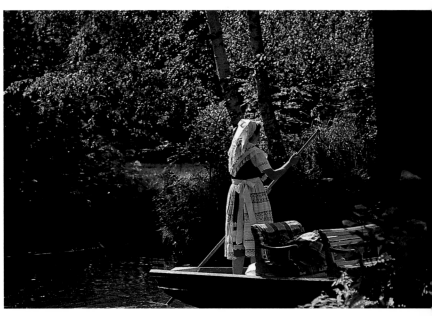

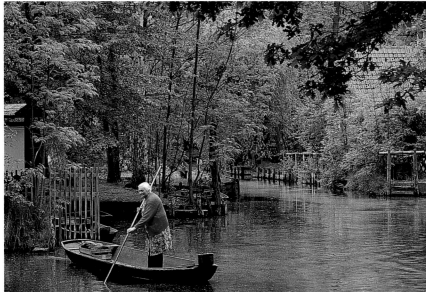

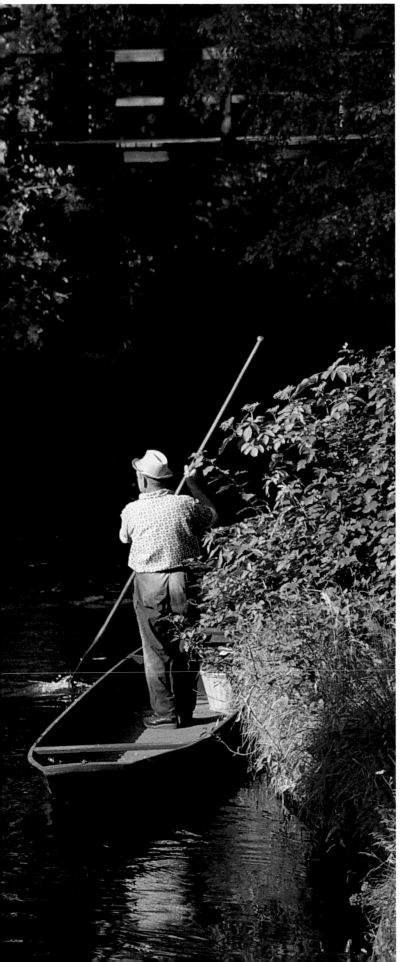

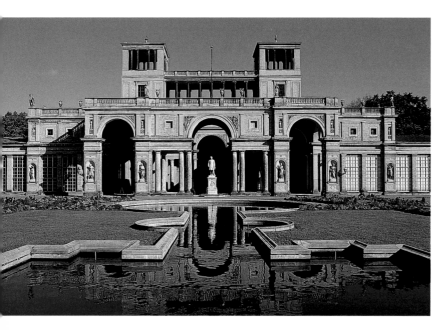

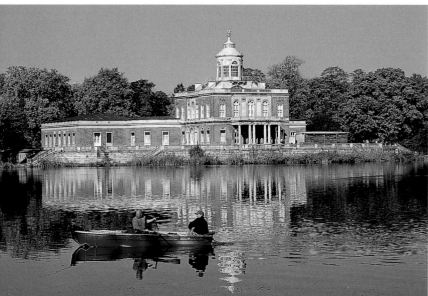

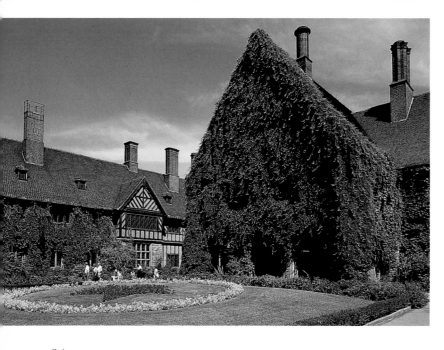

Centre left:
The marble palace of red brick and grey marble on the Heiliger See served Frederick William II (1744–1796) as a summer residence.

Bottom left:
Schloss Cecilienhof was erected between 1913 and 1917 in the style of the English country manor. It rose to fame through the Treaty of Potsdam, signed here on August 2 1945, which sealed the fate of post-war Germany.

Below:
The Sanssouci complex, with its many palaces and landscaped gardens, is one of the most elaborate in Germany.

The highlight of the park is without doubt the vineyard terrace beneath the Rococo Schloss Sanssouci.

Page 86/87:
The new buildings on Marlene-Dietrich-Platz in Berlin are just part of the reincarnated Potsdamer Platz in the heart of the city.

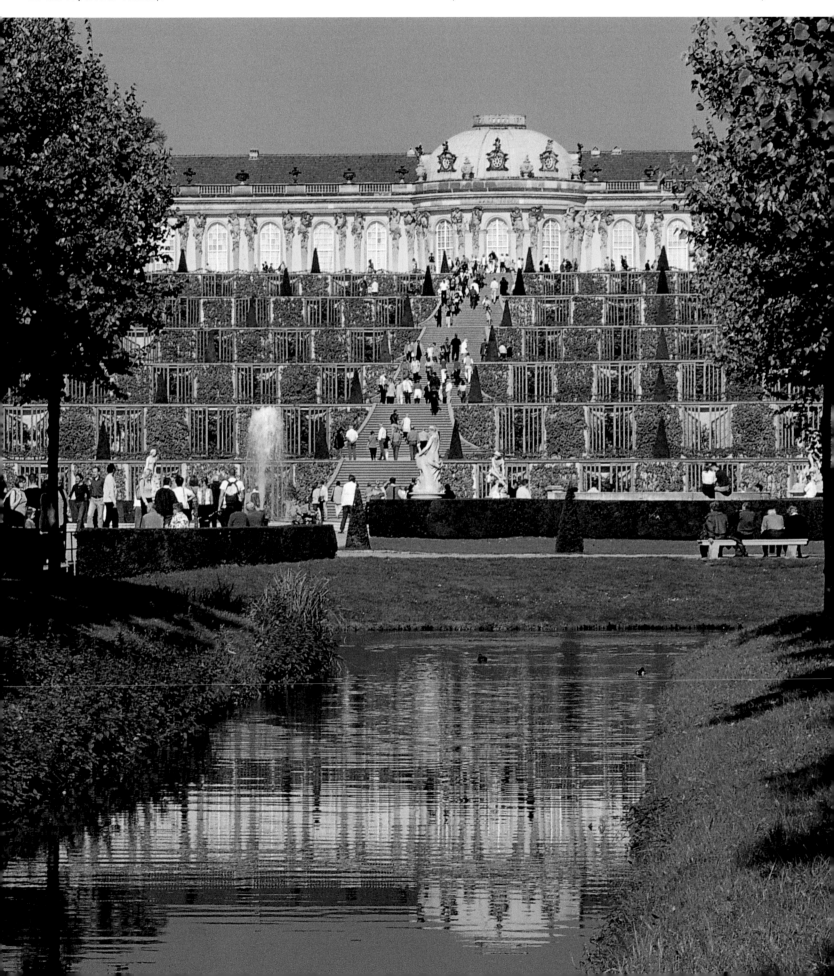

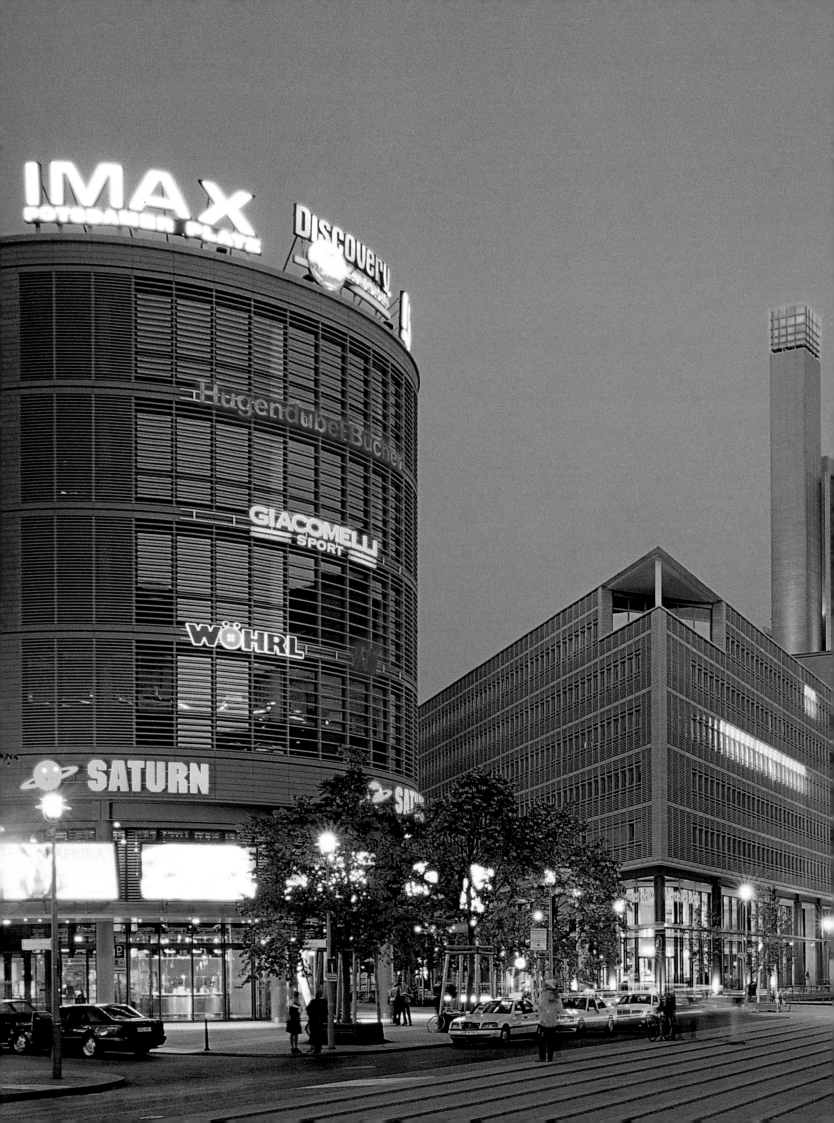

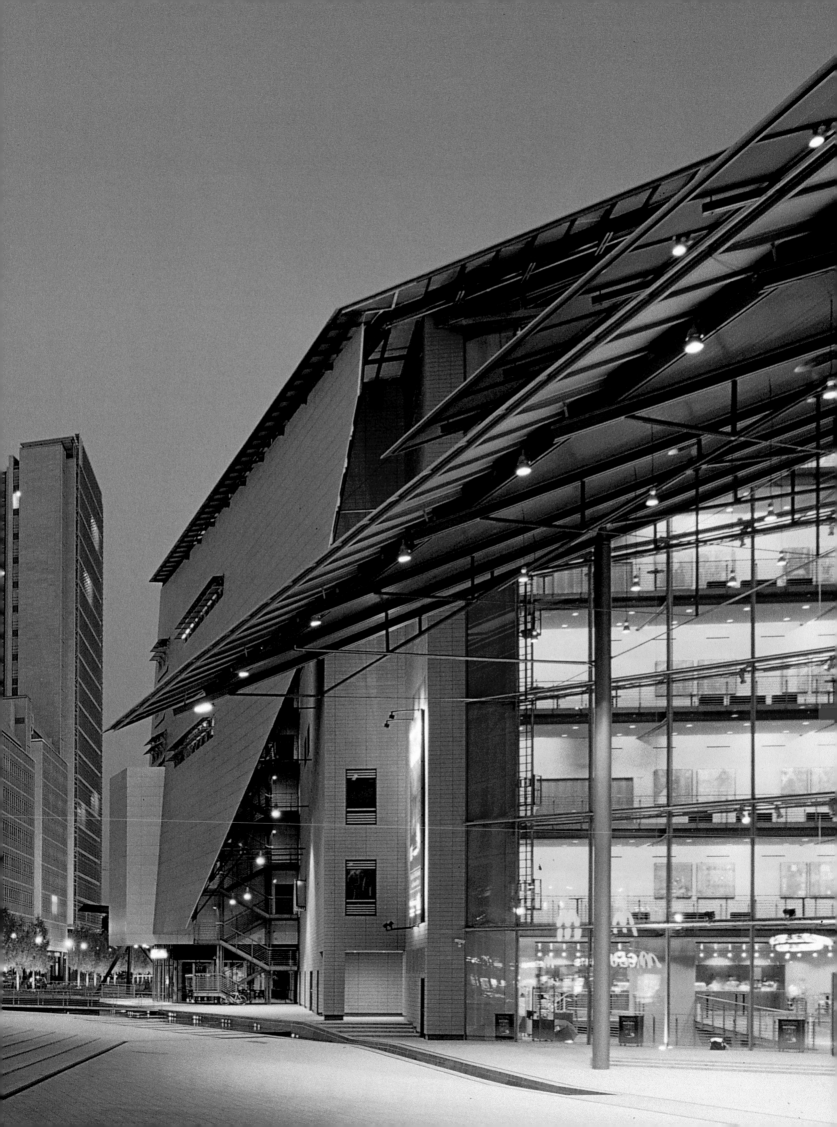

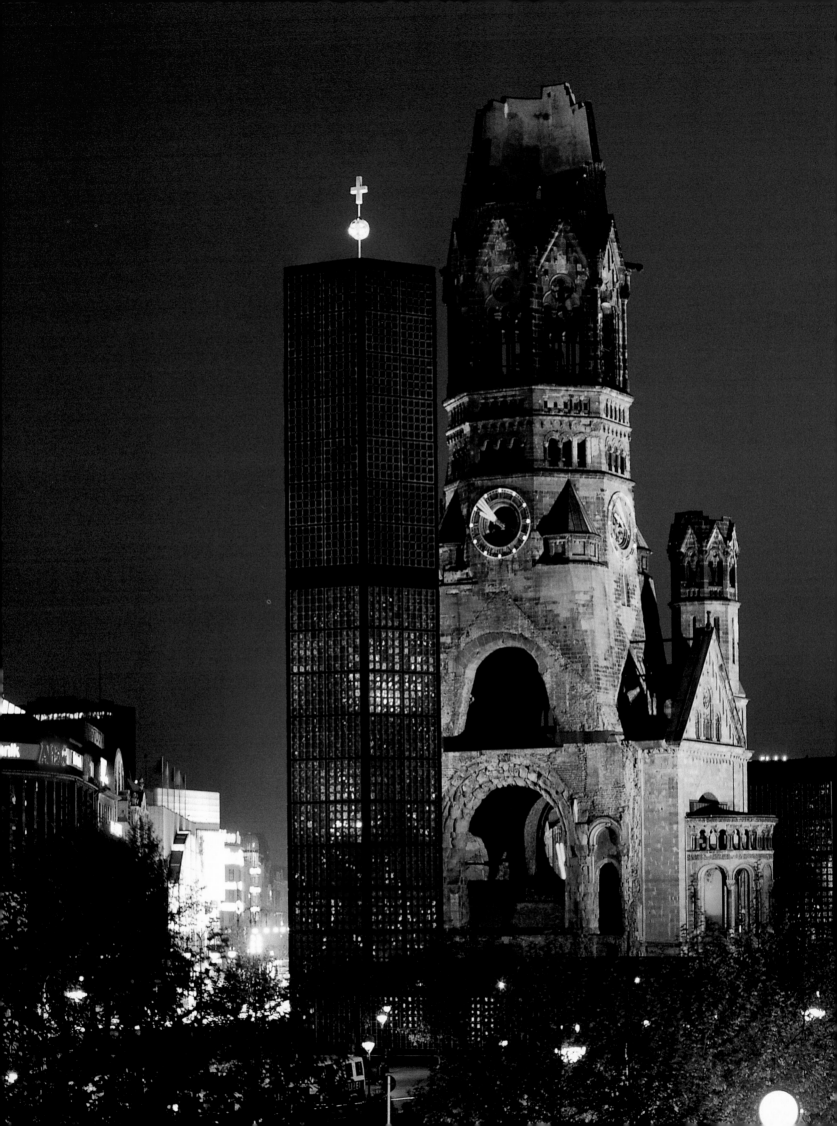

Left:
The ruins of the Emperor William Memorial Church, destroyed during the Second World War, have been left standing as a memorial. Next to them a new octagonal place of worship with blue glass windows has been erected. Together the two buildings on Tauentzienstraße are one of the hallmarks of Berlin.

Below:
Two more city landmarks and insignia of the Berlin Republic are the Quadriga on the Brandenburg Gate and the new glass dome of the Reichstag, designed by Britain's star architect Sir Norman Foster.

Below:
The collection at the Old National Gallery includes works by German artists, particularly those from Berlin from the 19th and early 20th centuries.

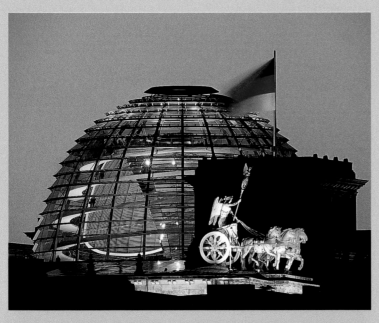

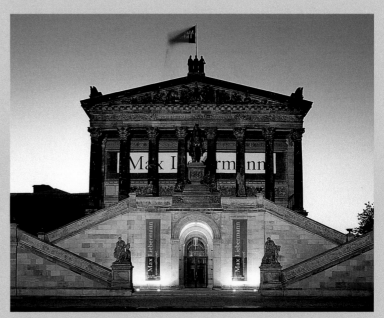

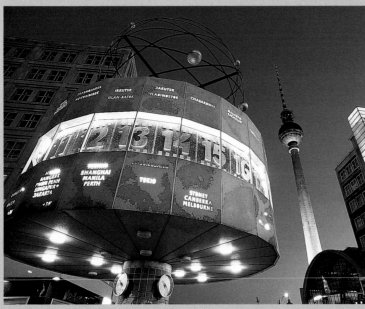

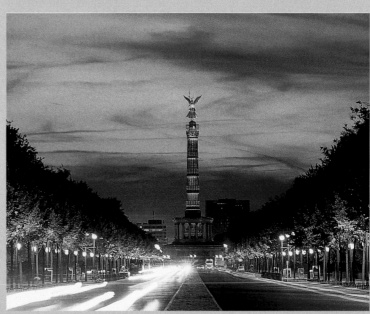

Above:
The World Time Clock on Alexanderplatz shows what time of day it is across the globe. The square is dwarfed by the Television Tower which has the best panoramic views of Berlin.

Above:
In the middle of Tiergarten, Berlin's largest inner city park, Victory Column on the Straße des 17. Juni rises up 67 m (220 ft) into the air. It originally stood outside the Reichstag and was moved to its present location in 1938.

89

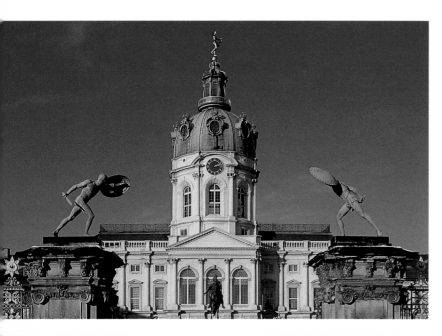

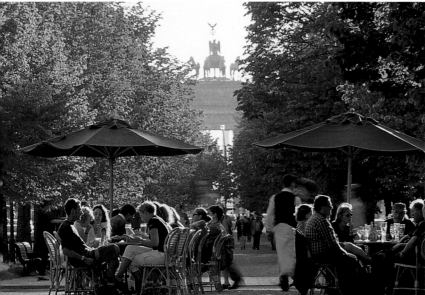

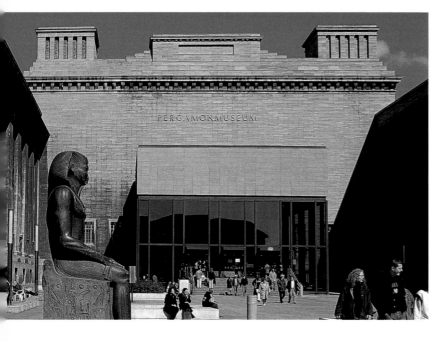

Top left:
Schloss Charlottenburg was initially planned as a hunting lodge for the electors of Brandenburg; in time it evolved into an absolutist symbol of power with a front almost 500 m (1,640 ft) long.

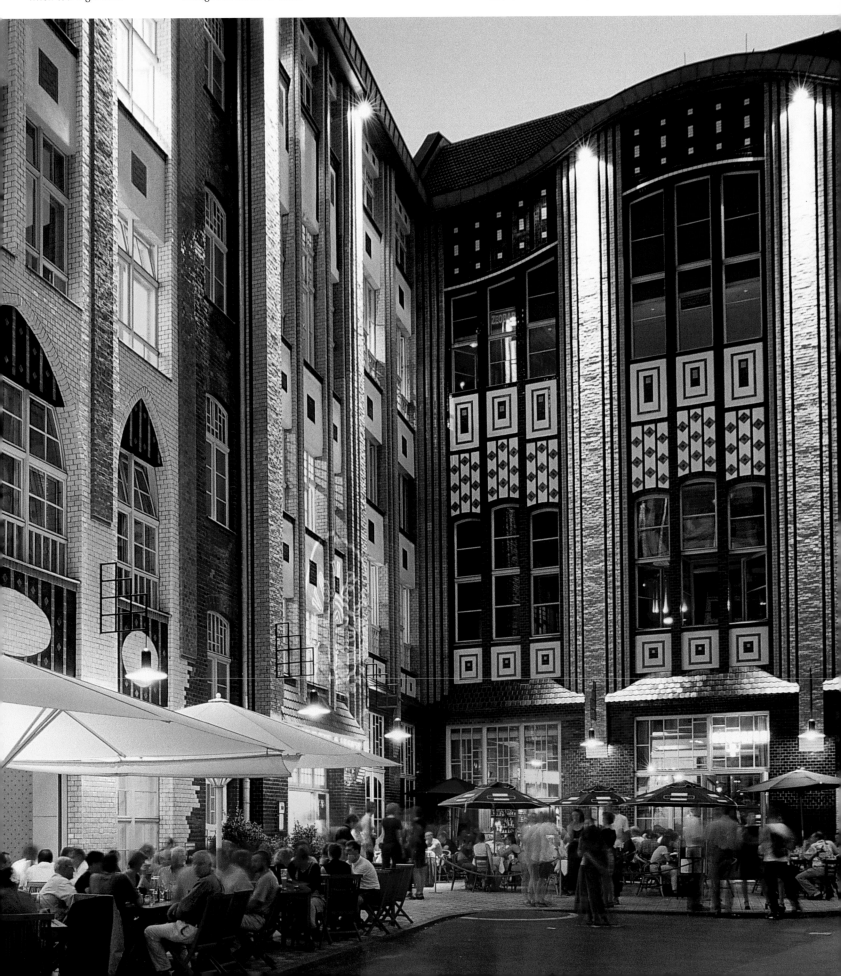

Centre left:
The central avenue of Unter den Linden, leading straight to the Brandenburg Gate, is one of the best places to sit down and have a rest when touring Berlin.

Bottom left:
One of the main attractions of Museum Island is the Pergamon Museum with the famous Pergamon Altar, brought to Berlin in 1902.

Below:
The Hackesche Höfe, built in 1908, once constituted the largest combined residential and commercial complex in Europe. Today the eight buildings provide space for restaurants and galleries, theatre and cabaret.

BREWED ACCORDING TO THE PURITY LAW OF 1516 – BEER

The oldest decree governing foodstuffs in Germany which is still valid today is the purity law of 1516, which stipulates which ingredients are to be used in the brewing of beer. Initially only applicable in Bavaria, in time it came into force across the country, being made law for the entire empire in 1906. Rumour has it that the Free State of Bavaria only joined the Weimar Republic on the condition that their purity law was upheld; soon afterwards it was introduced nationwide.

Over 5,000 different beers are made at ca. 1,200 breweries throughout Germany from the four basic ingredients of malt, hops, yeast and water. As the purity law doesn't actually state what the finished product should taste like each beer has its own specific flavour, resulting in an over-

Below left:
The word Kölsch is a designation of origin referring to the area around Cologne where the dark beer is allowed to be brewed.

Below right:
This postcard issued by the Dortmunder Actien-Brauerei (DAB) from 1913 advertises the fact that if you were a miner or a steelworker in the Ruhr, you drank beer.

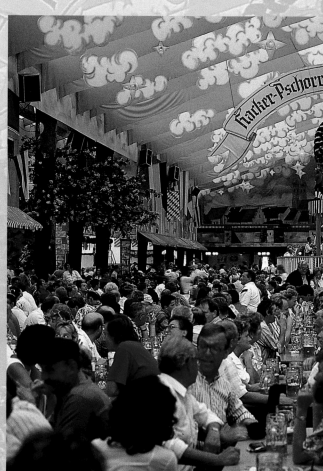

whelming diversity of brews. Both the quality of the raw materials, dependent on weather conditions, the harvest and the area of cultivation, and the skill and experience of the brewer contribute to the success or failure of a beer.

TOP- AND BOTTOM-FERMENTED BEERS

The various beers are categorised into top- and bottom-fermented varieties. Bottom-fermented beverages, where the yeast likes to be kept

cool and sinks to the bottom of the vat during fermentation, include Pilsner, lager and export. The yeast used in top-fermented ales, such as "Weizenbier" (wheat beer), dark "Altbier" and "Kölsch", does just the opposite. Further factors in determining the character of a beer are the cereals used and the type of malt these produce. The amount of malt and water are also significant. After several further stages of preparation, which include storage in fermentation cellars and various methods of filtering, the beer is ready to drink.

Beer tastes best after a long hike, drunk to wash down a hearty platter of bread, cheese and sausage.

Munich's Hofbräuhaus is an institution still frequented by the archetypal Bavarian.

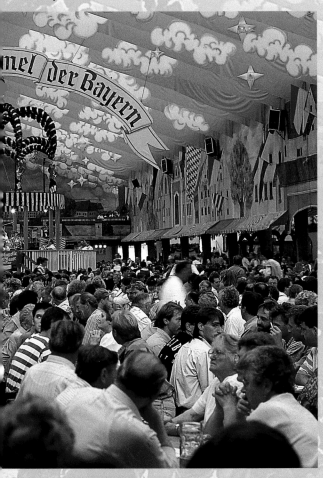

inquisitive travellers and thirsty hikers can try more different beers here than in any other region in Germany.

POPULAR PILSNER

The most popular beer in Germany is Pilsner or Pils, introduced in the 1870s. What is now a clear, light lager was dark and cloudy until 1842, when a brewer in Plzen in Czechoslovakia managed to produce a pale beer through exact adjustment of the malting temperature and proper application of the yeast. In the Czech Republic the word "Pilsner" is now used as a designation of origin; in Germany and elsewhere it simply refers to a certain type of beer famous for its floral aroma and strong aftertaste of hops.

Centre:
Munich's Oktoberfest is a place of pilgrimage for beer drinkers. The brew is the undisputed star beverage at the biggest festival in the world and is only served in huge litre jugs.

THE BEERS OF FRANCONIAN SWITZERLAND

Brewing is a major art throughout Germany but in the area known as Franconian Switzerland (Fränkische Schweiz) in northern Bavaria there are more microbreweries than anywhere else in the country. These small industries supply local restaurants and households or serve their beer (and food) at their own brewery pub. Here the private connoisseur is all-important, with modern marketing strategies of little significance;

Despite the enormous popularity of Pilsner regional tastes and preferences have done much to enlarge the spectrum of German beers; "Altbier" and "Kölsch" from the northern Rhine and "Weizen" from Bavaria are now fairly standard at any pub in the country.

Below:
The Nikolaikirche, Leipzig's main church, is dedicated to St Nicholas, the patron saint of merchants and business-men – hardly surprising in a city devoted to trade and exhibitions. What was once a Romanesque chapel was rebuilt in the neo-Classical vein by Johann Friedrich Carl Dauthe.

Below:
One hundred years after the Battle of Leipzig in 1913 this monumental memorial was installed. Its dimensions are impressive; the Hall of Fame is 60 m (197 ft) high and has no less than 324 figures on horseback arranged around the cupola.

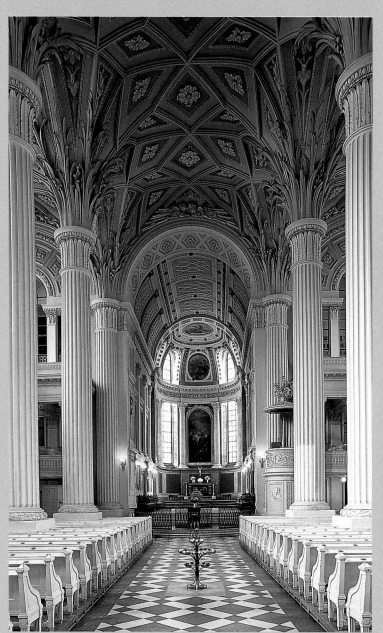

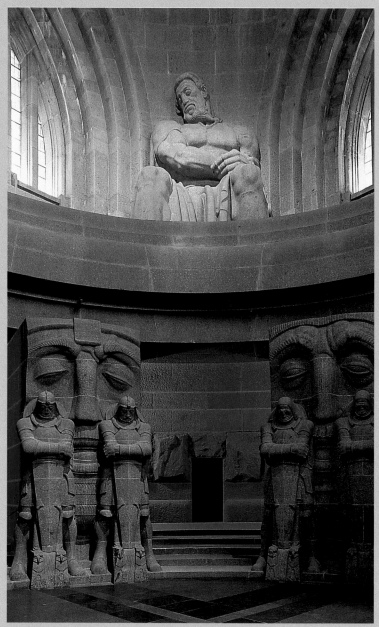

Page 96/97:
The famous panorama of Dresden, "the Florence on the Elbe", with its many art treasures. From left to right: the Schloss, Hofkirche, Semperoper and Augustus-brücke.

Above right:
This view of Leipzig shows the Gewandhaus to the far left with the old university high-rise alongside it, the opera house in the foreground and to the right the tower of the Neues Rathaus, all neatly restored since the reunifica-tion of Germany.

Bottom right:
The most famous guests to patronise Auerbachs Keller beneath the Mädlerpassage in Leipzig were Faust and Mephistopheles. Their crea-tor, Johann Wolfgang von Goethe, also probably dined here, gathering inspiration over a glass or two of wine.

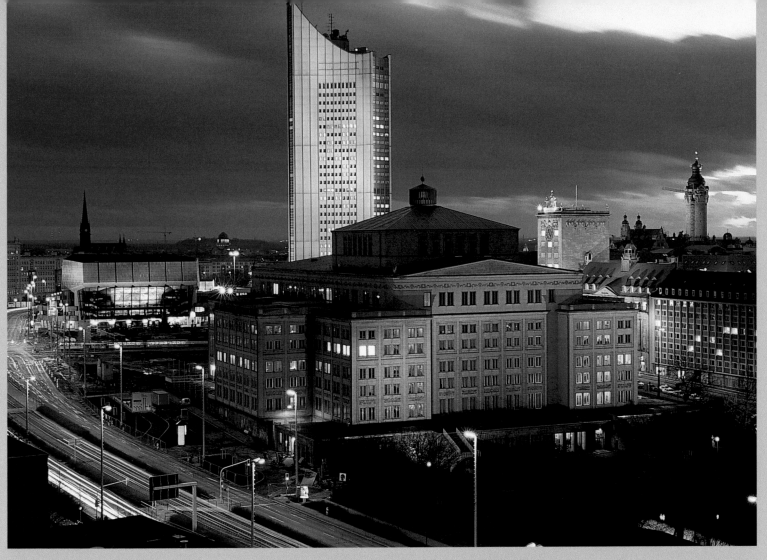

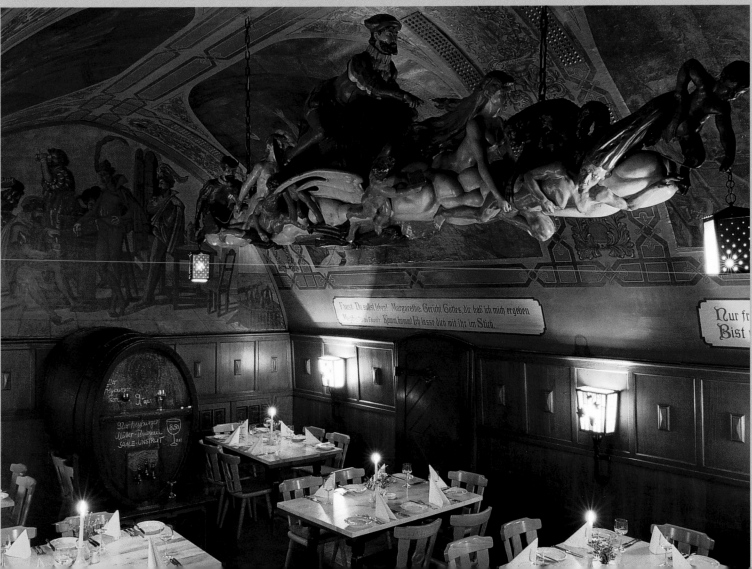

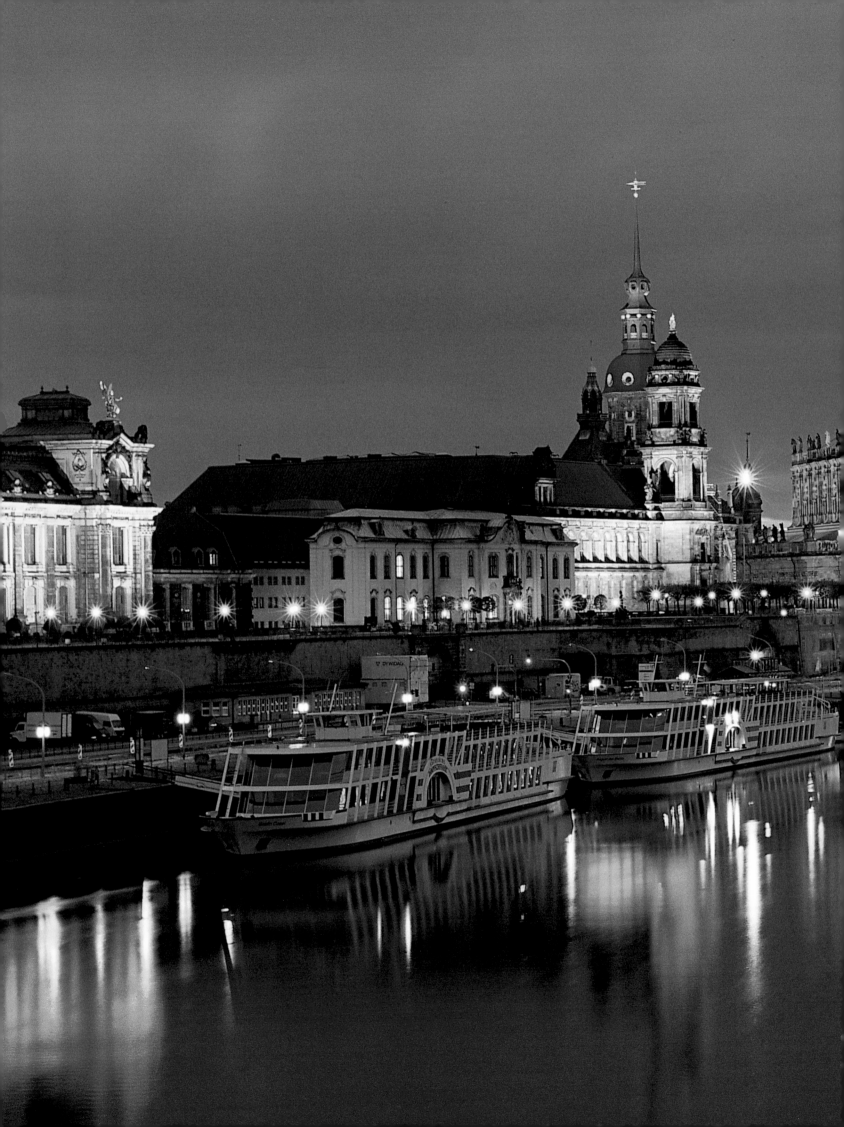

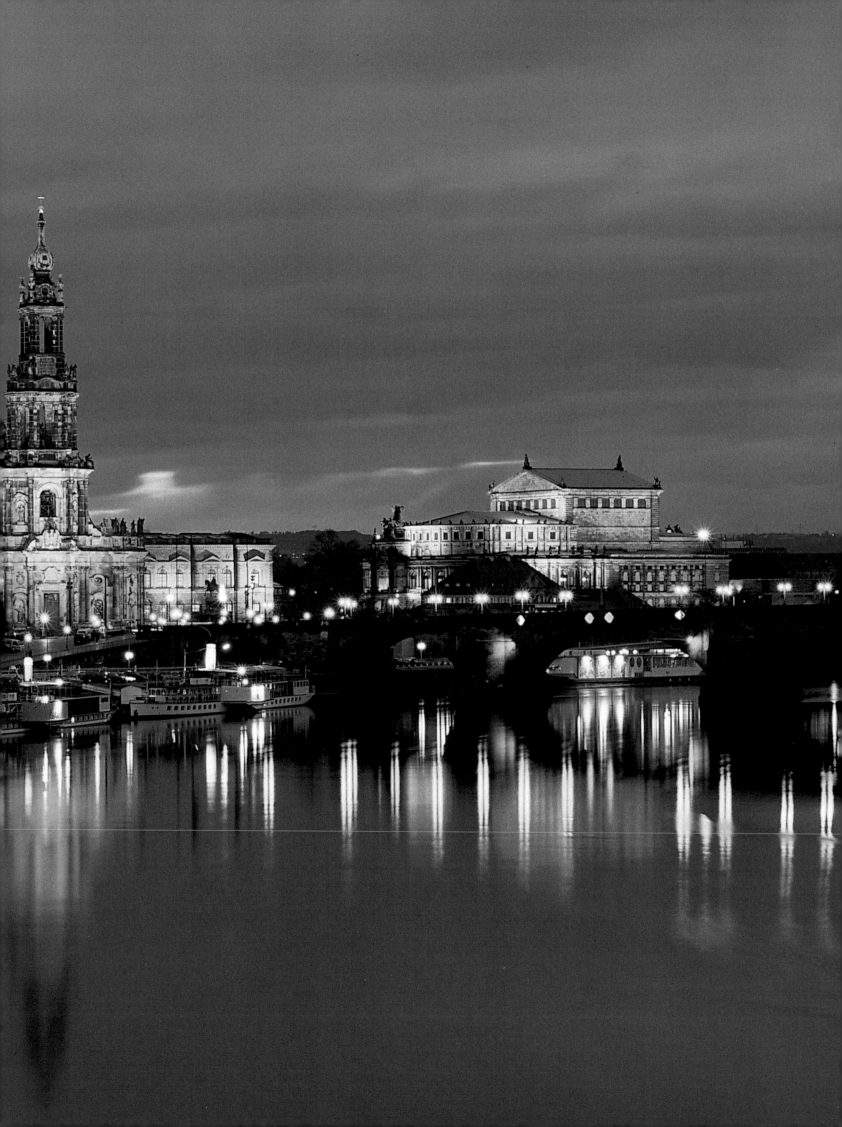

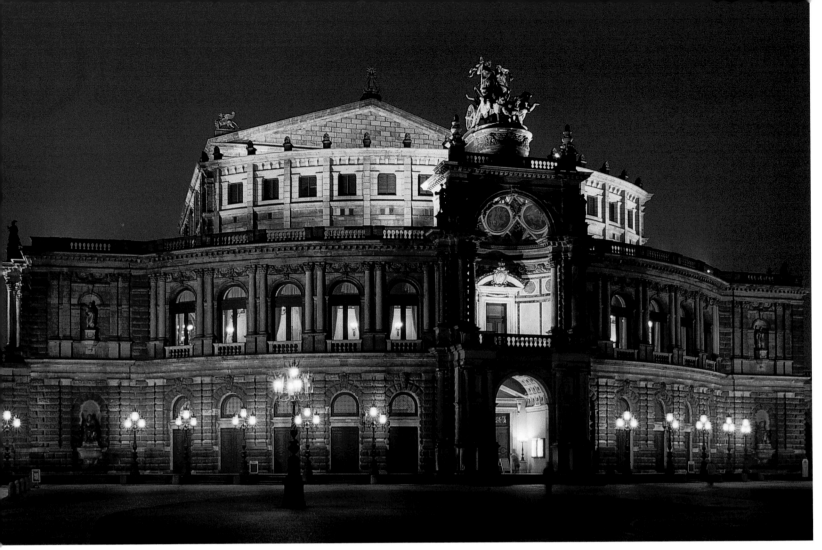

Above:
The Semperoper is named after its creator Gottfried Semper. The opera house, which first opened in 1841, was one of his major achievements. It was rebuilt and completed again in 1878 following a serious fire. After being completely obliterated during the Second World War it was again reconstructed and reopened in 1985.

Right:
None other than 'Augustus the Strong' dressed in his finest clothes invites you to visit the Zwinger, the world-famous baroque edifice in Dresden. The palace of prestige was named after the outer ring (Zwinger) of Dresden's fortifications.

Left:
Augustus the Strong had the Taschenbergpalais in Dresden built by Matthäus Daniel Pöppelmann for his royal mistress Countess Cösel. The restored building is now a chic hotel.

Below:
One wing of the Zwinger, built in the 19th century from plans by Gottfried Semper, houses the Alte Meister art gallery. It is the most lavish collection of European painting from the 15th to the 18th century.

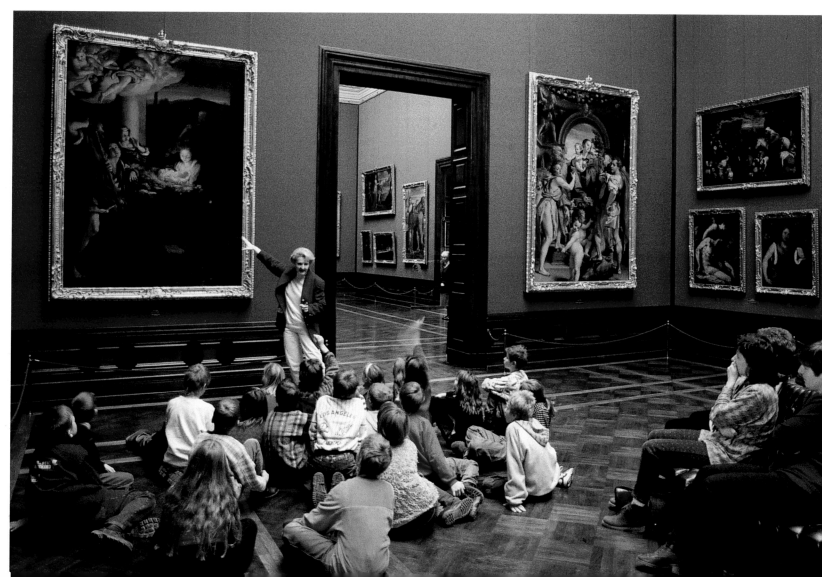

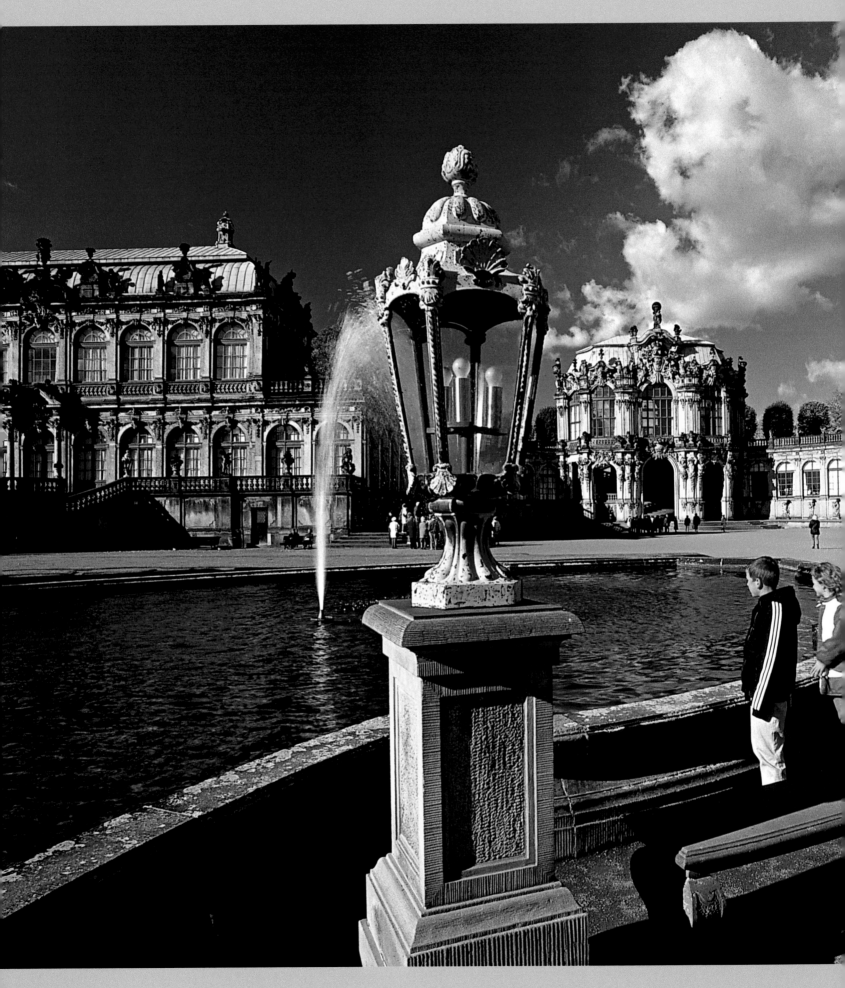

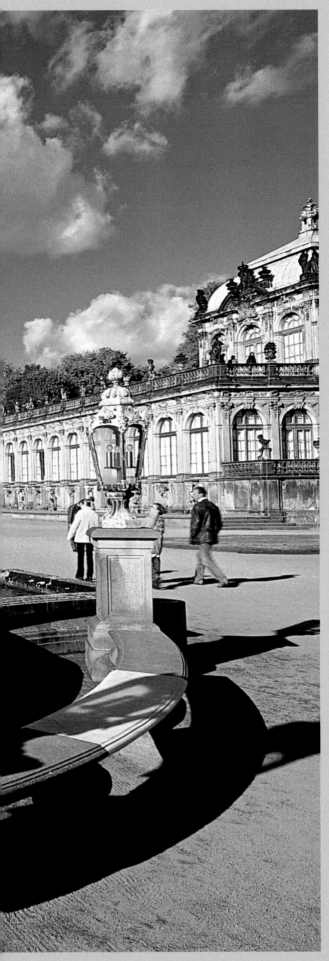

Left:
The Zwinger is the most famous building in Dresden and unique to the world of courtly baroque, created by architect Matthäus Daniel Pöppelmann and sculptor Balthasar Permoser. The complex was never designed for living in but was instead intended to represent the power and might of its owner, Augustus the Strong.

Below:
Moritzburg hunting lodge 18 kilometres (11 miles) from Dresden is also accredited in its present form to Augustus the Strong. He had Pöppelmann rebuild the lodge in baroque between 1723 and 1736.

Bottom:
Not far from Dresden on the River Elbe is Schloss Pillnitz, once the summer abode of the Saxon court. The moated palace was constructed between 1720 and 1723 with Pöppelmann again responsible for many of the plans.

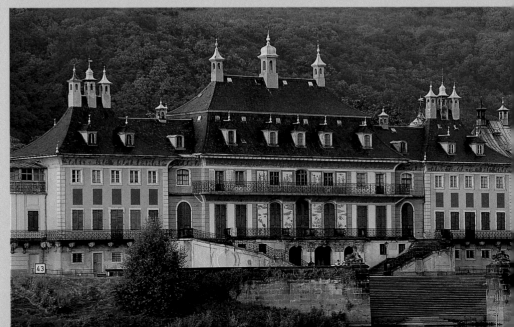

43

Right:
The sandstone elevations of the Elbsandsteingebirge with their bizarre rock formations and dense forest were named "Saxon Switzerland" or Sächsische Schweiz in the 18th century. The Basteibrücke, shown here, spans a yawning crevice over the Elbe and affords fabulous views out across the river and distant hills.

Below:
The Sächsische Schweiz is a great place for climbers; the rocky pinnacles prove almost as challenging to the physically adept as those of the Alps.

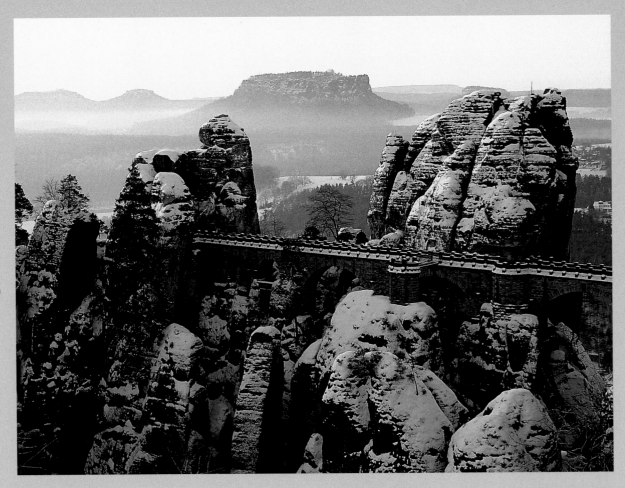

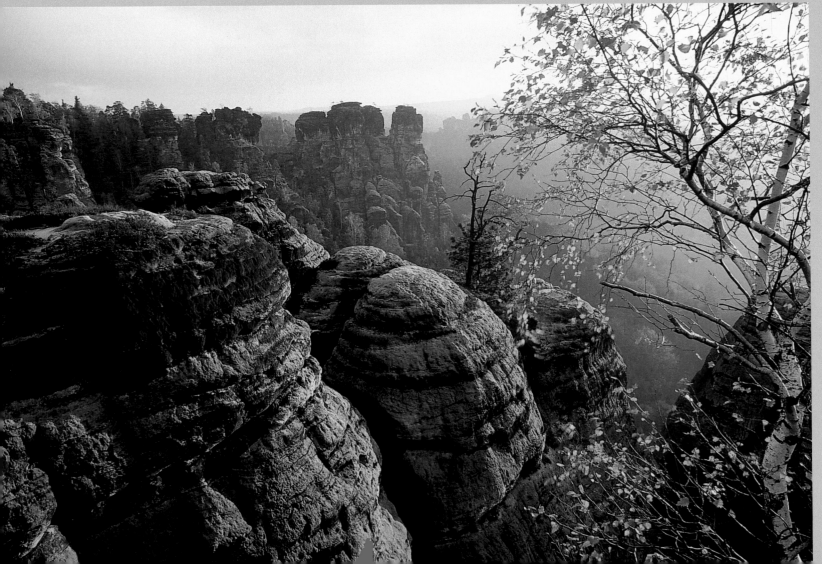

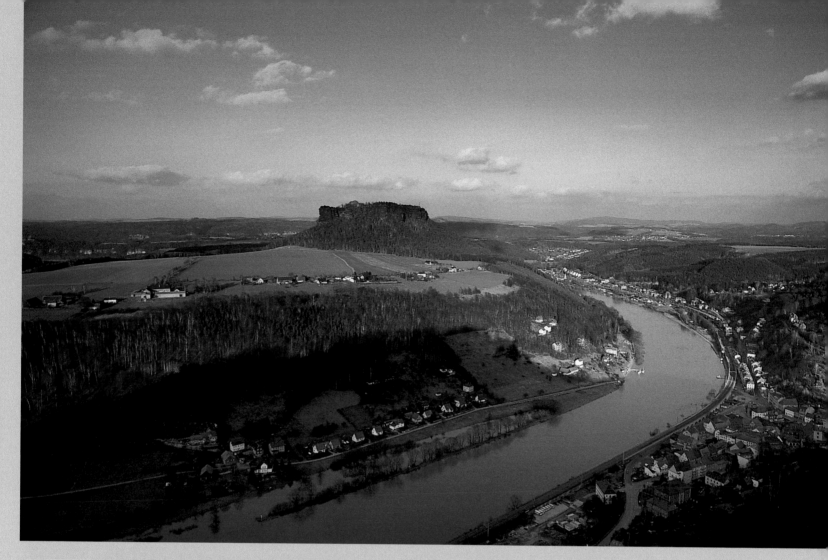

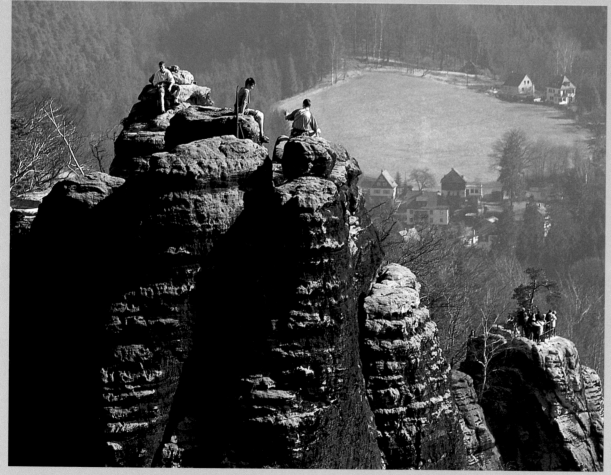

Above:
View of the Elbe and Königstein table mountain, in whose fortress of the same name prisoners were once incarcerated, the most famous being the inventor of porcelain, Johann Friedrich Böttger, who was put to work under the fierce gaze of his captors.

Left:
The best views of Saxon Switzerland are to be had from atop its rocky outcrops, most of which are difficult to climb.

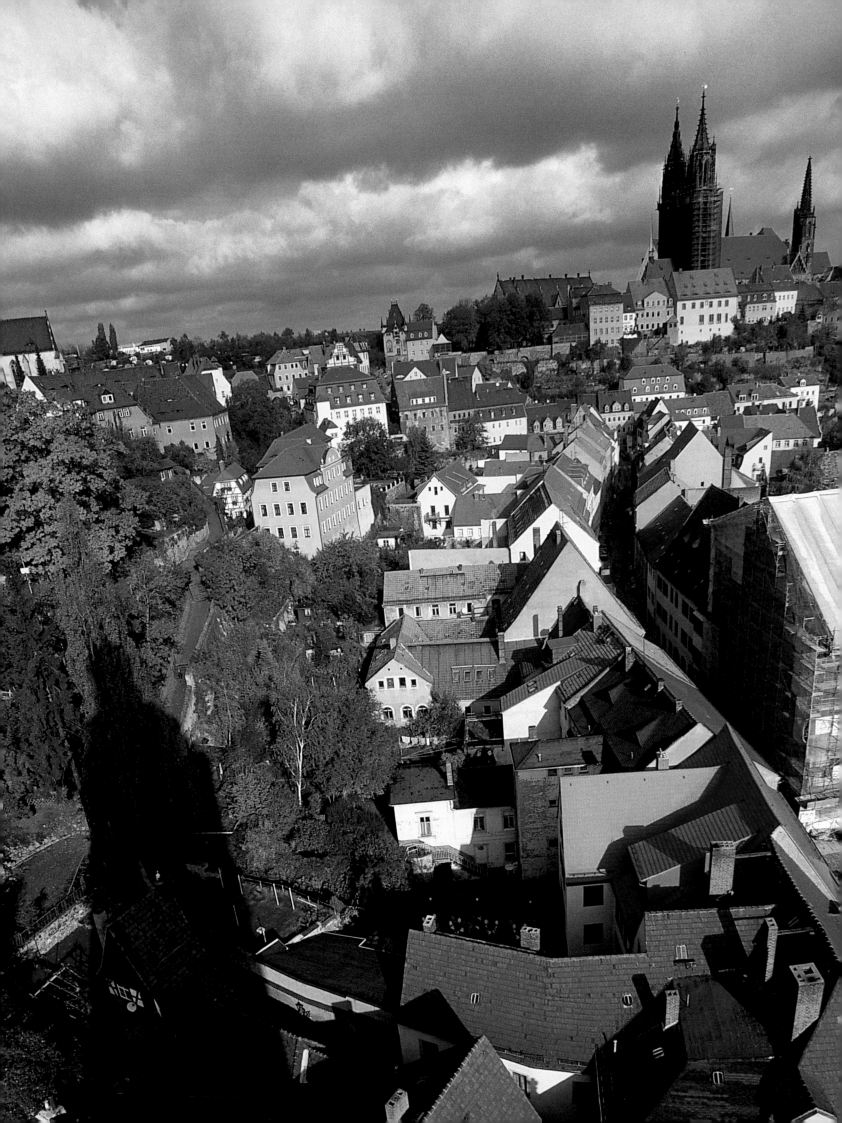

Left:
Meißen is the cradle of Saxony yet is far better known as the place where good porcelain comes from. From the Frauenkirche steeple in the distance you can see the castle mount with the cathedral and Albrechtsburg, one of the most beautiful late Gothic secular buildings in Germany.

Below:
Quedlinburg is dominated by its hilltop castle, former nunnery and convent church. Beneath these huddles the historic old town with its half-timbered buildings, now a UNESCO World Heritage Site.

Below:
The undisputed architectural highlight of Wernigerode is its medieval town hall on the market place. The beams are adorned with an unusual array of carved wooden figures which depict saints, fools and travelling entertainers.

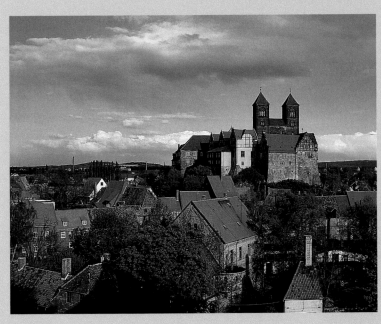

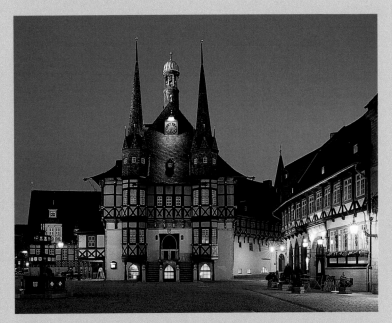

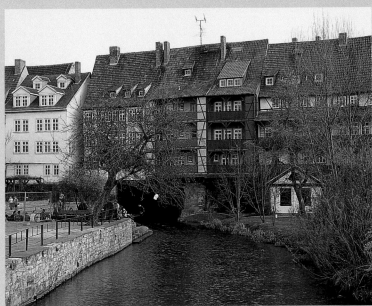

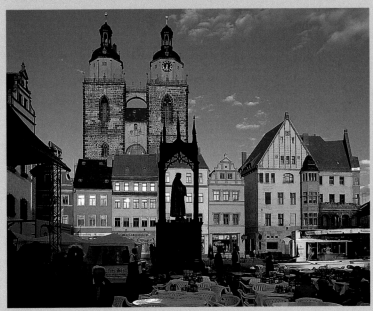

Erfurt is the state capital of Thuringia and boasts not only a famous cathedral but also the longest inhabited bridge in Europe, with 33 houses lining the city's Krämerbrücke.

The parish church of St Mary's in Wittenberg was once the domain of Reformer Martin Luther. A monument was erected in his honour on the market square with its splendid Renaissance houses in 1821.

105

THE GREATS OF CLASSICAL WEIMAR —
GOETHE & SCHILLER

Above:
Goethe lived in this garden cottage on the banks of the River Ilm in Weimar from 1776 to 1782.

Centre:
Goethe's study in his house in Weimar. This is where he wrote "Elected Affinities" and "Poetry and Truth", among other works.

Silhouette of Duke Charles Augustus. His friendship with Goethe helped turn Weimar into a centre of German intellectualism.

In the shortest space of time – almost overnight, in fact – the sleepy town of Weimar spiralled to fame as the centre of the intellectual and literary world. The initiators of this lightening transformation were Duchess Anna Amalia and her son, Duke Charles Augustus; the major players were Johann Wolfgang von Goethe and Friedrich von Schiller. The works of the two authors, ascribed to the Classical Weimar period, are among the most prized treasures of German literature and cover all forms of literary expression. The letters Goethe and Schiller wrote to each other are the liveliest and most eloquent record of life in contemporary Weimar and a touching attestation to a very close friendship.

Goethe and Schiller met in 1794, their companionship coming to an untimely end with the death of Schiller in 1805. This brief period was marked by an intensive exchange of ideas and the exertion of mutual influence on each others' works, such as in Goethe's reworking of "Faust", for example. In the first year of their acquaintance Goethe wrote to Schiller: "Pure pleasure and real benefit can only be reciprocal and I am delighted to depart to you on occasion what your conversation has accorded me, how I consider the days from this point forward to be an epoch, and how I am happy, without any specific encouragement, to have

gone on my way, for it now seems as if we, after such an unexpected meeting, shall continue along it together."

The temple of the muses where the writers of Classical Weimar converged was the residence of Anna Amalia, frequented by greats such as Goethe and Schiller, Johann Gottfried Herder and Christoph Martin Wieland. Friedrich Hölderlin, Wilhelm von Humboldt, Heinrich von Kleist and Jean Paul were also honoured guests of the duchess. This fruitful environment spawned an independent view of the world and the arts which inspired many of the highlights of German literature.

The palace theatre was the podium of Classical Weimar; founded in 1791, it was run by Goethe until 1816. The theatre blossomed into one of the major venues of Germany, its popularity peaking around the turn of the 18th century. Several of Schiller's plays which were premiered here contributed to the theatre's success, among them "Wallenstein" on 12.10.1798, "Maria Stuart" on 14.6.1800 and "William Tell" on 17.3.1804.

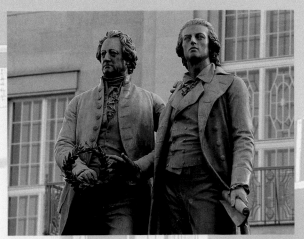

JOHANN WOLFGANG VON GOETHE

28.8.1749: born in Frankfurt am Main.

1765–1771: studies law in Leipzig, Strasbourg and Frankfurt. Comes into contact with Herder and the poetry of the "Sturm und Drang" in Strasbourg.

1774: back in Frankfurt he publishes the novel "The Sorrows of Young Werther" which makes him famous throughout Germany.

1775: moves to Weimar. Through his close connections with Grand Duke Charles Augustus he is soon involved in most major governmental matters.

1786–1788: travels to Italy.

1788: first meets Schiller.

1790: "Urfaust" is published.

1791–1816: director of the theatre in Weimar.

1806: marries Christiane Vulpius with whom he has lived for many years.

1807–1833: his autobiography, entitled "Poetry and Truth", is published.

22.3.1832: dies in Weimar.

FRIEDRICH VON SCHILLER

10.11.1759: born in Marbach on the River Neckar.

1773–1780: studies law and from 1775 onwards medicine at the Karlsschule in Stuttgart.

1782: his play "The Robbers" is premiered at the Royal and National Theatre in Mannheim. The young army doctor is now famous and deserts his military post in Stuttgart.

1789: professor of history in Jena to secure a steady income.

1790: marries Charlotte von Lengenfeld, daughter of a regimental officer.

1791: falls ill with tuberculosis.

1794: makes friends with Goethe with whom he closely collaborates.

1799: moves to Weimar.

9.5.1805: dies in Weimar.

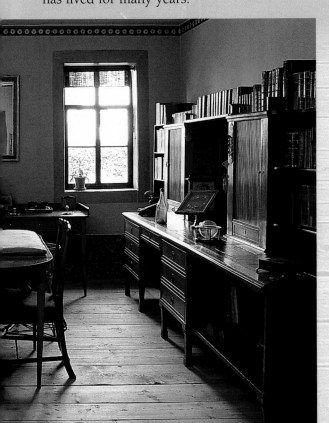

Right page:
Duchess Anna Amalia's magnificent Weimar library was established in 1761 and reads like a history of the city's literary achievements.

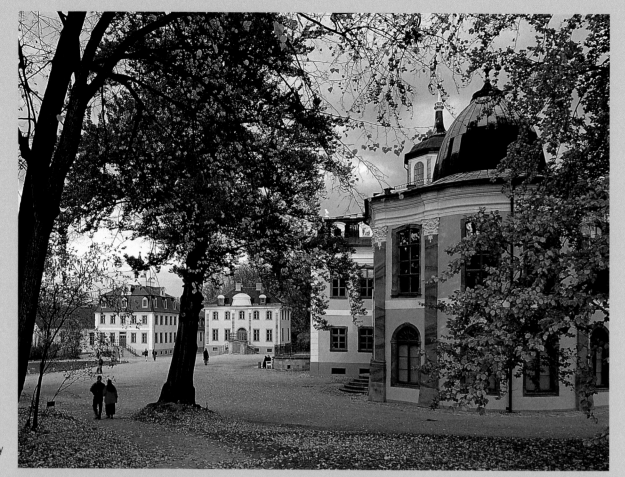

Right:
The palace and extensive park of Schloss Belvedere near Weimar served courtly society as a hunting lodge and summer residence. Today it houses a Rococo museum.

Right:
This building was home to Friedrich Schiller from 1802 until his death in 1805; he wrote his last works here. Now Schillerstraße 12, it's not far from here to Frauenplan, where Goethe's residence stood.

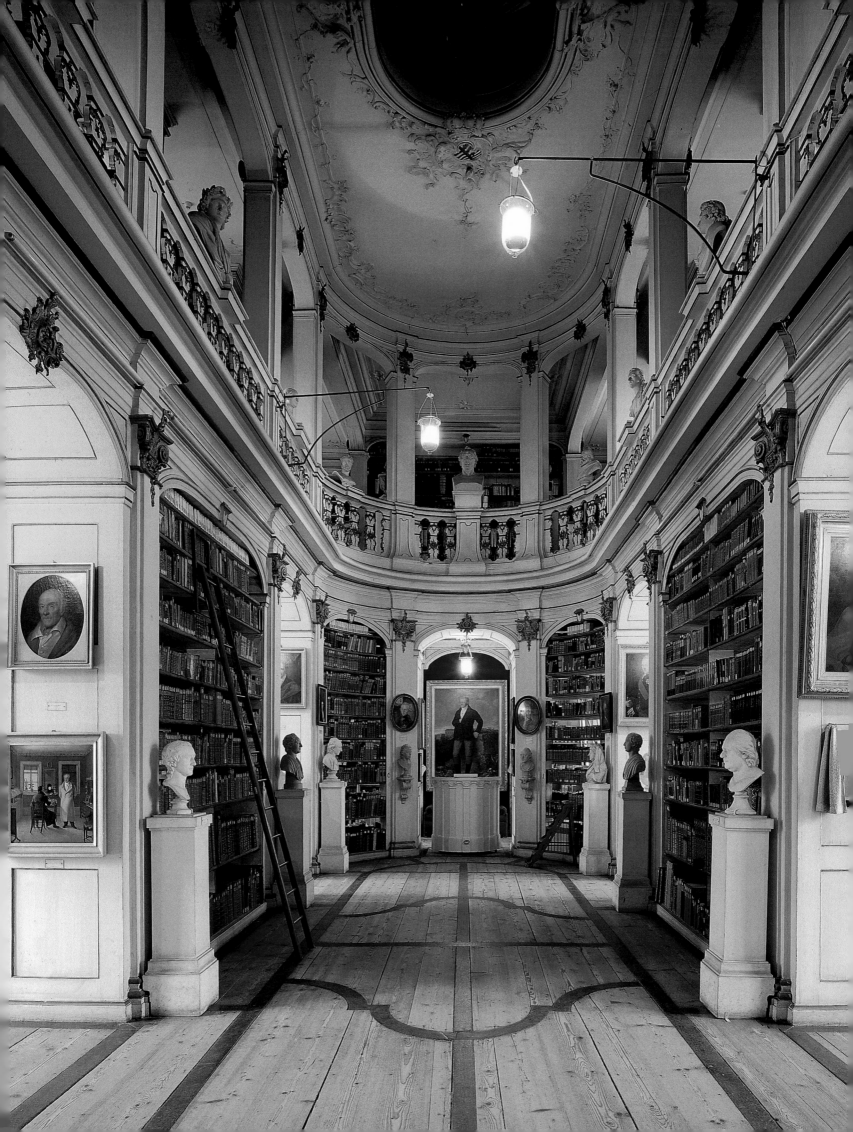

GERMANY'S SOUTH – FROM THE RHINE TO THE ZUGSPITZE

The route to southern Germany is mapped out by the River Rhine and its tributaries. South of Bonn it snakes through spectacular scenery, silently gliding beneath steep vineyards straddled by once mighty castles. Below Burg Gutenfels at Kaub Pfalzgrafenstein Castle clings to a rock in the middle of the water. The old Palatine stronghold once controlled the flow of traffic along the Rhine, levying tolls to replenish the coffers of the castle's lords and masters. The fortresses continue into the windswept hills of the Eifel and the Palatinate Forest. From the Rhine to the Eifel the River Moselle wanders through a fascinating cultural landscape. Wine has been grown here since the time of the Romans, who first set foot

The imperial fortress of Cochem has stood proud above the River Moselle since 1070. It took on its present form during the 19th century when the castle ruins were redesigned in neo-Gothic. During the 14th century the archbishop collected river taxes here, blocking the river off with a chain which was only opened once ships had paid their dues.

in Germany in Trier. The city was founded in 16 BC as Augusta Treverorum and from 293 to 395 AD was the imperial headquarters of the western half of the Roman Empire. The legacy of the Romans in Trier is impressive, with the famous Porta Nigra, the northern gate of the Roman city defences, part of a UNESCO World Heritage Site together with the magnificent cathedral and Liebfrauenkirche.

The most striking witnesses to the past in the Saarland go back to the industrial revolution. The history of the federal state was largely determined by the production of steel. The blast furnaces of old are now sculptures at the industrial

museum in Völklingen and also a UNESCO World Heritage Site. The Saarland not only has a turbulent industrial history behind it; it was also a pawn in the tussle for supremacy between Germany and France. The Treaty of Versailles drawn up at the end of the First World War gave the Saarland to France; it was only returned to Germany following a plebiscite in 1935. Despite its rather chaotic career the region boasts some fascinating countryside, the prime feature of which is the now 'deindustrialised' River Saar.

The river dominating the southern reaches of Hesse is the Main which also passes through the metropolis of Frankfurt, the centre of German

and European finance in the heart of the federal state. Parallel to the sober facts and figures of banking the city still has much of its hearty charm, encapsulated in its many cider taverns in the district of Sachsenhausen, for example. Frankfurt is also a focal point for the arts and publishing, the highlight being the huge international book fair which takes place among the skyscrapers of Mainhatten once a year.

ART AND DOCUMENTA

Every five years the art world migrates to the city of Kassel in northern Hesse for the documenta exhibition, one of the chief protagonists of which was the bold and revolutionary Joseph Beuys. Another form of culture nurtured in Hesse is wine. Along the gentle slopes of the Rheingau area the vines slowly migrate south.

THE LAND OF POETS AND PHILOSOPHERS

The vineyards continue almost uninterrupted on into Baden-Württemberg and open out onto the wide Upper Rhineland plateau, the flatness punctuated only by the marked elevation of the Kaiserstuhl, a remnant of volcanic activity. This is the warmest region in Germany; within spitting distance is Freiburg, which with its famous Gothic minster and the almost Mediterranean atmosphere of its market and old town is reminiscent of its Alpine cousins further south. The climate soon chills, however, on climbing up the Höllental Valley into the Black Forest, whose more temperate regions are dotted with stately farms and lush green meadows, interspersed with dense areas of dark pine forest. Stuttgart, the provincial capital, is emphatically industrious, with major concerns such as Bosch, Porsche and

Upper Bavaria at its most scenic. The spa of Rottach-Egern is popular in both summer and winter, particularly with hikers setting off for the summit of the Wallberg (right). The town lies 700 m (2,297 ft) above sea level on the banks of the picturesque Tegernsee.

Daimler-Chrysler boosting local economy. These are the obvious success stories of a hard-working populace; the less evident include great thinkers Friedrich Hölderlin and Friedrich von Schiller. Schiller's birthplace Marbach does, however, pay homage to its great son with its National Schiller Museum and the German Literary Archives.

Further south, one Bavarian institution to reverberate beyond its regional boundaries is Munich's Oktoberfest, the biggest public festival in the world. Since October 12 1810, when special horse races took place in honour of the marriage of King Ludwig I of Bavaria to Therese of Saxony, the two-week jamboree ending on the first weekend in October has been held at the Theresienwiese meadow, named after the king's bride. Besides the merry-go-rounds and big dippers the main pull are the beer tents which with loud oompah music, frothy litres of beer and hearty local specialities symbolise all that is 'typically' Bavarian. The Bavarian mentality is also moulded by the region's geography. From the jagged peaks of the Zugspitze and Watzmann mountains to the green foothills of the Alps to Franconia with its undulating hills and meandering rivers Bavaria has a scenic diversity barely matched elsewhere in Germany. Nuremberg, once a free city of the Holy Roman Empire and home of the imperial regalia, and Würzburg, formerly a royal residence and seat of the mighty prince-bishops, are just two cornerstones in Bavaria's rich and varied history.

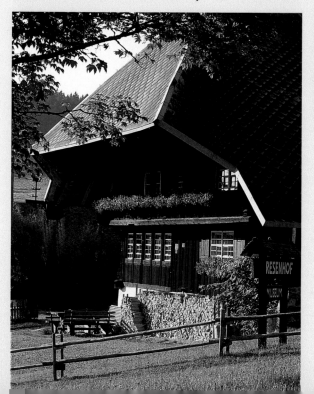

Left:
The Resenhof open-air museum near Bernau in the southern Black Forest has many agricultural buildings documenting the past life of the local farming community.

Top:
One of the best views of Freiburg in the Black Forest is from the Lorettoberg, the townscape dominated by the steeples of the minster and Johanniskirche and the Martinstor gate.

Above:
The Moselle flows into the Rhine at the Deutsches Eck in Koblenz, a marked spit of land crowned by the Emperor William memorial which was finally restored in 1993.

113

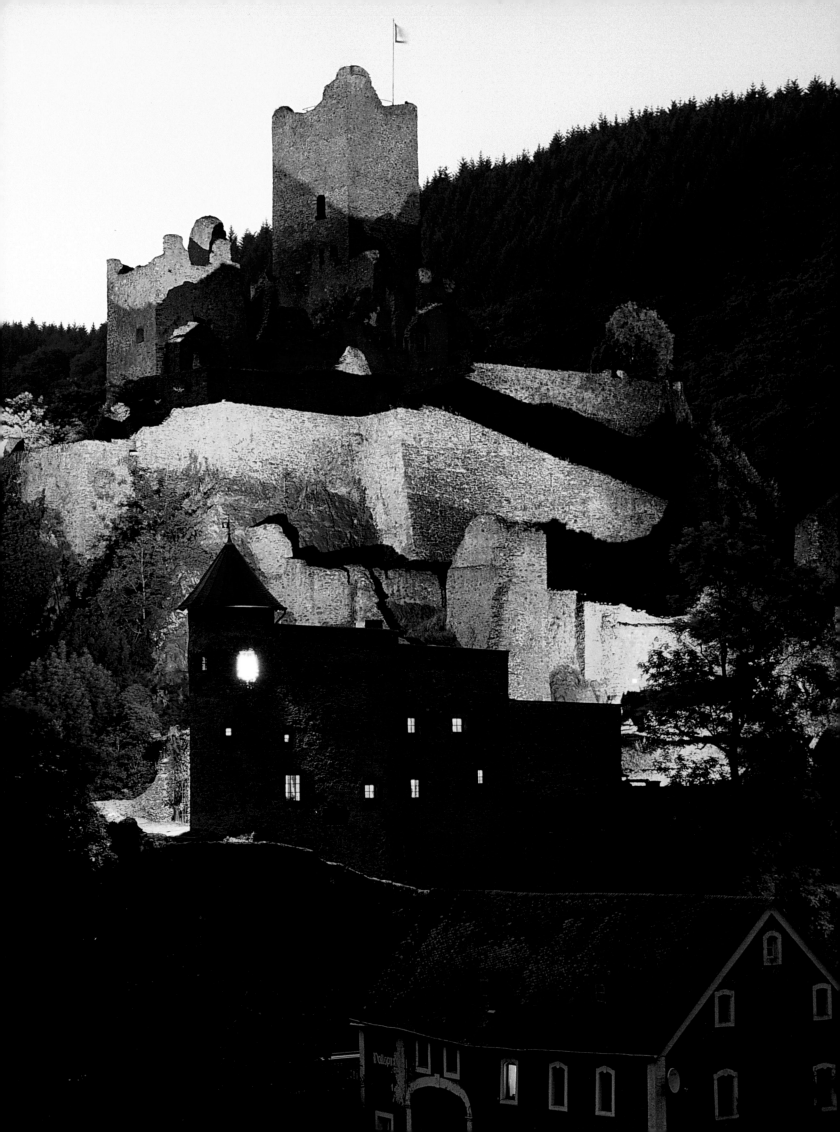

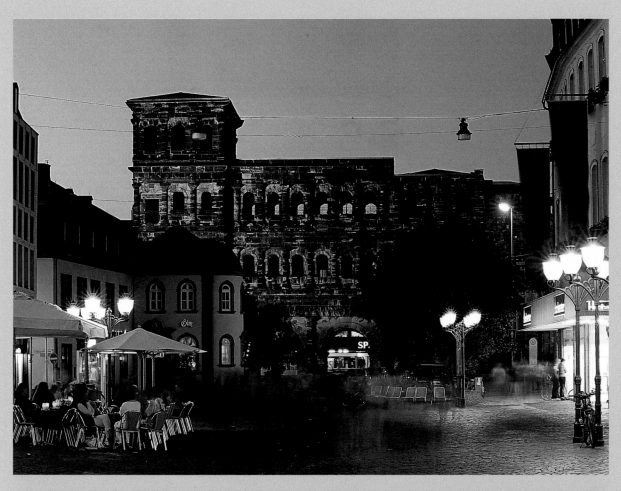

Left page:
The wooded countryside of the Eifel stretches from the mild climes of the Moselle Valley to the snowy peaks of the Eifel Hills. Burg Manderscheid is one of the best-known regional landmarks, its lower and upper fortifications boldly clinging to the jagged hillside.

Left:
Trier was founded by Emperor Augustus in 16 BC and is allegedly the oldest city in Germany. The 2nd-century Porta Nigra was once a Roman town gate.

Left:
Trier Cathedral, east of the market place, was erected in the 11th and 12th centuries on the site of a very early place of worship, making it one of the oldest church foundations in the world. Its interior is decorated with marvellous Gothic ribbed vaulting.

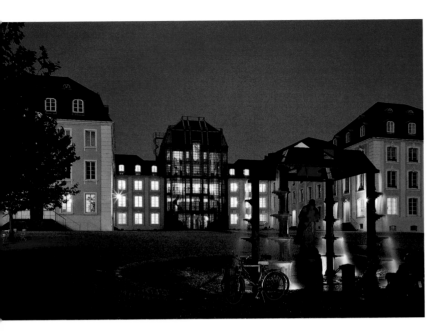

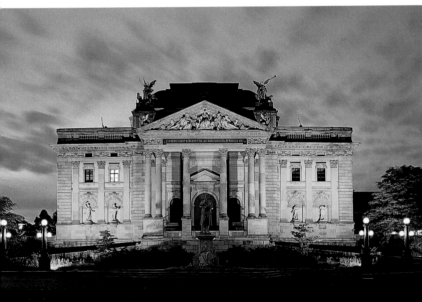

Top left:
The heart of Saarbrücken, the state capital of the Saarland, is Schlossplatz. The palace prevailing over the main square is a successful melange of baroque, neoclassicism and modernism and is now used as a centre of the arts.

Centre left:
Wiesbaden, the state capital of Hesse, sprawls between the Taunus Hills and the Rhine. The proud facade of the city's state theatre stands at the centre of the spa.

Bottom left:
Kaiserslautern rose to fame during the 12th century with the erection of an imperial palace for Emperor Barbarossa, now a ruin. The present city is modern in essence; here its renowned theatre.

Below:
An artists' colony was founded on Mathildenhöhe in Darmstadt in 1899 with Joseph Olbrich's Hochzeitsturm at its core. The small Russian chapel to the right seems strangely incongruous in this Art Nouveau environment.

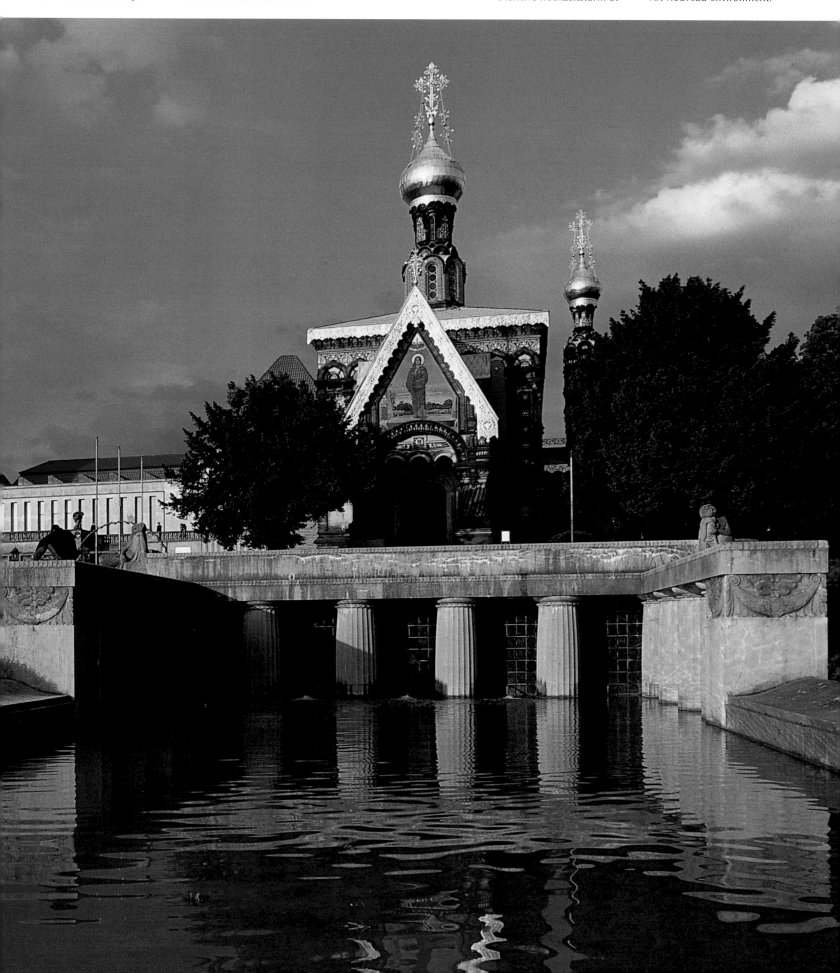

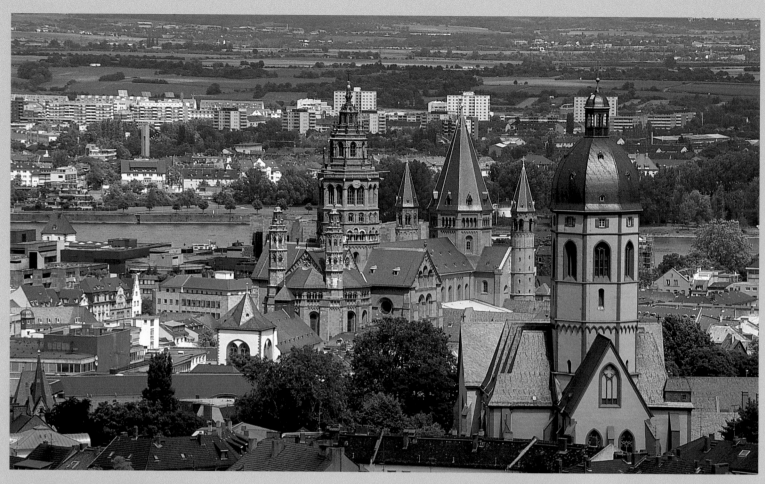

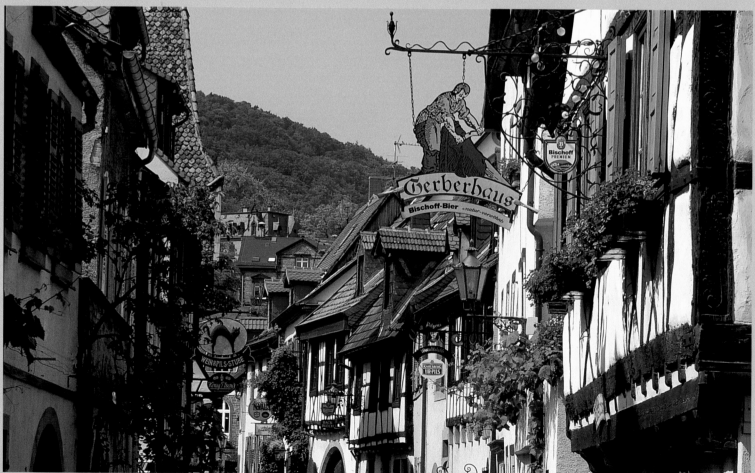

Left:
Mainz is dominated by church steeples; the Stephanskirche looms large in the foreground with the six towers of the cathedral behind it, one of the highlights of German sacral architecture.

Below:
The keep of the castle in Eppstein, which was begun in c. 1000, stands tall above the lovingly restored half-timbered houses of the town.

Below:
Marburg on the River Lahn evolved under the protection of its mighty fortification, now a palatial residence and still very much part of the town. In 1529 the fortress was the venue of the famous Marburg Colloquy of Luther and Zwingli.

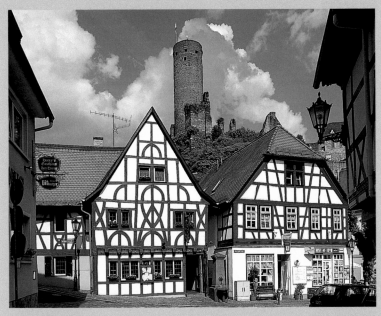

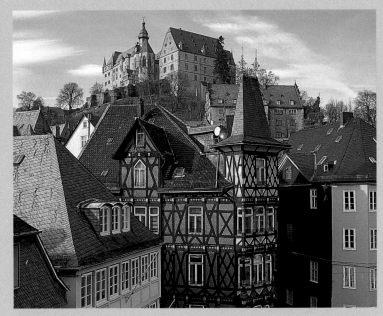

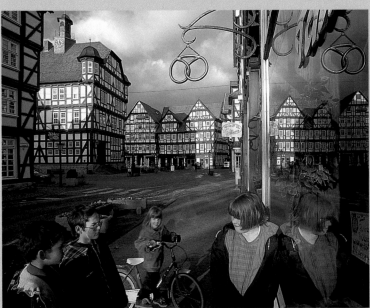

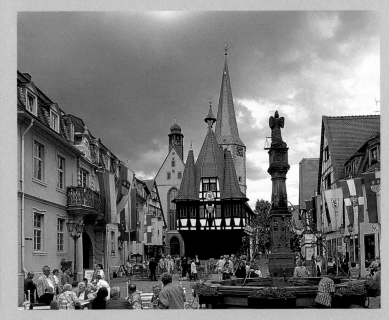

Left:
Neustadt an der Weinstraße, the buzzing centre of the Palatinate with its romantic streets and wine taverns, is surrounded by fertile vineyards.

Above:
Melsungen, a town of half-timbered buildings in the Hessian hills not far from Kassel, was established in the 12th century and is well worth a visit.

Above:
Michelstadt is one of the most picturesque destinations in the Odenwald. The wonderful late Gothic, half-timbered town hall was built on its market square in 1484, the market fountain being added in the 16th century.

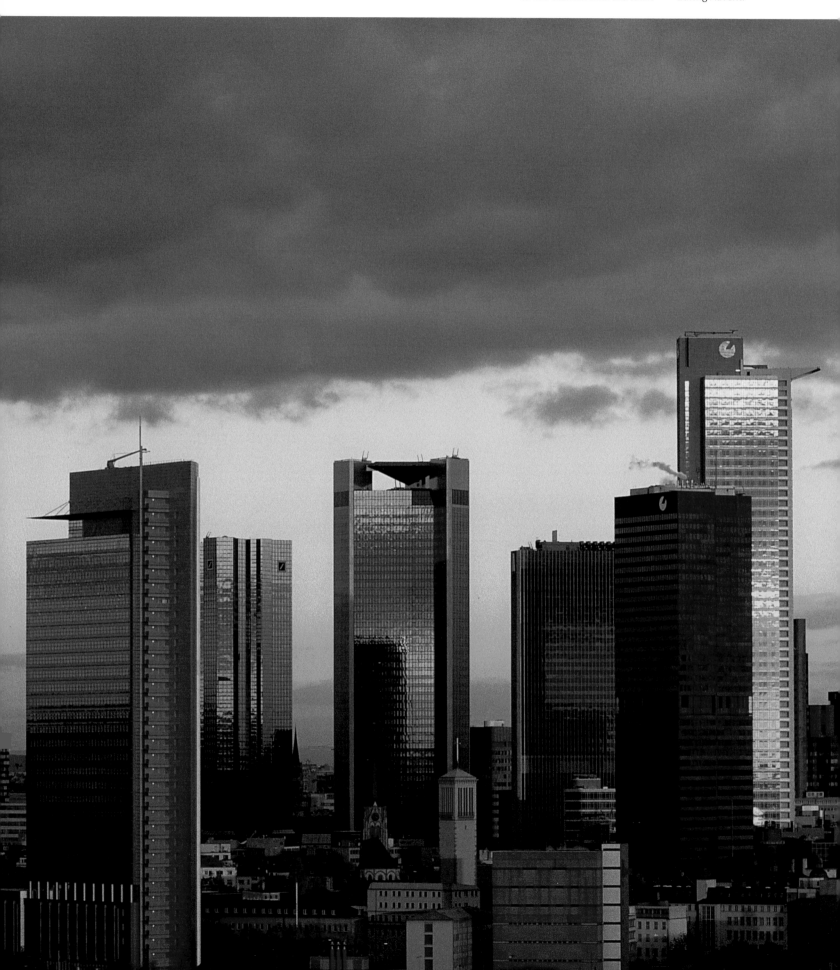

Below:
The Frankfurt skyline is unique in Germany, clearly emphasising the city's role as a centre of trade and finance.

Frankfurt was granted the privilege to hold fairs and exhibitions as far back as in 1240.

Top right:
Römerberg is the historic heart of Frankfurt, with the old Nikolaikirche, the houses of the Ostzeile and the town hall lining the edges of the cobbled Römer. The annual Christmas market is held here during Advent.

Centre right:
Frankfurt clings to the tree-lined banks of its main traffic artery, the River Main, where locals come to relax. To the left is the cathedral.

Bottom right:
The Alte Oper juxtaposed against the modern sky-scrapers of Frankfurt belongs to another age. The late 19th-century opera house is now used as a concert hall and congress centre.

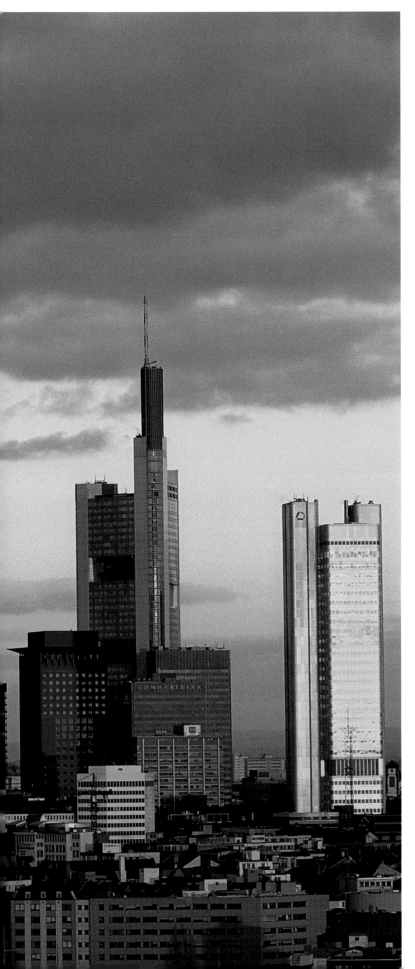

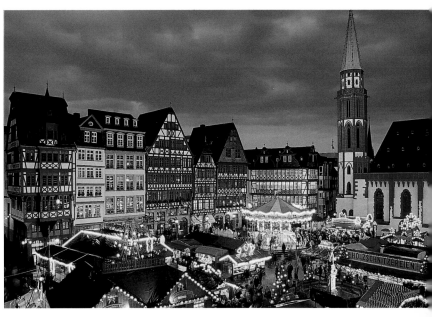

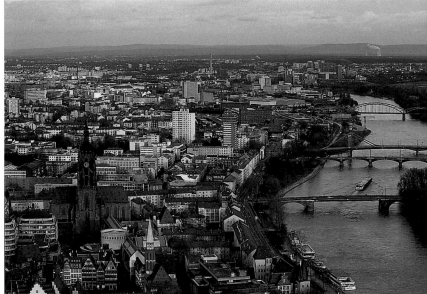

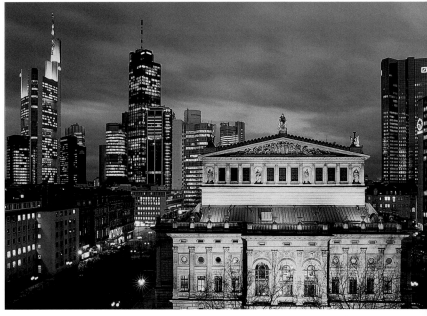

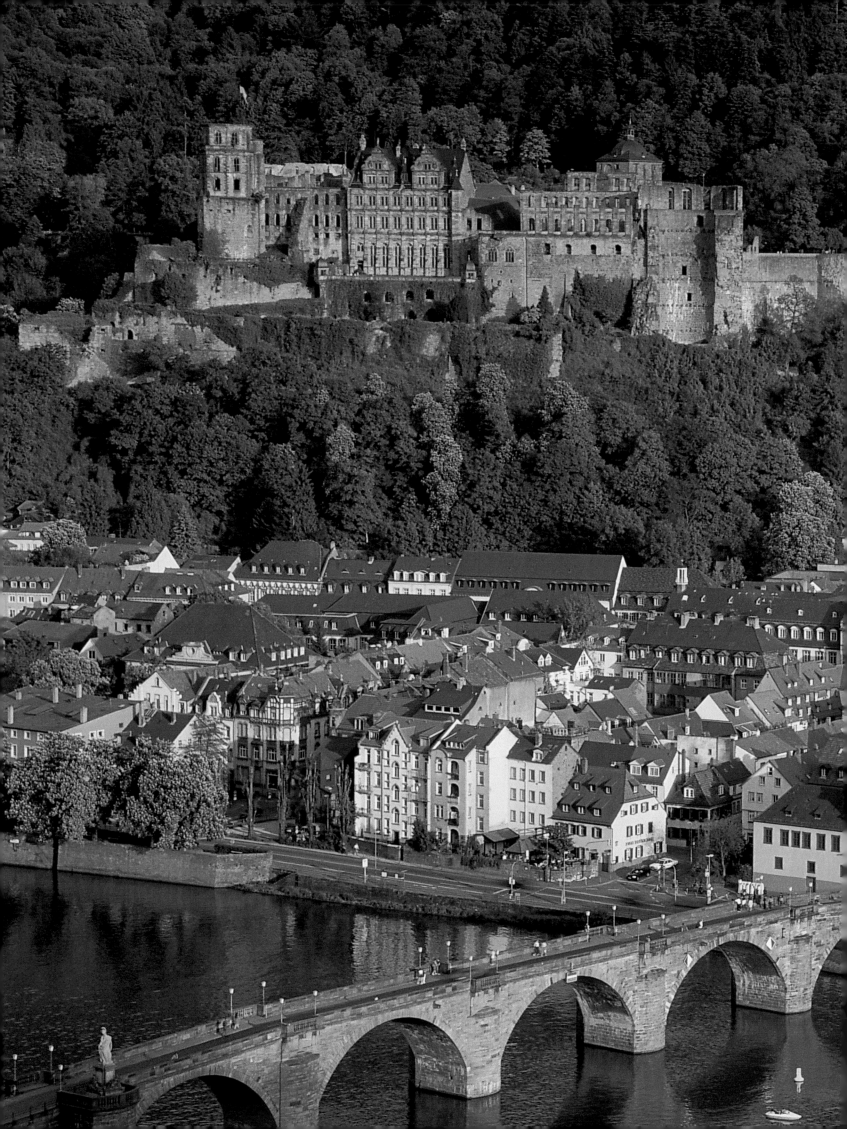

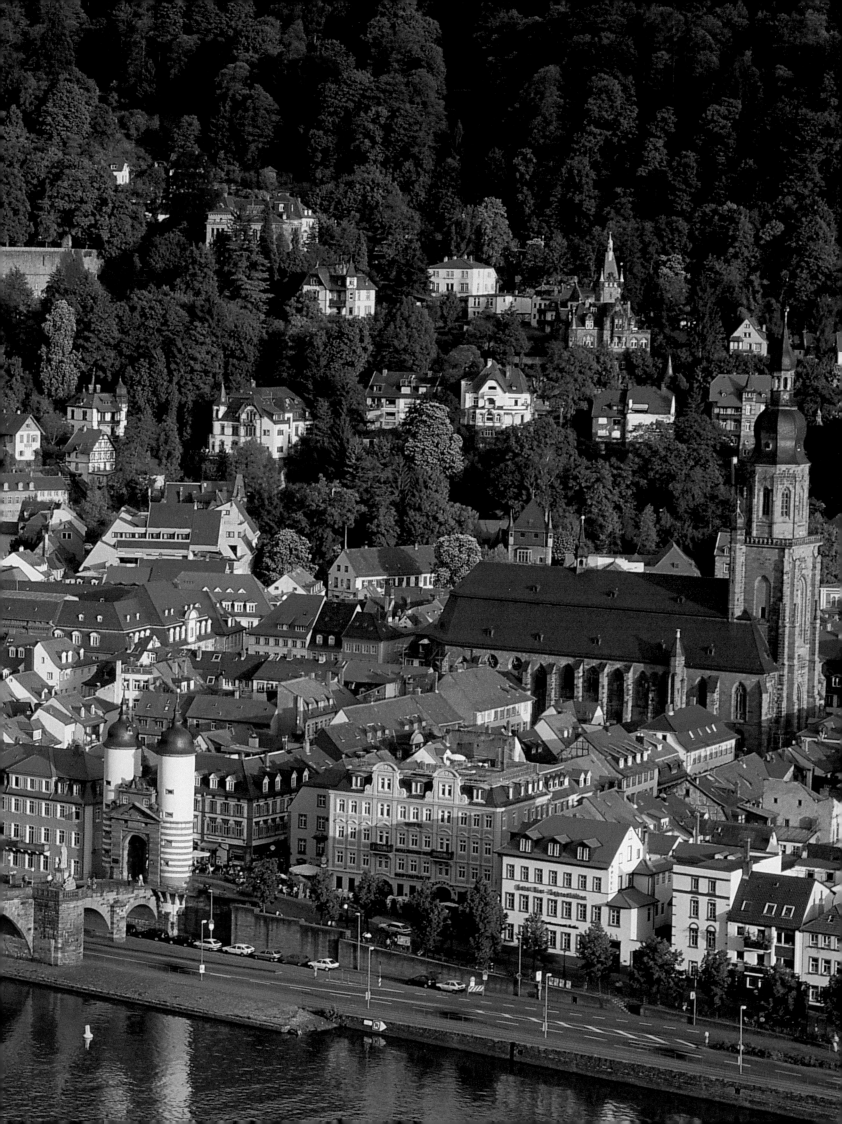

Page 122/123:
Heidelberg is at its most scenic viewed from Philosophenweg. Its setting on the River Neckar, with its enormous castle towering above the ancient houses and churches of the old town, is without equal.

Right:
Stuttgart's Neue Staatsgalerie, built by James Frazer Stirling from Scotland, is one of the showpieces of postmodernist architecture. It houses one of Germany's most significant collections of 20th-century art.

Below:
The epicentre of Stuttgart is Schlossplatz, the illuminated spectacle of the Neues Schloss and Jubiläumssäule best enjoyed over a glass of local wine.

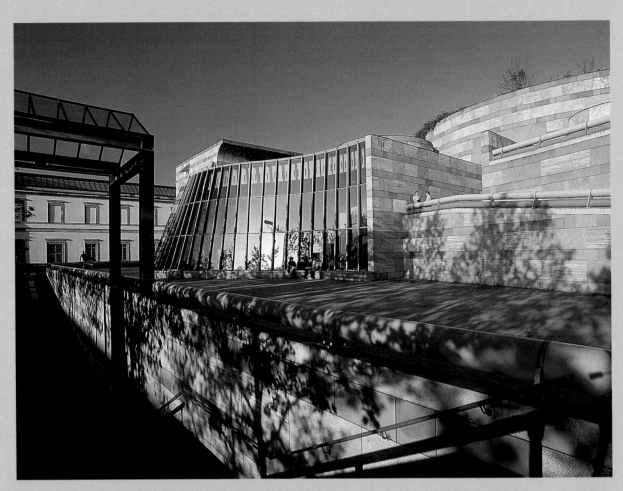

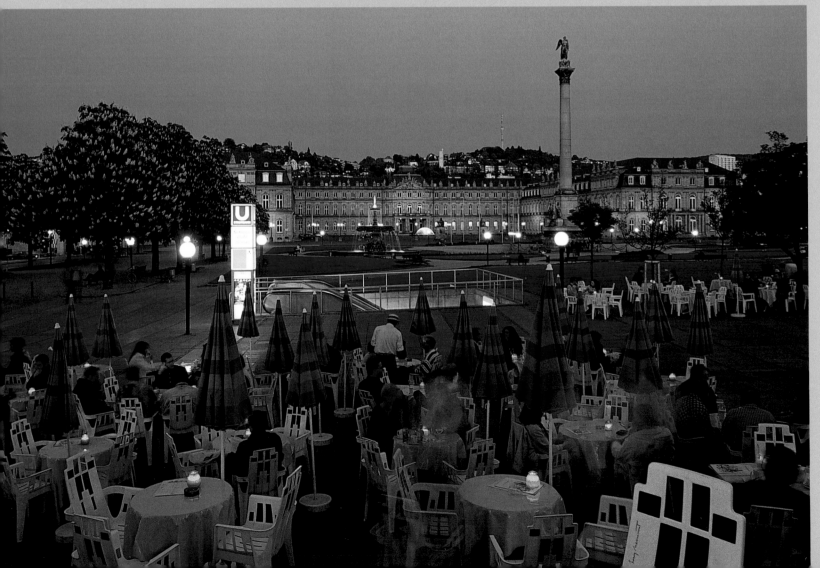

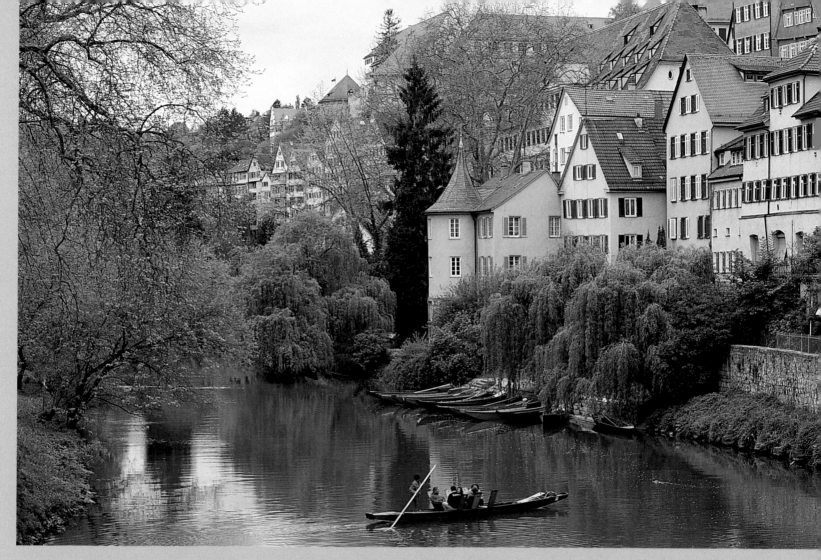

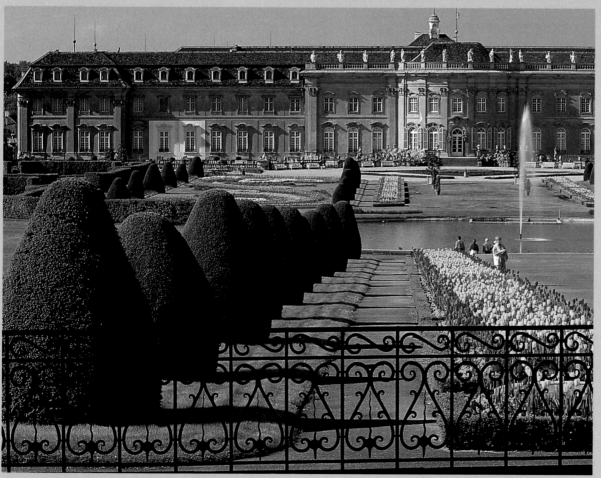

THE GIFT OF THE ROMANS —
WINE

Wine is cultivated across the globe in a narrow band of the northern hemisphere between the 40th and 50th degree of latitude. Germany's vineyards are situated at the northern end of the spectrum, with some even nudging beyond it. Year in, year out vintners hope and pray that the weather will be kind to them, with no late frosts in May, plenty of sun and a warm spell shortly before the harvest. The fact that German wines are grown so far north does have its advantages, however, often resulting in very interesting wines, such as the light, typically German Riesling with its fine acidic note.

The Romans, who introduced wine to Germany from Gaul, planting the first vineyards outside Trier on the River Moselle, also battled with the inclement conditions of the 'north'. In the first centuries AD viniculture spread to the River Rhine. The vine soon took root throughout the country, even becoming established in regions which were not particularly fertile. The wines these yielded were often extremely acidic. During the 19th century the vine louse more or less decimated Germany's entire stock; when the vineyards were eventually replanted only suitable areas were cultivated, many of them in or near river valleys. The number of vineyards was thus drastically reduced.

Today there are 13 areas of wine cultivation in Germany. The Rhine is particularly mild and is

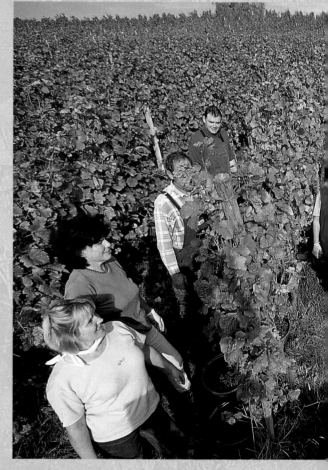

split into the following regions, from south to north:

Baden: widespread and diverse with wines of varying quality, the most well-known being Kaiserstuhl-Tuniberg and Ortenau. The Markgräflerland produces some very nice Gutedel (Chasselas) vintages.

Hessische Bergstraße: at 370 hectares (914 acres) this is one of the smallest wine-growing areas which mainly yields white wine, half of which is Riesling.

Rheinpfalz: the second-largest area of cultiva-

Top:
Even in the early days of viniculture farmers realised how important it was to weed their crops.

Above:
The high point of work in the vineyards is tasting the wine.

126

tion and one which with its young generation of keen vintners is proving very promising.

Rheinhessen: Germany's biggest wine region has recently started to loom large on the nation's list of wines.

Rheingau: this area is of national and international importance, providing ideal conditions for Riesling which constitutes 80 % of the local yield.

Mittelrhein: the Middle Rhine, spreading from the mouth of the River Nahe to the environs of Bonn, is famous for its Rieslings.

Left:
Many of the wine villages in Baden have retained their rustic character. Here, Ebringen in the Markgräflerland basks in the evening sunlight with Kaiserstuhl Mountain in the background.

Left:
Every region where wine is cultivated has its own taverns serving local vintages and delicious culinary specialities; here on Münsterplatz in Freiburg.

Below:
Before wine presses were commonplace grapes were pressed with the feet, as this illustration vividly demonstrates.

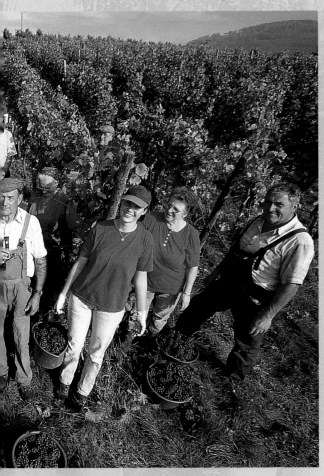

There are a further five wine-growing areas situated along tributaries of the Rhine:

Württemberg: concentrated along the River Neckar, the excellent red wines produced here are little known outside the region.

Franken: the slopes along the River Main are primarily planted with white grapes used to make dry wines with a fruity aroma.

Nahe: a region which has begun to produce top-quality wines in the past few years.

Mosel-Saar-Ruwer: this area has wines of high

quality which bear comparison with those of the Rheingau.

Ahr: red wine is the speciality of this tiny region.

There are also two regions in the east of Germany:

Saale-Unstrut and **Elbe:** after a long fallow period these areas are now developing nicely, thanks to the enthusiasm of a number of dedicated wine-growers.

Where German wines have held little significance for the international market in the past, they are now recognised contenders. This is primarily due to the hard work of a number of vintners who have helped to nurture a new awareness for quality wines. Cultivation and production methods have developed to such an advantage since the 1980s that connoisseurs are guaranteed to find a wine they love wherever they live in Germany.

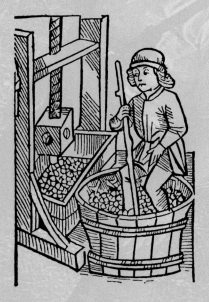

Centre:
During the grape harvest it's a case of all hands on deck! Here, the entire Faller family is out in their Schönberg vineyard near Freiburg.

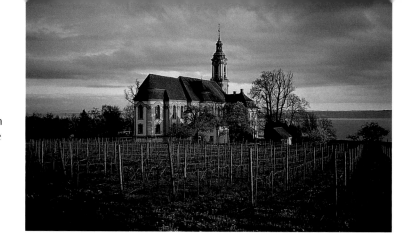

Below:
From the old fortress at Meersburg there are spectacular views of Lake Constance, with the Swiss Alps visible on a clear day. Poet Annette von Droste-Hülshoff lived and worked at the castle over 150 years ago.

Right:
Another famous edifice high up above the shores of Lake Constance is the pilgrimage church at Birnau, dedicated to St Mary. The interior boasts a colourful effusion of elaborate Rococo unique to the area.

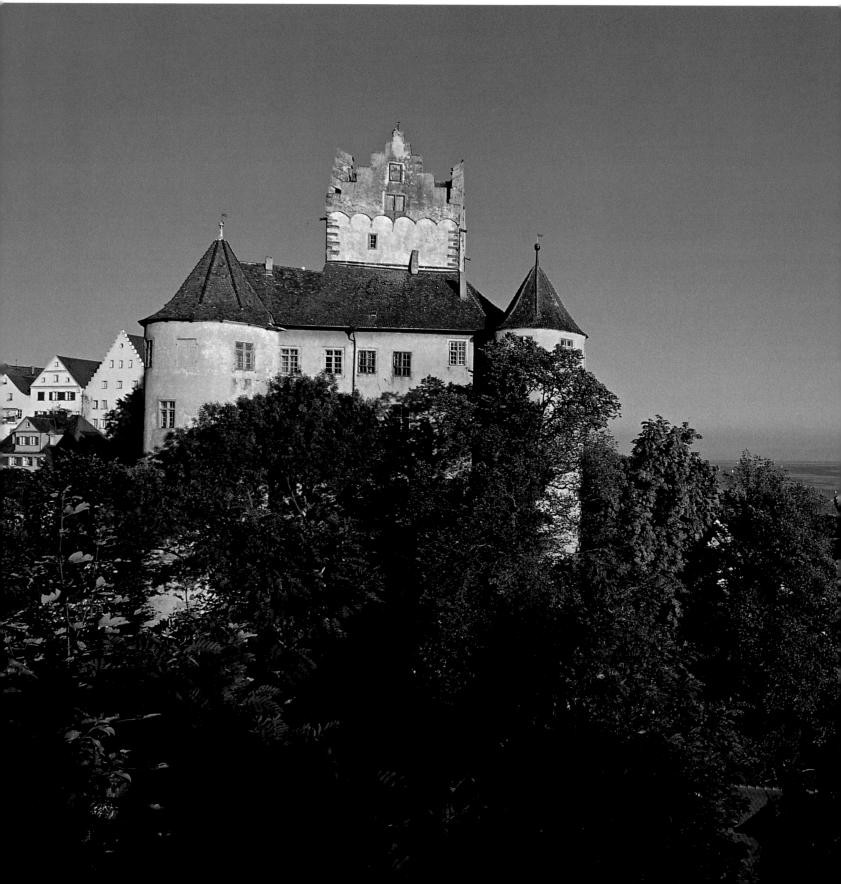

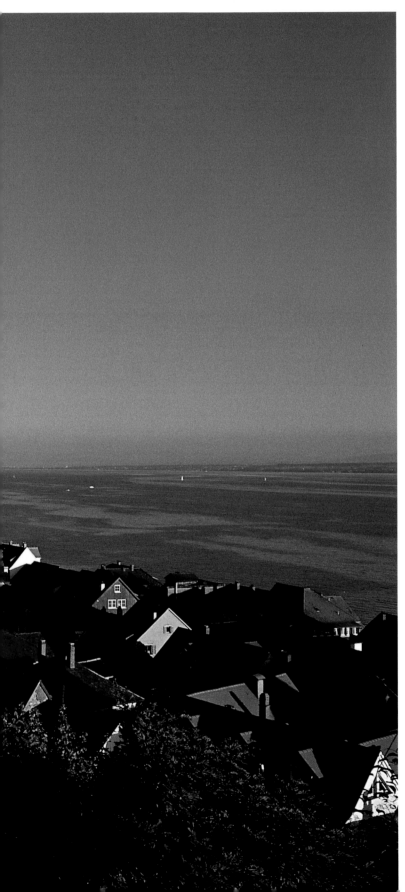

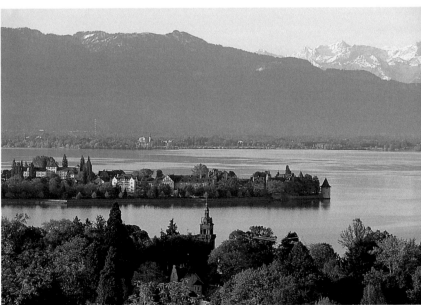

Left:
One of the highlights of the church year on Lake Constance are the processions at Corpus Christi. Participants don their local dress and set out across the lake in boats decorated with floral wreathes.

Below:
The city of Constance dates back to the Romans, the most important event in its history being the Council of Constance held between 1414 and 1418. The best views of town and lake are to be had from the tower of the minster.

Above:
Lindau was originally a tiny fishing island in Lake Constance which boomed through trade and shipping during the 13th century. It is now best known for its flowers; the mild climate allows an inimitable array of blooms to thrive in its parks and gardens.

129

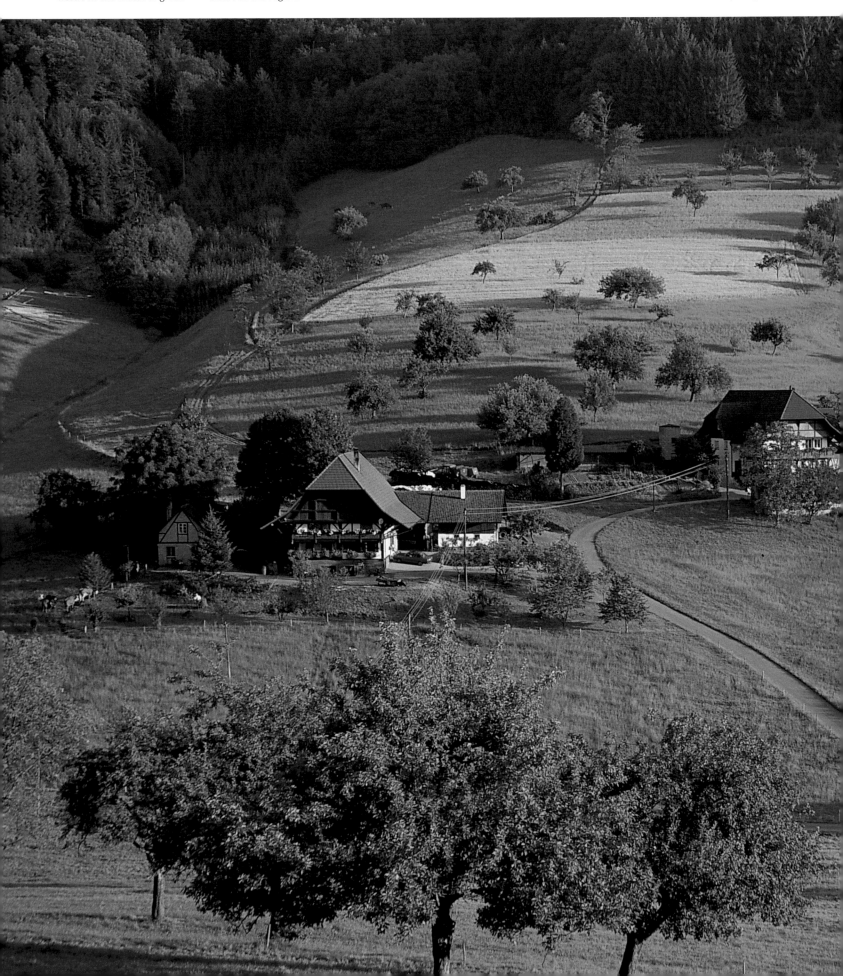

Below:
The countryside of the Black Forest effects a harmonious balance of nature and rural industry. Spacious farmhouses nestle in the midst of green pastures and lush orchards or cling to the pine-clad slopes of the mountains – here at Emersbach, Biberach, in the heart of the region.

Top right:
Feast days in Gutach are celebrated in traditional dress, with women sporting their Black Forest pom-pom hats.

Centre right:
Ancient handicrafts are demonstrated at the Resen-hof open-air museum in Bernau, practised by the farming community when work outside was curtailed for the winter.

Bottom right:
No festival in the Black Forest would be complete without the dulcet tones of the local "Blaskapelle". Here the wind band in Bernau in full swing.

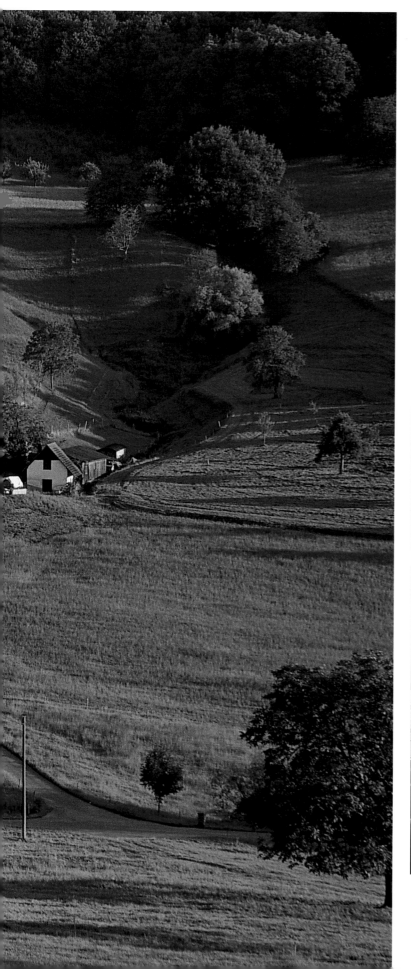

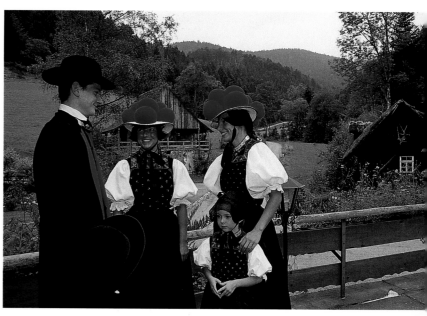

131

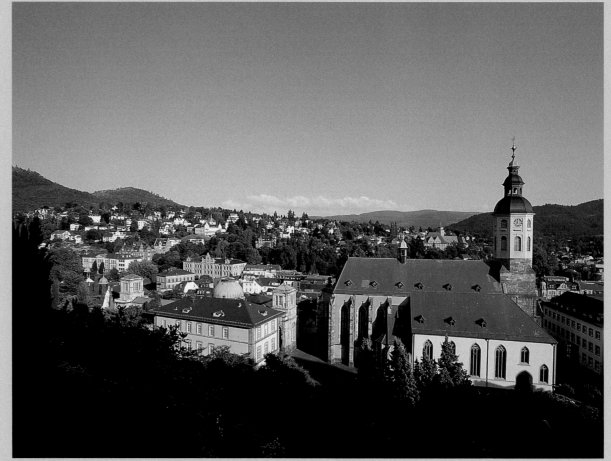

Baden-Baden is not particularly famous for its location on the edge of the Black Forest but for its casino, popular beyond the national boundaries, its hot springs and the international horse races held just outside the city. This view from the Altes Schloss takes in both the elegant spa and the surrounding hills.

It's not far from St Märgen in the southern Black Forest to the pastoral scenery of the Ohmkapelle, one of the most charming holiday destinations in the area. The green plateau 900 m (2,953 ft) above sea level stretching from Freiburg to Furtwangen is an eldorado for hikers, with fantastic views out in all directions.

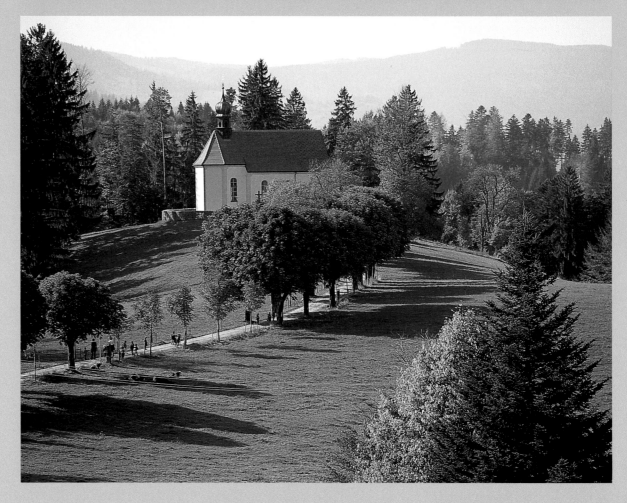

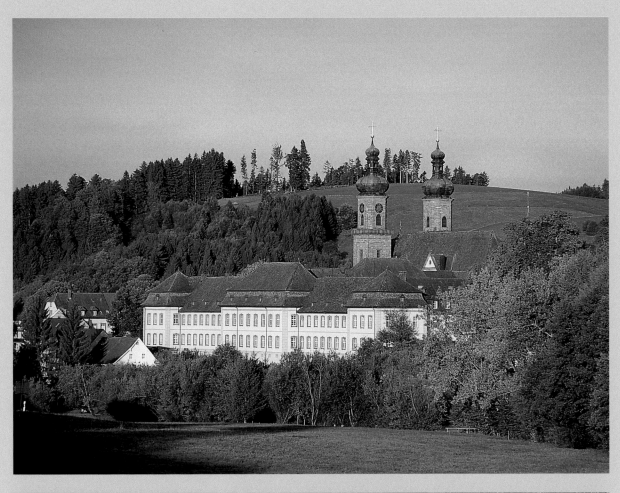

St Peter's, originally an 11th-century Benedictine monastery, lies at the foot of the Kandel in the upper Black Forest. The complex with its baroque church is now the seminary for the archbishopric of Freiburg; it was once closely affiliated with the Zähringer dynasty, serving as their chief monastic outlet and final place of rest.

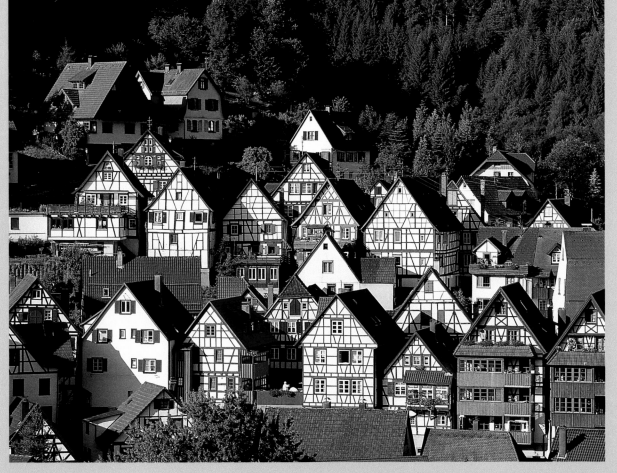

Schiltach in the Kinzig Valley used to be home to a thriving community of raftsmen and tanners who used the waters of the Kinzig and Schiltach to transport wood and treat leather. By 1896 the advent of the railway had put paid to the need for transportation by river; the last tannery in the Black Forest is still in operation, however, and can be visited.

133

Below and bottom:
The traditions of Alemannic Carnival go back a long way, manifested in the wooden masks and rag costumes worn at this time of year. Devils, demons and other dervishes parade loudly through the streets, driving out the spirits of winter and calling on the rites of spring. In the Carnival stronghold of Elzach the eerie figures also convene at night, the ghostly goings-on orchestrated by candlelight.

Right:
At 1,414 m (4,639 ft) the Belchen is the third-highest mountain in the Black Forest and one of the most scenic viewing points in the country. From the summit you can see as far as the Alps of Switzerland. The mountain was of great importance to the Celts who set up a place of worship here.

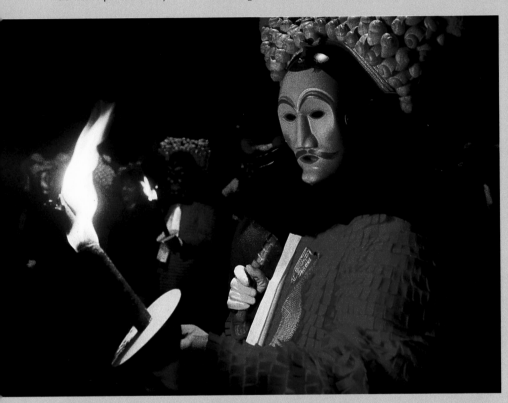

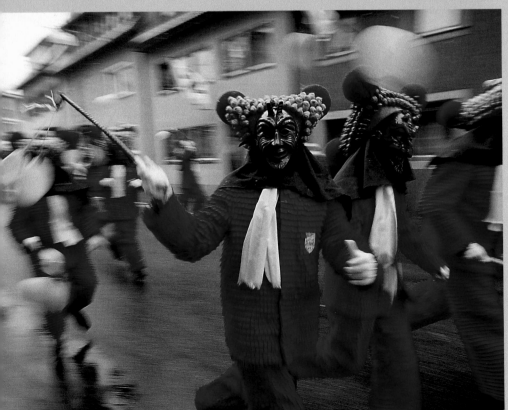

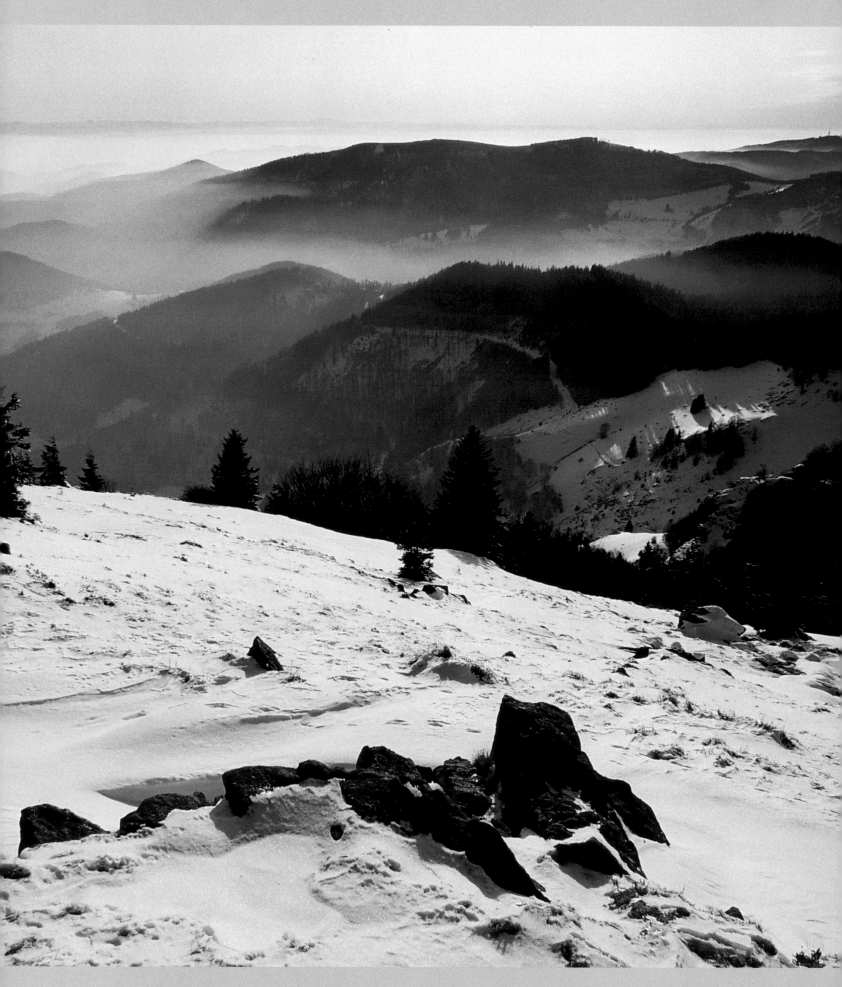

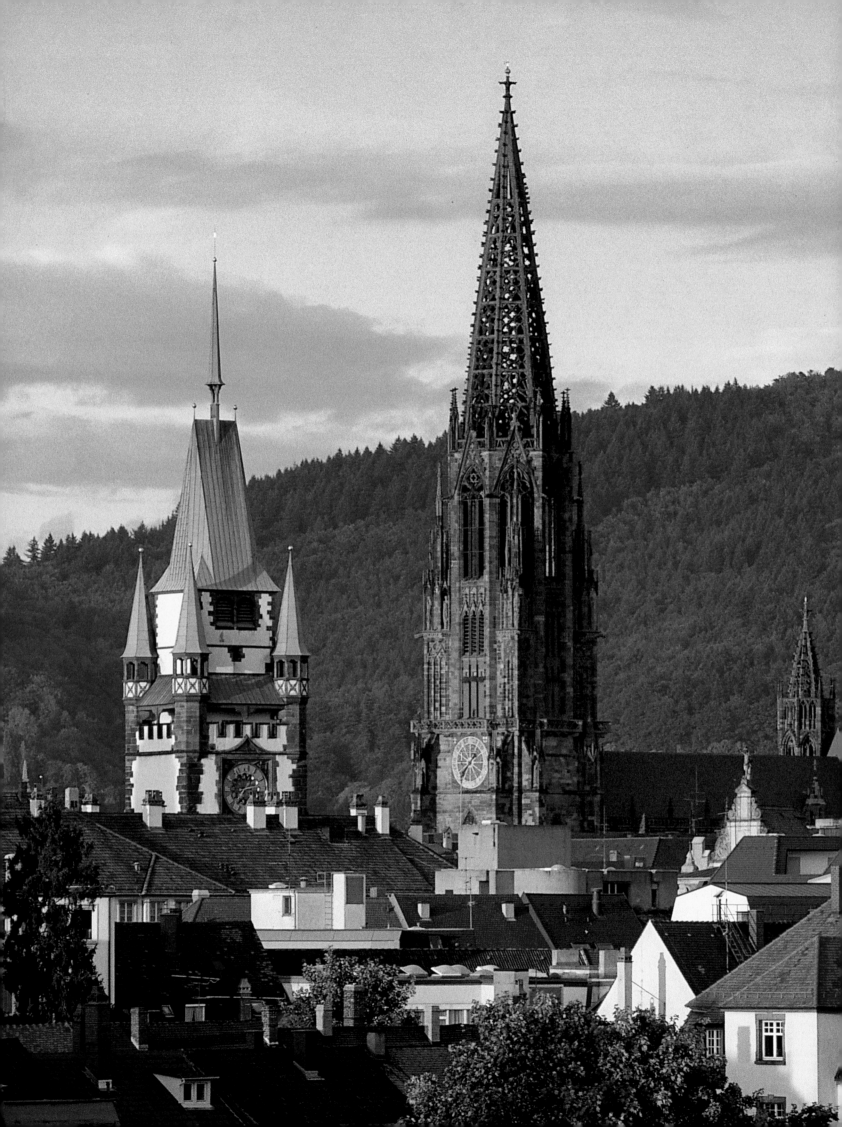

Left and below:
The focal point of Freiburg is its minster, whose 115 m (377 ft) tower historian Jacob Burkhardt once described as the most beautiful in all Christendom. The panoramic views of the charming old town and the Schlossberg from atop its steeple are indeed breathtaking.

Below:
The centre of Freiburg is riddled with a system of miniature canals fed by a side arm of the River Dreisam. In summer the streams are a great place to cool off, popular with children and adults alike.

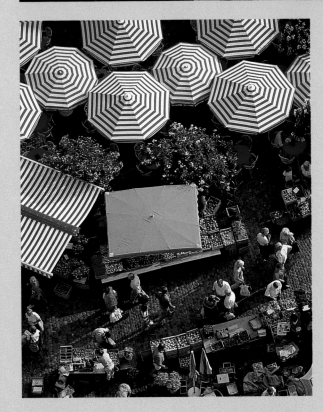

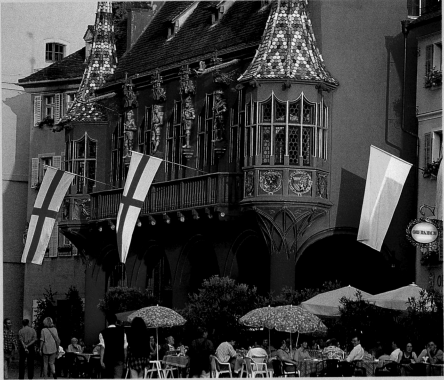

Above:
One of most atmospheric places to shop in Freiburg is the market on Münsterplatz, where you can buy Black Forest ham and fresh fruit and vegetables from local farms.

Above:
The historic Kaufhaus, completed in 1532, is also on the cathedral square in Freiburg. The imposing edifice was where the guild of merchants once convened and is now used for receptions and various cultural events.

137

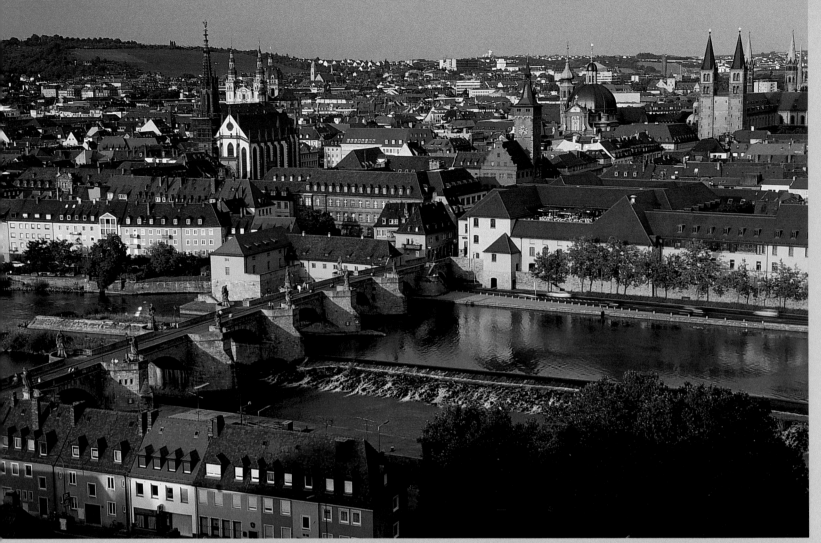

Above:
Looking down from the fortress onto the venerable city of Würzburg its silhouette is punctuated by late medieval towers and spires, reminiscent of one of its most famous sons, sculptor Tilman Riemenschneider. The old bridge across the River Main, flanked by life-size figures of saints, points to the legacy of the city's powerful archbishops, who in the residential palace have bequeathed to us one of the most significant monuments of the baroque.

Right:
Nuremberg is the metropolis of Franconia and the second-largest city in Bavaria. It has retained much of its medieval charm, one example of which is the old Heilig Geist hospital on the banks of the River Pegnitz.

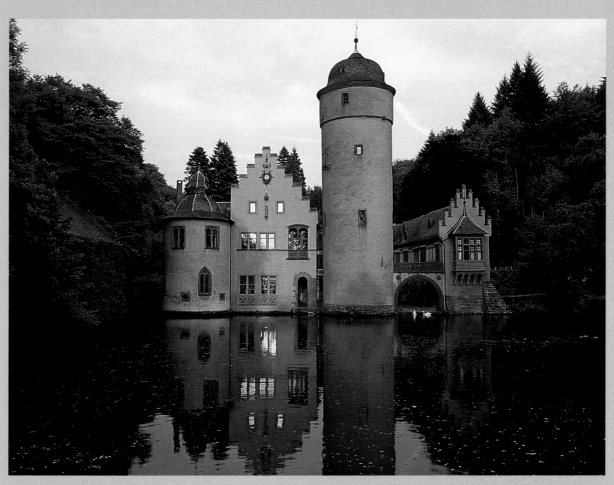

Left:
Schloss Mespelbrunn hidden away in the dark forest of the Spessart is a place of bewitching enchantment. Dating back to the 15th century, its present appearance is the result of several periods of refurbishment.

Below:
Bamberg, an ancient imperial city and bishopric in Franconia, has a 1,000-year-old architectural history, at the heart of which is the medieval cathedral (left) crowning one of its seven hills. The Altes Rathaus with its half-timbered extension, the Rottmeisterhaus, was built in the middle of the city's River Regnitz on the boundary between the secular and sacred quarters of town.

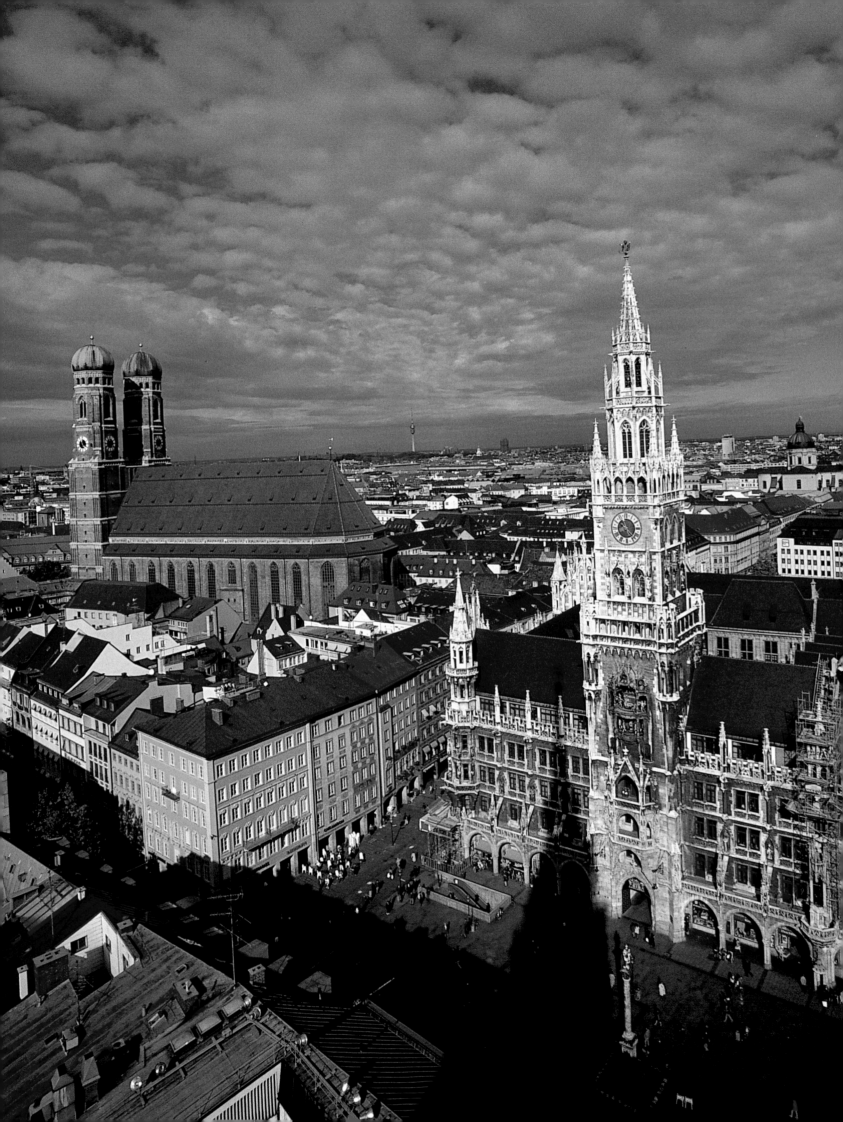

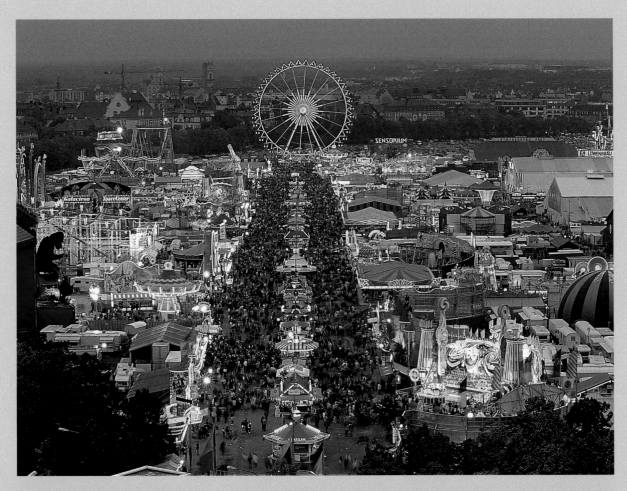

Left page:
Munich is the undisputed capital of Bavaria, the view from the top of St Peter's taking in two of its most famous landmarks: Marienplatz with the old town hall (right) and the Frauenkirche (left) with its twin onion domes.

A further Munich highlight is the largest public festival in the world; year in, year out, seven million visitors trek to the Oktoberfest on Theresienwiese to take in the side-shows and – most importantly – the beer.

Once a year Munich celebrates its founding in a colourful spectacle on Marienplatz outside the Altes Rathaus. Even more impressive are the spontaneous jubilations on the square when the local football team wins the championship.

Top left:
When summer draws to a close the cattle are driven down from their Alpine pastures to the stables in the village. In Buching in the eastern Allgäu region the occasion is a cause for celebration.

Centre left:
Ramsau on the River Ache with its tiny parish church dedicated to St Fabian and Sebastian is truly unforgettable and undoubtedly one of the most beautiful spots in the Berchtesgadener Land.

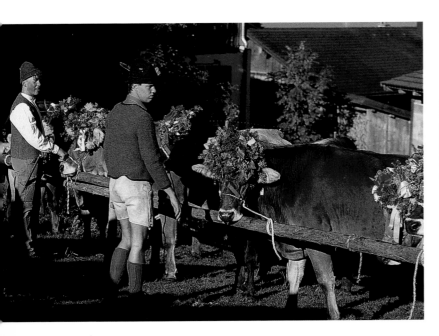

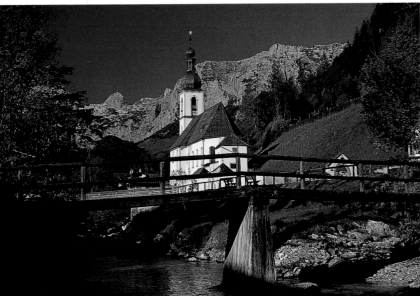

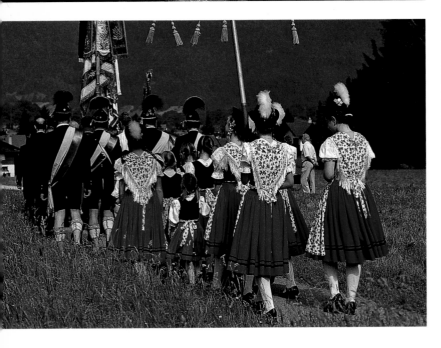

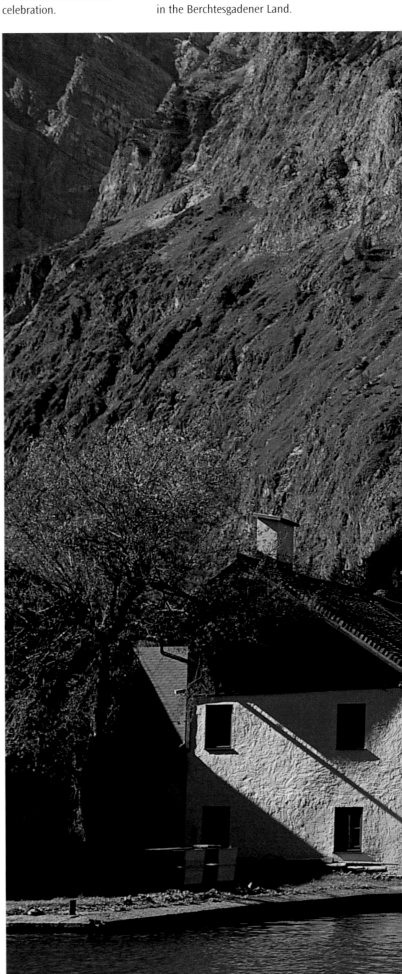

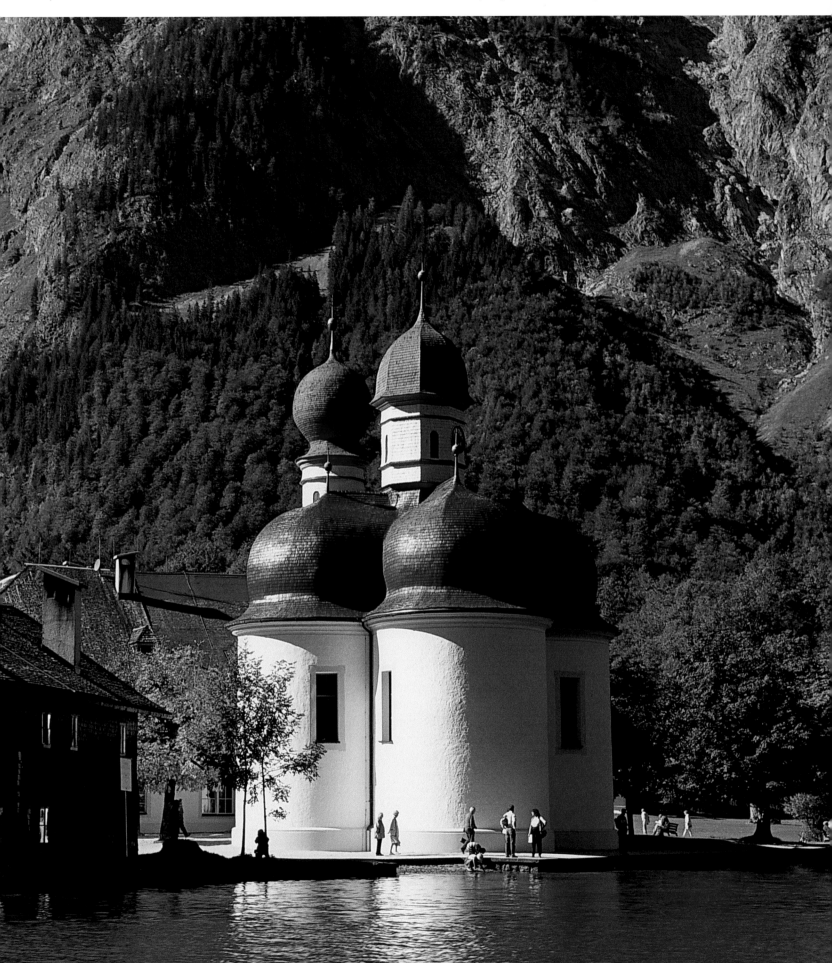

Bottom left:
In Unterwössen in the Chiem-
gau Alps church festivals,
such as the procession at
Corpus Christi, are events
in which the entire village
takes part.

Below:
The Königssee with the pil-
grimage chapel of St Bartho-
lomä cowering beneath
precipitous limestone slopes

is one of the absolute gems
of the Berchtesgadener Land.
The characteristic church has
been a place of pilgrimage
since the 12th century.

A GERMAN FAIRYTALE KING –
LUDWIG II

King Ludwig II first saw the light of day on August 25 1845 in Schloss Nymphenburg. His parents, King Maximilian II and Queen Marie of Bavaria, were delighted at the birth of their son who, following the early death of his father, succeeded to the throne on March 10 1864 to become king of Bavaria. During his reign he fought on the side of Austria in the Seven Weeks'

Below:
Richard Wagner was only able to realise his various musical projects with the help of Ludwig II.

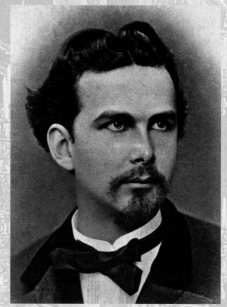
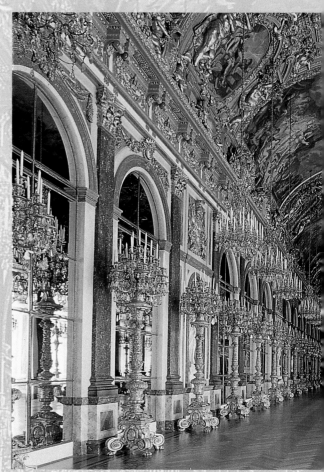

Above right:
Ludwig II, not adverse to the newest technological achievements of his day and age, allowed himself to be photographed.

War and sealed Bavaria's entry to the German Empire. On June 13 1886 he drowned in the Starnberger See.

If these facts were the only record of Ludwig's life and times, he could simply be dismissed as one of the more insignificant figures in Germany's long royal history. He was, however, also a keen architect and patron of the arts. Events which greatly shaped the young king's life were his love of the music of Richard Wagner and his meeting with the composer on May 4 1864.

Following this Wagner was given the financial freedom to realise his various operatic projects as he saw fit. On May 22 1872 construction began on the opera house in Bayreuth which from August 6–8 1876 saw the premiere of Wagner's "Ring". The composer continued to be generously supported by the king; without this royal funding, many of his pieces would not be known to the world today.

The permanent legacy of Ludwig II, today a huge magnet for tourists, are his lavish castles,

particularly Neuschwanstein, Herrenchiemsee and Linderhof. There are sources claiming that his love of architecture goes back to the days when he played with toy bricks as a boy; others state that building was simply a traditional royal pastime.

SCHLOSS NEUSCHWANSTEIN – A ROYAL VISION

In 1870 King Ludwig II began building Schloss Linderhof, wanting to revive the splendour and

it came to the interior design, the king himself often intervened with suggestions and ideas.

Another of Ludwig's grand architectural projects was Herrenchiemsee. He had acquired the Herreninsel in 1873; building commenced in 1878. The new edifice consciously sought to emulate Louis XIV, particularly in the Hall of Mirrors which was to be reminiscent of Versailles.

The more time Ludwig II devoted to his architectural undertakings – he had more or less

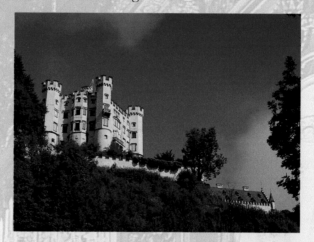

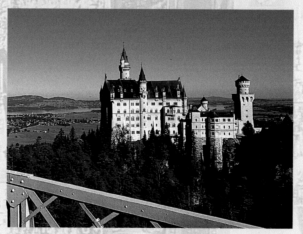

Centre:
Schloss Herrenchiemsee on the Herreninsel in the Chiemsee was built between 1878 and 1885 and modelled on Versailles. The Hall of Mirrors appears to be a direct copy.

Left:
Schloss Hohenschwangau rises up above the Schwangau area, erected between 1832 and 1836 for King Maximilian II, Ludwig II's father.

Below left:
Ludwig II's most famous edifice is Schloss Neuschwanstein. The best view of his fairytale castle is from the Marienbrücke which dizzily spans the precipitous Pöttlachschlucht.

Below:
Schloss Linderhof is the smallest of Ludwig II's residences and the only one he actually inhabited. Hidden away in a solitary mountain setting, it was constructed between 1874 and 1878.

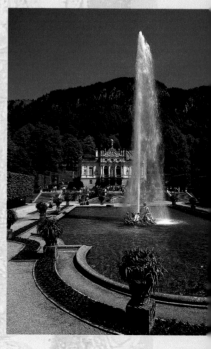

pomp of the French kings of the 18ᵗʰ century. One year prior to this his plans for Schloss Neuschwanstein began to take shape. Theatrical set designer Christian Jank sketched out a fairytale palace high up on a rocky outcrop above the family's estates in Neuschwangau. It was to be built in the style of a medieval German castle, with references to "Lohengrin" and "Tannhäuser", Ludwig wrote on May 13 1868 in a letter to Wagner. In 1869 the foundations were laid and even the Franco-Prussian War of 1870/1871 did little to hinder the progress of the project. When

retired from public life – the louder the voices criticising him for neglecting his governmental duties became. On June 10 1886 Ludwig was dethroned, declared insane and removed to Schloss Berg on the Starnberger See. On June 13 he arranged to meet Dr von Gudden, the director of the lunatic asylum in Munich, for a stroll around the lake. Hours later, after nightfall, the search for the former king began; his body was dragged up from the lake, together with that of the doctor. The circumstances surrounding his death have never been clarified.

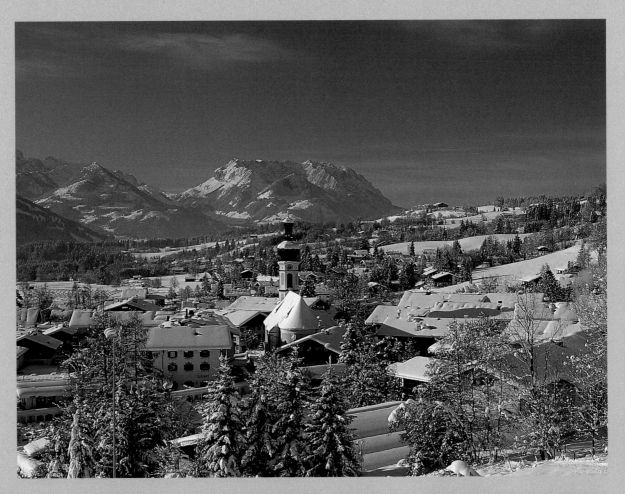

Right:
Reit im Winkl in the Bavarian Alps is in one of the snowiest regions of Germany. You don't have to be a winter sports freak to enjoy the brilliant scenery of this glorious area.

Below:
Garmisch-Partenkirchen spreads out into the wide valley of the Loisach below the peaks of the Wetterstein Range. Here in Garmisch the snowy roofs of the houses on Sonnenstraße lead to the parish church of St Martin's and the summit of Mount Wank in the distance, right on the town's doorstep.

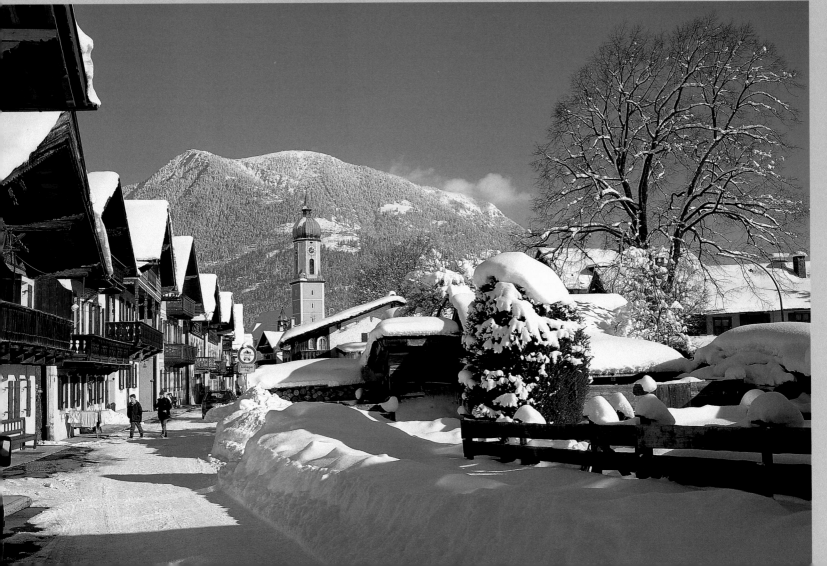

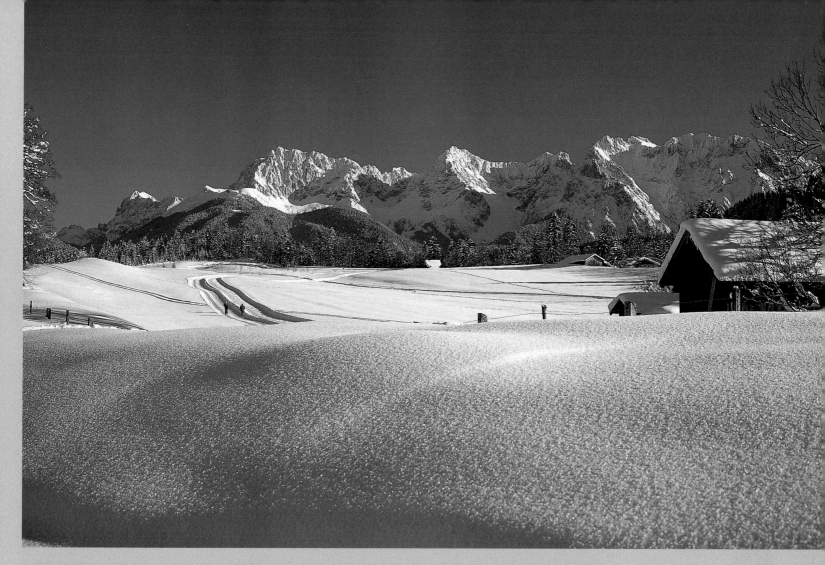

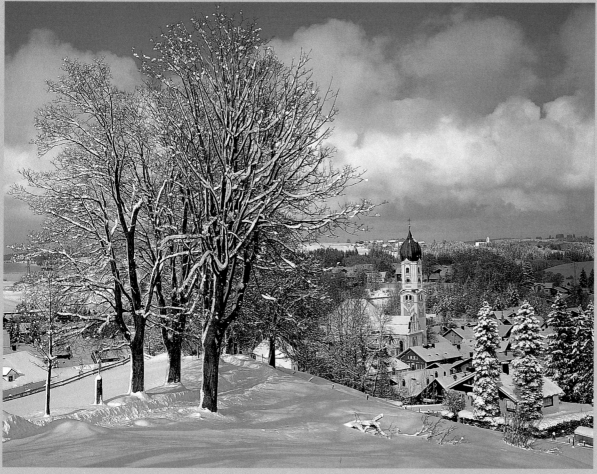

Above:
With ski runs leading along the edge of the Geroldsee and the icy crags of the Kar-wendel Range in the back-ground, the Werdenfelser Land is a winter paradise for cross-country skiers.

Left:
With its undulating meadows and areas of forest the Allgäu is one of the most popular places for holidays in the south of Germany. Nessel-wang in the east doubles as a spa in the summer and a ski resort in the winter.

Centre right:
Ludwig Thoma, born in this house in Oberammergau in 1867, is known for his "Lausbubengeschichten" (Rascal's Tales) –and not just in Bavaria.

Bottom right:
The Passion Play, a local amateur production which only takes place every ten years, has made Oberammergau famous all over the world. This particular scene shows the way of the cross.

149

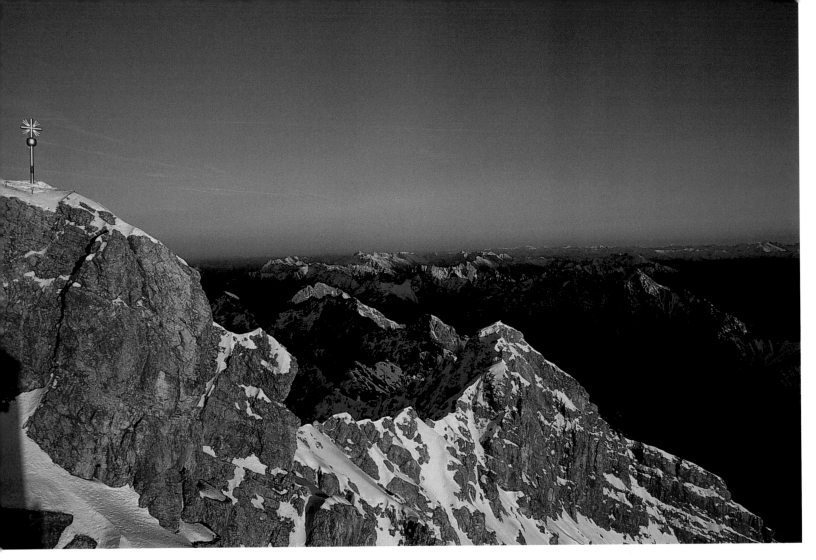

Above:
Southwest of Garmisch-Partenkirchen is the Zug-spitze, at 2,962 m (9,718 ft) the highest elevation in Germany. To the left is the cross at its summit. In winter the Schneeferner is one the most popular skiing areas here.

Right:
In the Bavarian Alps life often seems idyllic, with the entire family helping to drive the cattle down from their summer pastures.

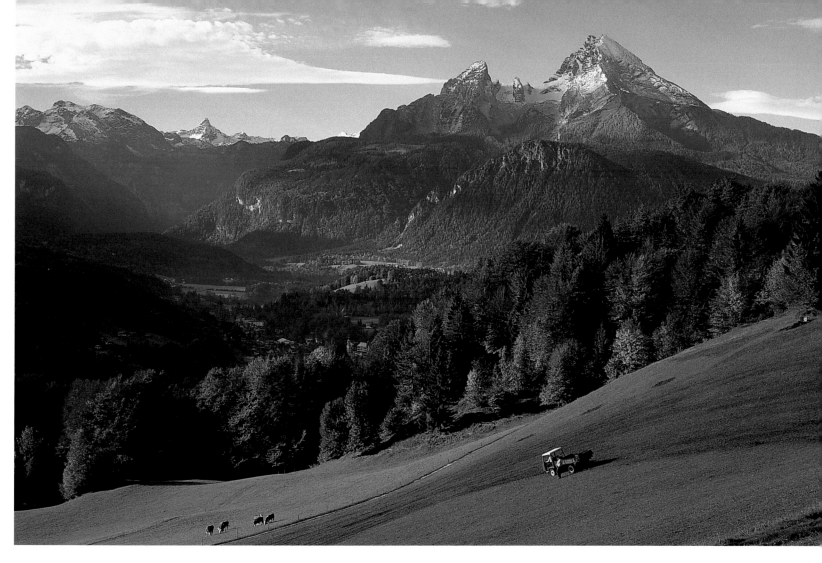

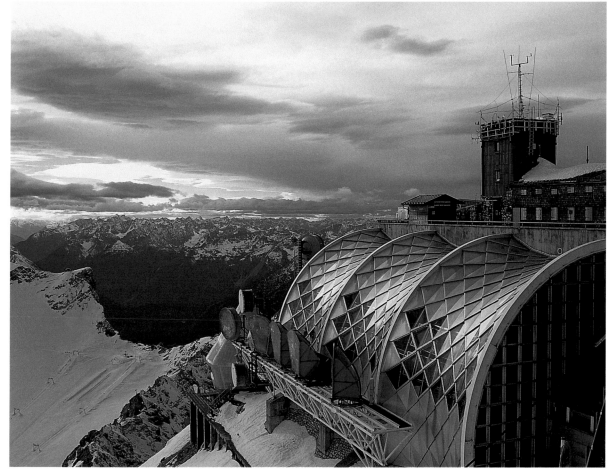

Above:
View from the Kneifelspitze across lush pastureland to the majestic Watzmann Massif in the Berchtesgaden Alps.

Left:
The top of the Zugspitze is home to both the highest weather station in Germany and also the terminus of the mountain railway up from Garmisch-Partenkirchen and the Eibsee.

Page 152/153:
The pilgrimage church of St Koloman near Schwangau was built in this marvellous Alpine setting in the Allgäu in 1685.

151

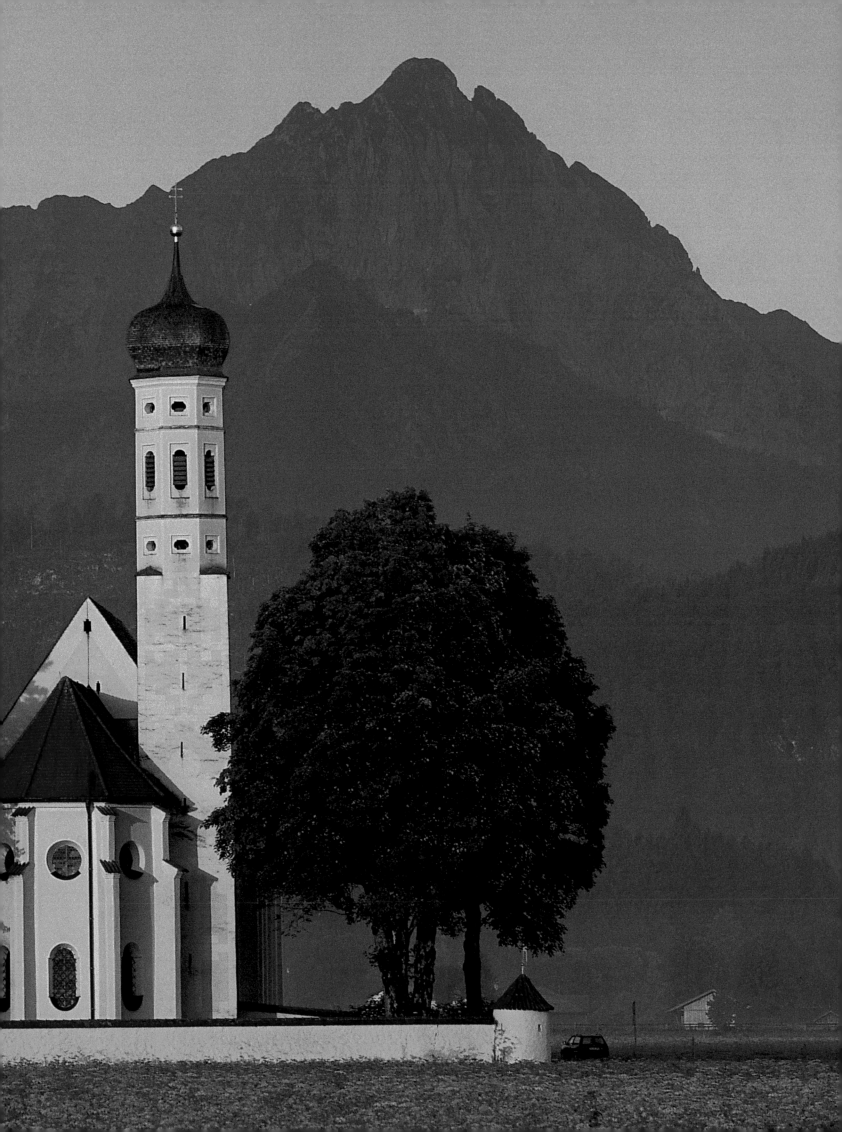

REGISTER

	Text	Photo
Aachen		61
Ahlbeck	70	71, 75
Ahrenshoop		74
Amrum	31	
Augsburg	44	
Baden-Baden		132
Bamberg		139
Bayreuth	144	19
Berlin	21-24, 71f	7, 11, 23f, 73, 85, 89ff
Bernau		113, 131
Biberach		130
Blankenberg		59
Bonn	72, 110	69
Borkum	32, 127	
Bremen	32, 44	40, 42f
Bremerhaven	32	
Buching		142
Celle		55
Cochem		111
Cologne	33, 44	60f, 92
Constance		129
Darmstadt		117
Dessau	73	25
Detmold		59
Dortmund		21, 67, 92
Dresden	73	19, 24, 94, 98-101
Düsseldorf	33	68
Duhnen		36
Ebringen		127
Elzach		134
Eppstein		119
Erfurt		105
Essen		67
Fehmarn		32
Flensburg		38
Frankfurt	21, 44, 107, 112	20, 120f
Freiburg	112	22, 113, 127, 132f, 137
Freudenberg		20
Furtwangen		132
Garmisch-Partenkirchen		146, 150f
Göttingen	33	54
Greifswald	70	77
Güstrow		76
Gutach		130
Hamburg	30f, 44f	31, 33ff, 38, 41, 44
Hamelin		32
Hannoversch Münden		54
Hanover	32	52f
Heidelberg		124
Herrenhausen		52f
Hildesheim		54
Kaiserslautern		117
Kassel	112	119
Kiel	21, 31, 44	39f
Klein Zicker		25
Koblenz	64	113
Leipzig	20, 24, 44, 73, 107	18, 94, 107
Lemgo		32
Lindau		129

	Text	Photo
Lübeck	31f, 44f	44f, 48
Lüneburg	44	
Mainz	64	118
Marbach	107, 113	107
Marburg an der Lahn		119
Markneukirchen	73	
Meersburg		64, 128
Meißen		73, 105
Melsungen		119
Michelstadt		119
Minden	32	
Molfsee		40
Münster		54
Munich	113, 145	93, 141
Mylau		24
Naumburg	72	
Nesselwang		147
Neuruppin		23
Neustadt an der Weinstraße		119
Neuwerk		38
Nuremberg	113	138
Oberammergau		148f
Quedlinburg		105
Ramsau		142
Reit im Winkl		146
Rieden		31
Rostock	44	76
Rothenburg ob der Tauber		17
Rottach-Egern		112
Rügen	70	25, 75, 78ff
Saarbrücken		116
Sahlenburg		37
Schiltach		133
Schleswig		33
Schwangau	145	145, 151
Schwerin	71	72, 81
St Märgen		132
St Peter		133
Stralsund	44	77
Stuttgart	107, 112	124f
Sylt	31	36
Trier	110, 126	115
Tübingen		125
Unterwössen		143
Usedom	70	71, 75
Völklingen	111	
Volkerode		51
Wangerooge	32	
Weimar	21, 73, 106f	106ff
Wernigerode		105
Wiesbaden		117
Wilhelmshaven	21, 32	
Wismar	19, 44	
Wittenberg	19, 72	105
Wolfenbüttel	33	156
Wolfsburg		69
Worpswede		40
Würzburg	18, 113	11, 138

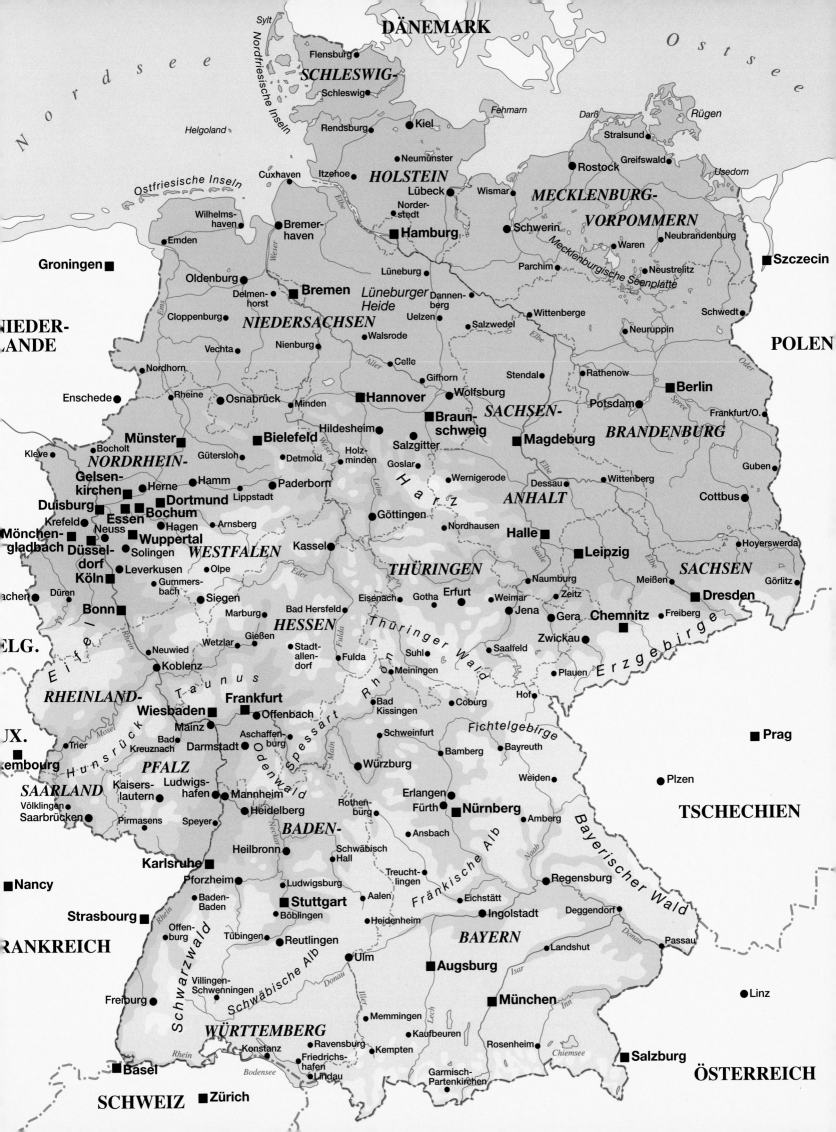

IMPRESSUM

Design
Förster Illustration & Grafik, Würzburg

Map
Fischer Kartografie, Fürstenfeldbruck

Translation
Ruth Chitty, Schweppenhausen

Printed in Germany

Repro by Artilitho, Trento, Italy
Printed and bound by Offizin Andersen Nexö,
Leipzig
Typesetting by Fotosatz Richard, Kitzingen

© 2002 Verlagshaus Würzburg GmbH & Co. KG

ISBN 3-8003-1567-X

Photos

Jürgen Henkelmann:
p. 6/7, p. 14/15, p. 19 centre, p. 24 top,
p. 70/71, p. 74 (2 ill.), p. 75 top, p. 76 bottom,
p. 77, p. 80 top, p. 82, p. 83 top, p. 83 bottom,
p. 84-91 (14 ill.), p. 95 bottom, p. 98 (2 ill.),
p. 99 top, p. 101 top, p. 101 bottom, p. 103
(2 ill.), p. 107 right top, back jacket.

Karl-Heinz Raach:
p. 8/9, p. 22 (2 ill.), p. 113 left bottom, p. 113
right top, p. 126/127 centre, p. 127 right top,
p. 127 right centre, p. 128-137 (21 ill.).

Martin Siepmann:
Front jacket, p. 12/13, p. 28/29, p. 36 bottom,
p. 39 top, p. 39 bottom, p. 42/43 (4 ill.),
p. 50 (2 ill.), p. 92/93 centre, p. 93 top, p. 93
bottom, p. 112, p. 140/141 (3 ill.), p. 143
(3 ill.), p. 144/145 centre, p. 145 right (3 ill.),
p. 146-149 (8 ill.), p. 150 (2 ill.), p. 151 top.

Horst and Daniel Zielske:
p. 5, p. 16/17, p. 18, p. 19 top, p. 19 bottom,
p. 20/21 (4 ill.), p. 23 (2 ill.), p. 24 centre,
p. 24 bottom, p. 25, p. 25/27, p. 30-35 (9 ill.),
p. 36 top, p. 37 (2 ill.), p. 38, p. 39 centre,
p. 40/41 (4 ill.), p. 44/45 centre, p. 46-49 (4 ill.),
p. 51-69 (36 ill.), p. 72/73 (4 ill.), p. 75 bottom,
p. 76 top, p. 76 centre, p. 78, p. 79, p. 80 bottom,
p. 81, p. 83 centre, p. 94 (2 ill.), p. 95 top,
p. 96/97, p. 99 bottom, p. 100, p. 102 (2 ill.),
p. 104/105 (5 ill.), p. 106 left top, p. 106/107
centre, p. 107 left top, p. 107 left centre,
p. 108/109 (3 ill.), p. 110/111, p. 113 right
bottom, p. 114-125 (22 ill.), p. 138/139 (4 ill.),
p. 143, p. 151 bottom, p. 152/153, p. 156.

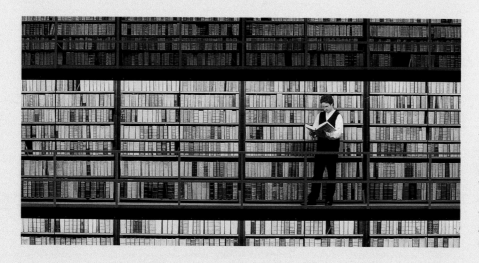

The library named after Duke Augustus in Wolfen-büttel has one of the most valuable collections of books and manuscripts in the world. Wilhelm Leibniz and Gotthold Ephraim Lessing both worked here.

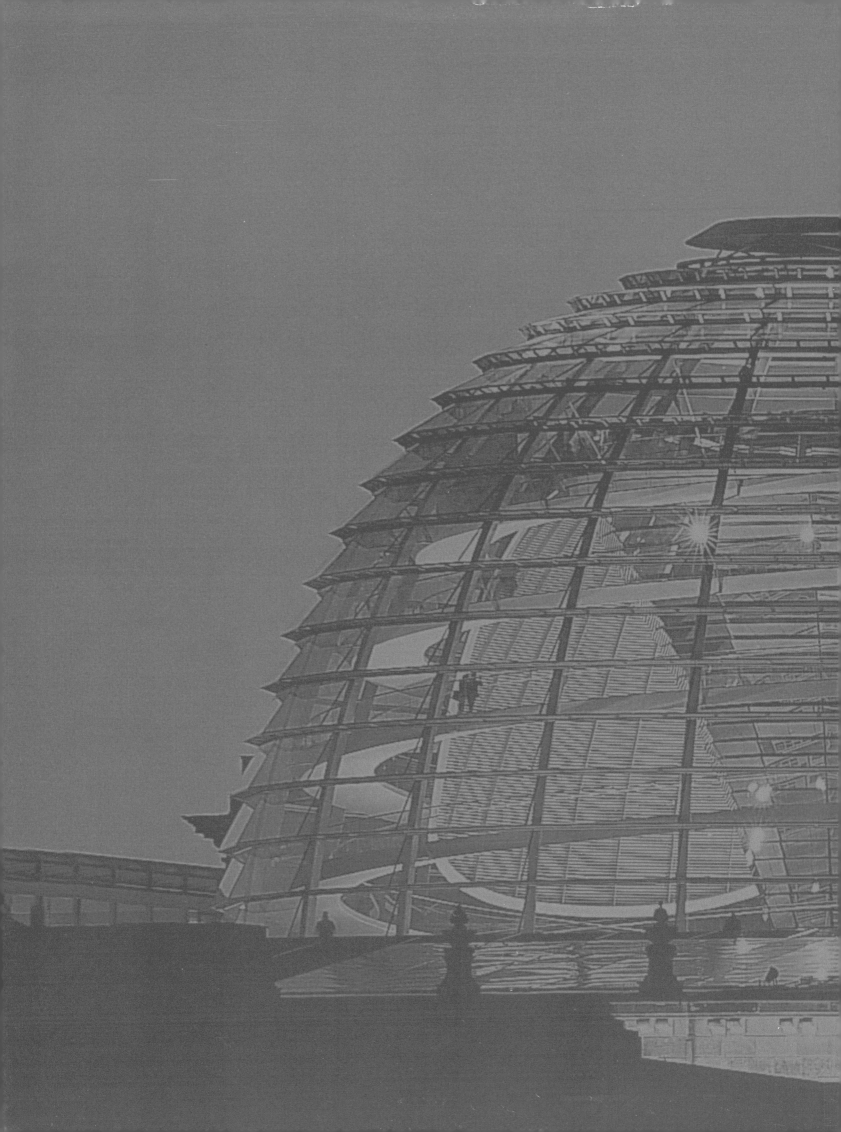